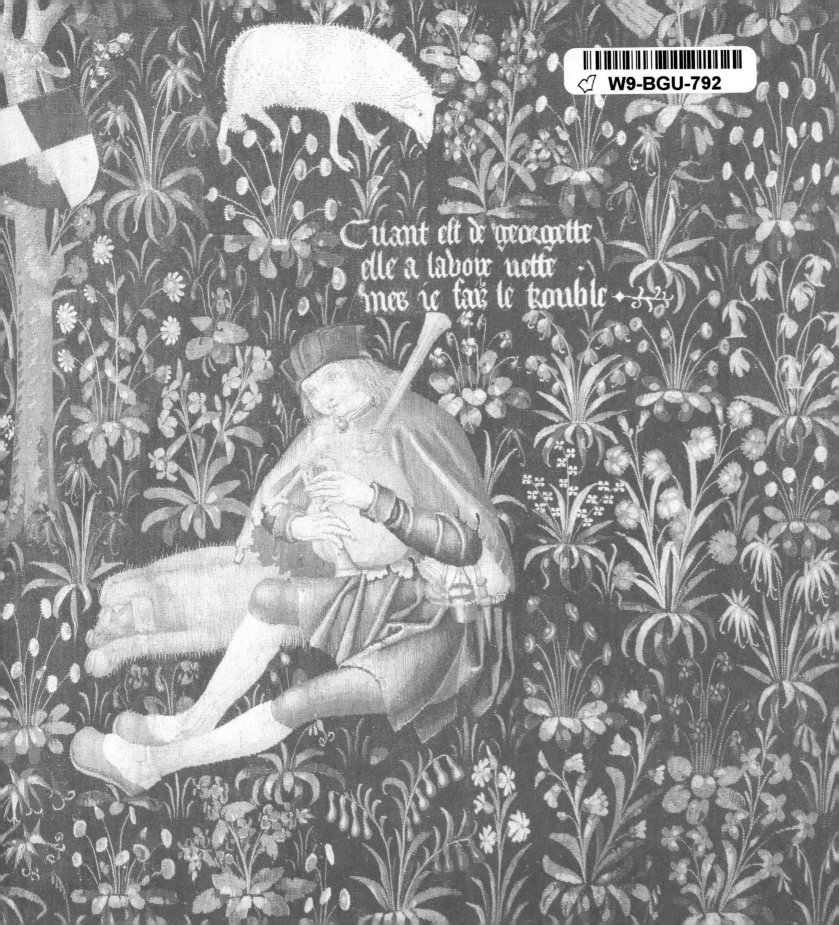

Couples
IN ART

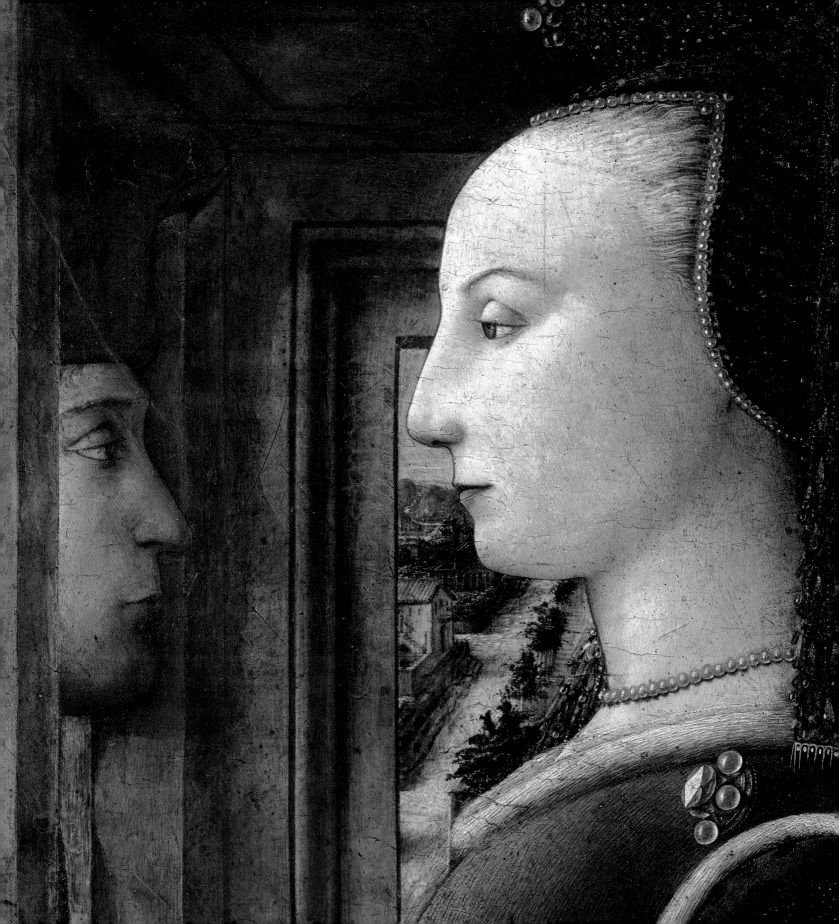

Couples
IN ART

Christopher Lyon

Artworks from
The Metropolitan Museum of Art
selected by Colin Eisler

in collaboration with Caroline Kelly

DELMONICO BOOKS · PRESTEL
MUNICH LONDON NEW YORK

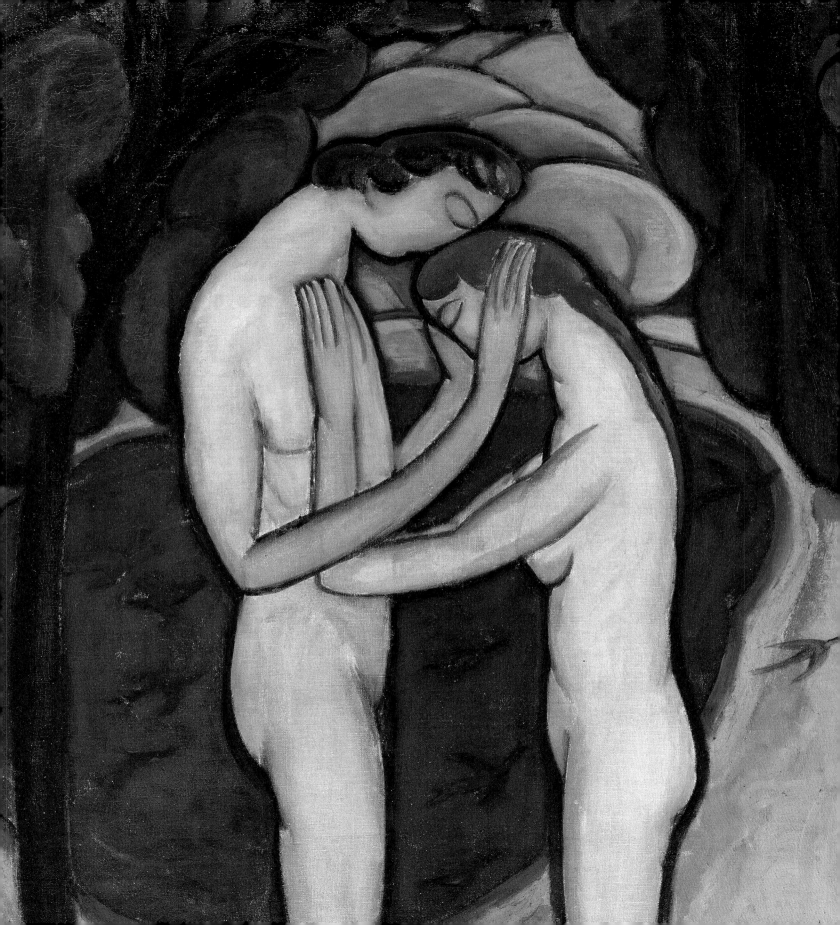

COUPLES IN ART

Could Central Park be Eden? William Zorach imagined it so in 1914, picturing himself and his wife, the painter Marguerite Thompson, as a new Adam and Eve, oblivious to all but themselves in the middle of New York City (opposite and page 143). On the perimeter of that Eden stands The Metropolitan Museum of Art, sheltering that picture, and the many others in this volume, that bear witness to the imaginative energy that the subject of couples has elicited from artists and craftspeople since antiquity. ✢ On the next pages is a pair of canvases that represents a more traditional vision of Adam and Eve, painted by Giuliano Bugiardini toward the end of the first decade of the sixteenth century. One might expect a classical rather than a Biblical theme to appear in a bedroom, where these paintings apparently were intended to hang, but Adam and Eve's story is nearly universal in the Western tradition. The First Couple represent Husband and Wife, Everyman and Everywoman. They give us the primal narrative of humanity in the Christian, Jewish, and Muslim faiths, which, despite their different interpretations, share the belief that God created Adam and Eve in the Garden of Eden and then banished them to earth for the sin of eating the forbidden fruit, thus ensuring their mortality. ✢ Bugiardini knew something of banishment. According to Vasari, he was part of a small team of Florentine artists recruited by Michelangelo to help him with the daunting task of fresco-painting the Sistine Chapel ceiling in Rome. But when Michelangelo had them paint a specimen portion of the work, he was so disappointed that he destroyed their painting and locked them out of the chapel, and they had to return home, "ashamed and mortified," as Vasari says. Kind of like being thrown out of Eden by God. ✢ Adam and Eve are usually depicted standing under the Tree of Good and Evil, often with a tempting snake at Eve's side. Here we see prone figures — à la Michelangelo's sleeping Adam on the Sistine ceiling,

< **WILLIAM ZORACH**
Spring in Central Park (detail), 1914
Oil on canvas; 46 × 36 in. (116.8 × 91.4 cm)

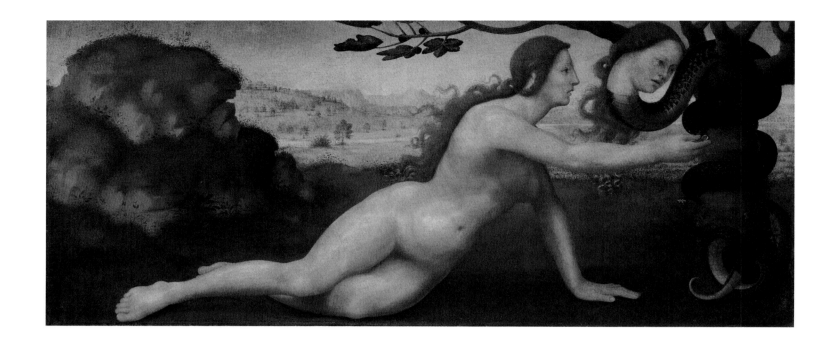

though the landscape and the figures' sharp contours suggest that Bugiardini must have been familiar with Northern European paintings and prints. ❧ Artists and patrons alike have shared a passion for depictions of the sinning first couple. Even when faith flickered or faded, Adam and Eve were seldom if ever lost to view, since they provided a reassuringly moral excuse for painting, drawing, printing, or sculpting two naked and usually attractive young people. ❧ Just as we all descend, in the imagination of Western religions, from Adam and Eve, so portraits of couples in European cultures may be said to be children of art depicting the First Couple. More ancient cultures and tribal societies are hardly lacking in attention to couples, however. For centuries, images of the intimacies, ecstasies, and tragedies of the pagan gods were all that allowed us to visualize the consequences of unleashed passion and sexuality. Unlike the monotheistic Judeo-Christian deity, who usually avoids intimate involvement with humanity, classical gods of both genders maintained close connections with mankind and shared its vices and virtues. Often they yearned for the love of beautiful mortals, coupling with them while disguised as bulls, thunderbolts, swans, or even a shower of gold — a euphemism, perhaps, for the bribing of those charged with keeping a virgin safe from men and gods. ❧ Couplings of mortal and divine were the stuff of countless illuminated manuscripts, prints, paintings, statues,

GIULIANO BUGIARDINI
Adam and *Eve,* 1st decade of the 16th century
Oil on canvas; each 26⅜ × 61¾ in. (67 × 156.8 cm)

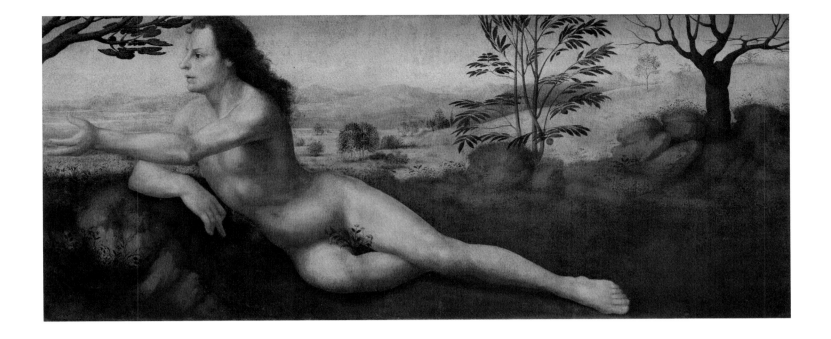

and tapestries. Why should a god, who presumably has everything, pine after one whose life will end in sure and certain death? We humans, or some among us, must be irresistible: Cupid and Psyche, Perseus and Andromeda, Ganymede and Apollo, Venus and Adonis, Diana and Actaeon — their love stories abounded in the visual arts of antiquity and were revived in the late Middle Ages, remaining popular to this day. ✥ In the prudish nineteenth century, ancient mythology afforded topics for titillating paintings with the requisite acreage of bare flesh, tempered by an essential twist of drapery here, a hand or piece of foliage there. Massive nudes in close proximity to one another, enacting the tantalizing trysts of the gods, proved a staple of artistic production. The canvases were listed as "naked pictures" in special guides to the annual Paris Salons so that the true art lover need not waste his time looking in the wrong halls. ✥ As time passed, we became increasingly interested in ourselves at the expense of gods, our own foibles, failures, and successes instead of theirs. A charming 15th-century engraving of a couple courting, by Israhel van Meckenem (see page 78), allows us to glimpse a gentle stream of emotion that would one day become the mighty river of today's romantic films and novels, among other entertainments. ✥ Today, the very concept of courtship seems as quaint as smelling salts. Yet for earlier generations the many routes to the altar were governed by formal measures for

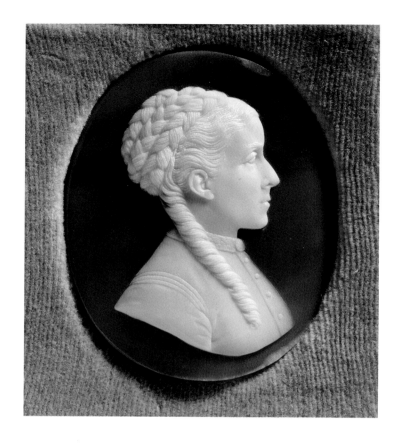

mutual arrangements and common approval. The mysteries of first meetings, misunderstandings, rivalries, expectations, and frustrations were anticipated (and savored) aspects of courtship. So much mythology, faith, literature, and even history hinged upon the right (and wrong) roads to tying the knot or signing the certificate. Romantic preliminaries teemed with expectation and a sense of possibilities but also left open the chance of failure. ❧ Yet we do not cease to pursue one another, via the Internet's social networking sites, in the modern equivalents of the taverns and cafés depicted here and, yes, even in museums like the Met where extended evening hours have generated a high-voltage dating scene. We still savor the fine comforts of sharing a romantic moment, and still celebrate our partnerships when we have attained a ripe age and understanding. And we care deeply about the partners we have lost. ❧ In about 1861, the thirteen-year-old Augustus Saint-Gaudens, apprenticed to a cameo cutter, was commissioned to make a likeness of a local lawyer,

AUGUSTUS SAINT-GAUDENS
Hannah Rohr Tuffs, 1872; and *John Tuffs,* ca. 1861
Shell; Hannah: 2 × 1½ in. (5.1 × 3.8 cm); John: 1¾ × 1½ in. (4.5 × 3.8 cm)

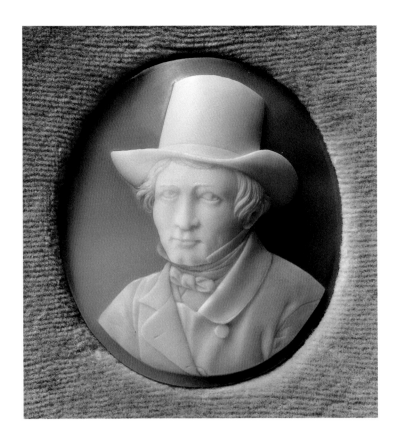

John Tuffs, by his widow. Based on a photo of his deceased subject, the ghost-like cameo is animated but uncanny. Eleven years later in Rome, Mrs. Tuffs ran into the artist, soon to become America's most celebrated sculptor of public monuments such as the Robert Gould Shaw Memorial on Boston Common. She recognized him and asked him to cut her likeness, based on a drawing. She had that second cameo paired with her late husband's, and both are preserved in the original velvet-lined boxes. ❧ Only memory and art may see to it that Death never does us part. For thousands of years, belief in, or hope for, eternal love and immortality has kept painters, builders, sculptors, and, most recently, photographers at work creating innumerable paired likenesses and providing for their display. Many of these double images take on a dynamic role as surrogates for the deceased, some to receive prayers and offerings as part of ancestral observances. In spaces private and public, these paired portrayals "live" in art as enduring presences.

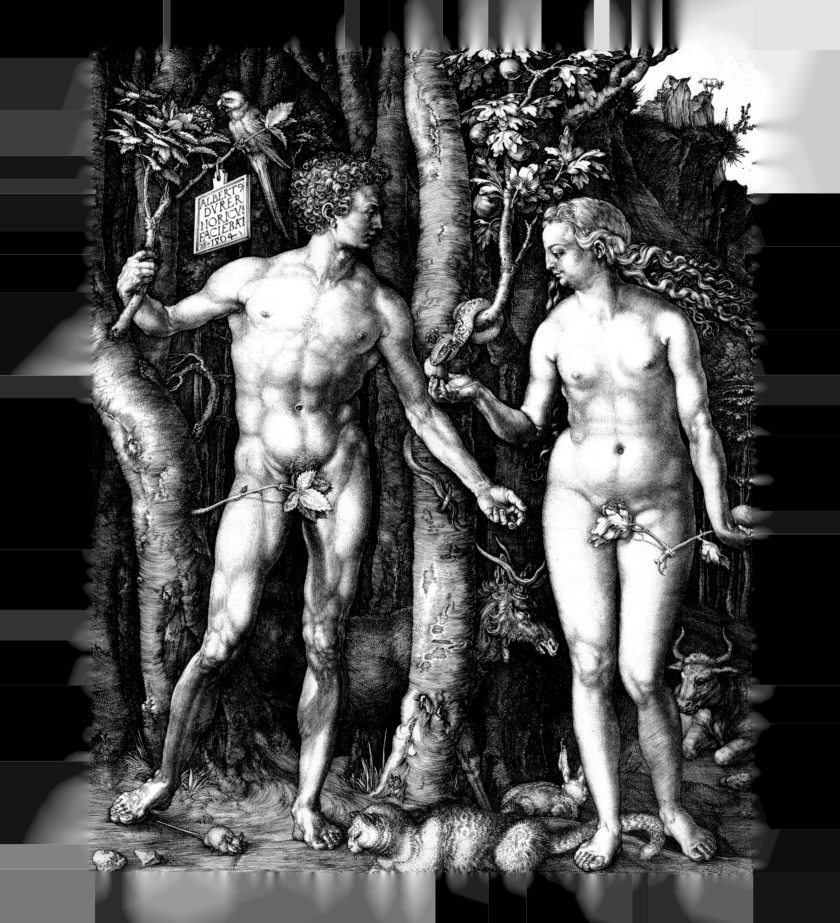

Albrecht Dürer's research into the proportions and construction of the ideal human figure culminated in this engraving of 1504, depicting Adam just as he reaches for the tempting fruit offered by Eve, which the snake thoughtfully places in her hand. The strategic leaves are provided by Nature; for a few moments yet the couple will be unaware of their nakedness. Dürer seems to have adapted Adam's pose from a drawing of the soon-to-be famous Apollo Belvedere, the ancient Roman sculpture discovered a few years earlier. The four animals at the couple's feet represent the medieval four temperaments: the cat choleric, the rabbit sanguine, the ox phlegmatic, and the elk melancholic. Merging this medieval iconography with classical art and learning, as seen in the figures' proportions, and with attention to the specific qualities of plants and animals worthy of a modern scientist, the work epitomizes a moment in modern European history when past and future collide, as they do here for the first couple, with fateful consequences. ✣ Frank Eugene's Adam and Eve understand that they are naked. With their heads scratched out, obliterating identity, and with Adam turned away, the picture is a study in shame. Born in New York, Eugene trained in Munich as a painter and became expert in complicated photographic techniques after his return to the United States in 1894. In line with principles of the Photo-Secession, which he helped found in 1902, Eugene treated photography as a fine-art medium, etching his negatives, as he does here, to produce moody Pictorialist images. As with Dürer's Adam, Eugene's Eve recalls a celebrated sculpture, the *Eve* of Rodin, a favorite artist of the Photo-Secession, which caused a sensation when it was debuted at the Paris Salon of 1899.

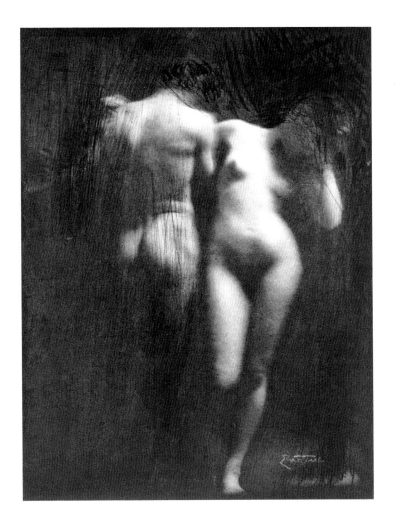

<ALBRECHT DÜRER
Adam and Eve, 1504
Engraving; fourth state; 10³/₁₆ × 8¹/₁₆ in. (25.9 × 20.4 cm)

∧ FRANK EUGENE
Adam and Eve, 1909
Photogravure; 7 × 5¹/₁₆ in. (17.8 × 12.8 cm)

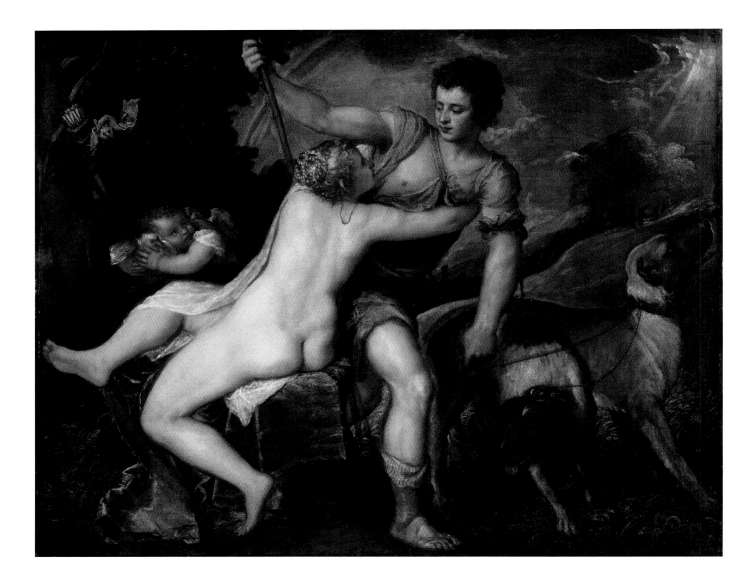

Titian's *Venus and Adonis* interlock in this compact canvas, love goddess and love object becoming a human pinwheel. Venus restrains Adonis, who struggles to escape her embrace. Like many subjects dealing with passions shared by gods and mortals, this scene is from Ovid's *Metamorphoses*. Here, a mere mortal succeeds in opposing divine will. Rejecting the goddess's love to pursue the hunt, handsome Adonis will pay the price and be gored by his prey, a wild boar. Titian responds to the tragedy of youth's folly by showing Cupid incapable of aiding his mother.

After that tragic youthful fling, Venus settles down with a corporate titan of the gods, Mars, in Veronese's canvas from about the same period as the Titian. Not taking any chances, Cupid binds Mars, the god of war, to Venus with a garter. With its graceful ensemble of figures, the painting conveys a restrained musicality. The painter's sense of decorum, seen in his exquisite, yet powerful, coloring, points to the art of the following two centuries. Venus holds her breast in a gesture betokening love, generosity, and nurture. The magnificent dark figure of Mars is a foil for her blond grace.

∧ **TITIAN**
Venus and Adonis, ca. 1570
Oil on canvas; 42 × 52½ in. (106.7 × 133.4 cm)

> **PAOLO VERONESE**
Mars and Venus United by Love, 1570s
Oil on canvas; 81 × 63⅜ in. (205.7 × 161 cm)

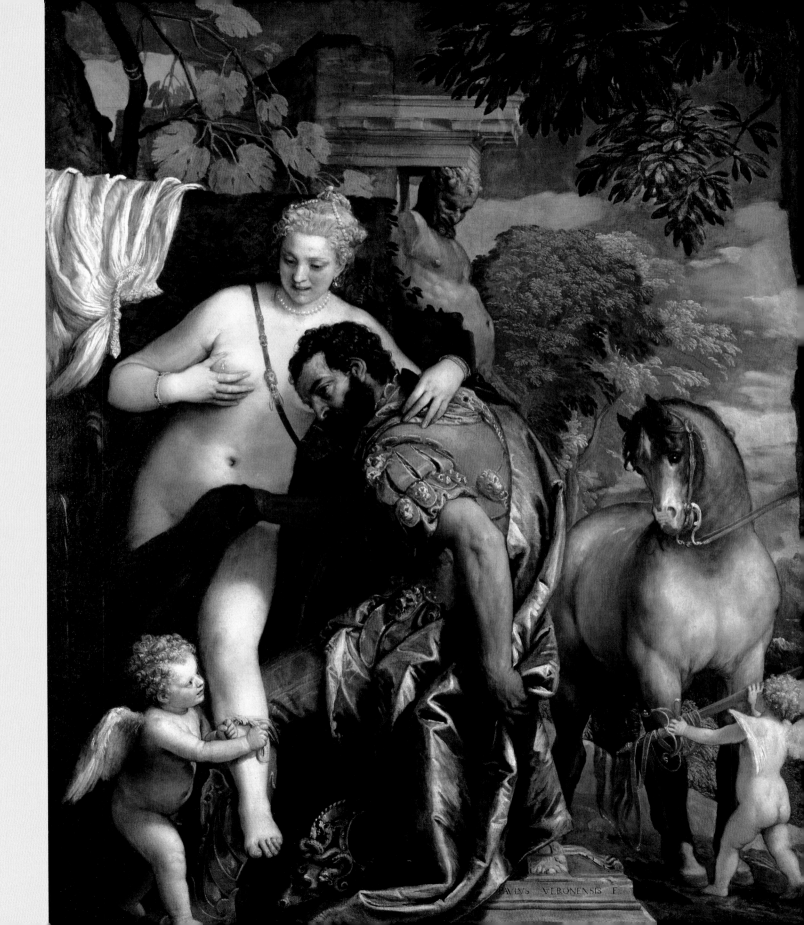

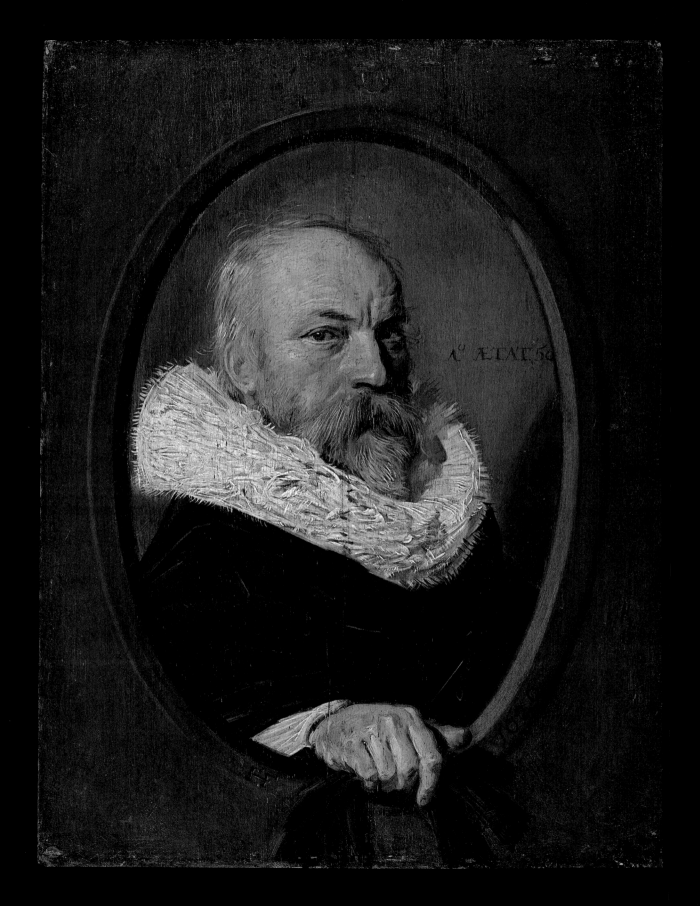

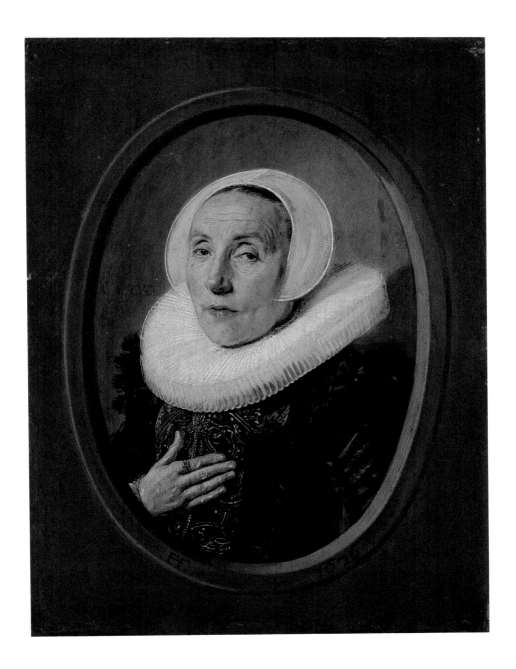

B risk and ever perceptive, without Rembrandt's porten-
tousness, Hals's images are so seemingly spontaneous
that we feel we have just caught the eye of his subjects.
Petrus Scriverius, a well-known writer, is seen here through an
oval enclosure, with his right hand grasping the frame in
trompe-l'oeil fashion and holding gauntlets, attributes of social
status. The historian's wife wears an austere, if not forbidding,
expression, as at odds with her rich attire as it is with the
romantic gesture of hand over heart. Both were fifty years old
when Hals painted them in 1626. Often commemorated in
portraiture, the half-century mark was regarded as a command-
ing age, equally free of youthful folly and elderly feebleness.

FRANS HALS
Petrus Scriverius (1576–1660) and Anna van der Aar
(born 1576/77, died after 1626), 1626
Oil on wood; each 8¾ × 6½ in. (22.2 × 16.5 cm)

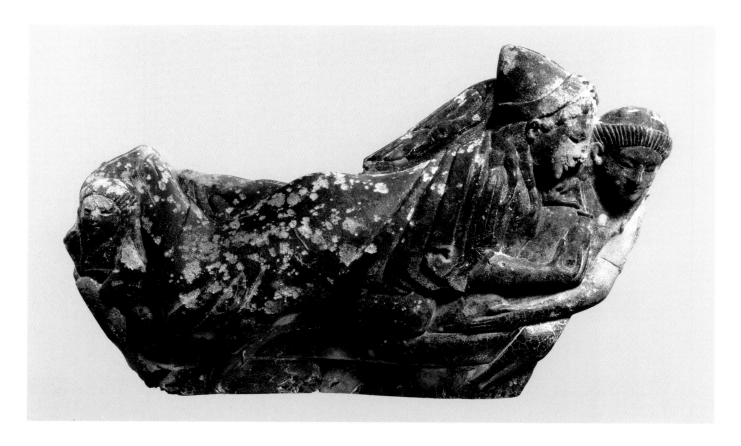

Amber, fossilized tree resin, varies in color from opaque yellow and orange to translucent, glowing red. Traded in antiquity throughout Europe and the Near East, it was endowed with magical qualities and thought to promote health and love. Its erotic associations may explain why this unusually large piece, one of the most important amber objects of pre-Roman Italy, was shaped into a relief of recumbent lovers on a couch. While numerous details are Etruscan, it is impossible to identify where the artist came from and whether the figures are mortal or divine. The woman, seemingly the elder of the two, holds an *aryballos*, a small vase for perfume or precious oils, which she touches with her left hand, perhaps to anoint her companion. Just as insects and plants are sometimes trapped within amber, the embrace of this couple is captured for eternity.

There are more than two hundred versions in some fifty languages of the *Panchatantra*, a collection of originally Indian animal fables in verse and prose. Translated as *Kalila wa Dimna* in AD 750 by the Persian scholar Abdullah Ibn al-Muqaffa, it is regarded as the first masterpiece of literary prose in Arabic. This folio from an illustrated manuscript, made in Egypt or Syria, illustrates the story of the foolish carpenter of Sarandib (Sri Lanka), under the bed on which lie his wife and her lover. The unfaithful wife avoided severe punishment because she spied her husband's foot poking out from under the bed and contrived a story to convince him of her innocence. In the Islamic tradition, Sarandib is the place where Adam touched down after he fell from heaven.

∧ **CARVED AMBER BOW OF A FIBULA (SAFETY PIN)**
Etruscan, Archaic or Classical; ca. 500 BC
Amber; l. 5½ in. (14 cm)

> **FOLIO FROM *KALILA WA DIMNA***
Egyptian or Syrian, 18th century
Opaque watercolor, ink, and gold on paper; 12½ × 8⅞ in. (31.8 × 22.6 cm)

قال لها يا شقيقة الروح نامي فانك كنت ساهرة و تعبت البارحة وسمعت
ما قلتيه من محبتك ابأى فلا انت صنو عيني وشقيقة روحي ٠
وهذه صورة المرأة مع خليلها على السرير
وزوجها الجاهل نائم تحته ٠

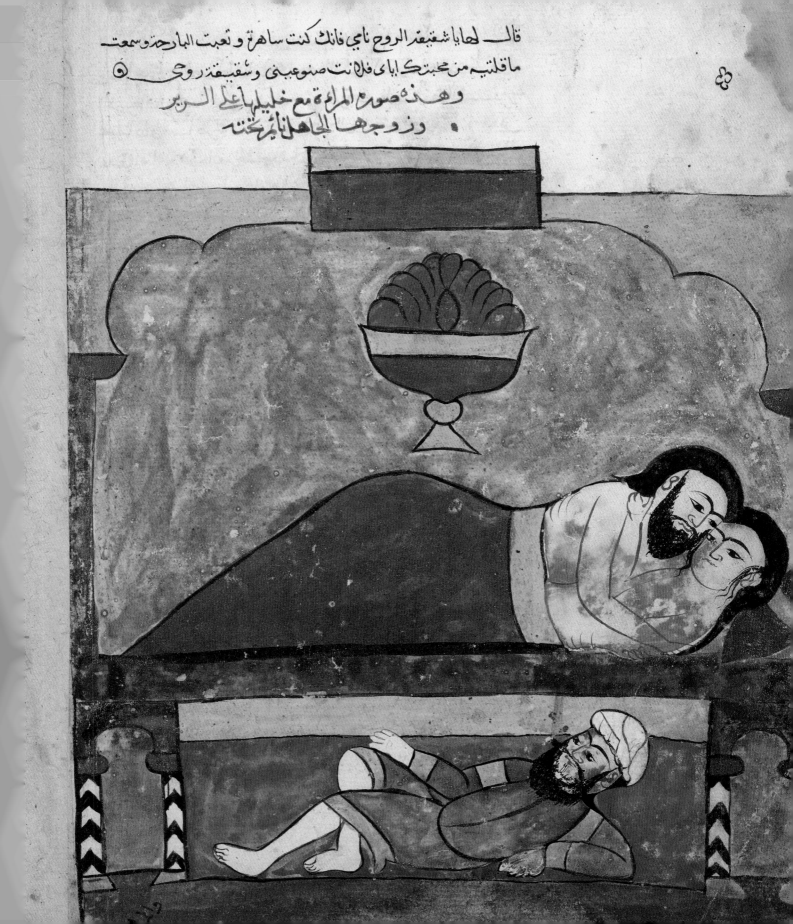

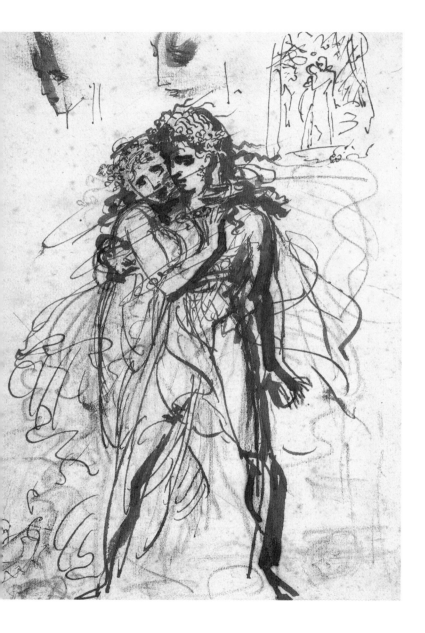

On repeated viewings, few works of art continue to come as great surprises, yet this scintillating sketch by the French painter Antoine-Jean Gros always succeeds in doing so. Composed of finely penned brown ink lines and broad strokes of wash over black chalk, the image vibrates, as if sharing the excitement of the couple's embrace. Cheek to cheek, their bodies pressed together, they seem on the verge of passionate abandon. In its sense of release, Gros's graphic expression anticipates Rodin's terracotta and plaster sketches and Giacometti's drawings. ✤ Our word *chalice* is derived from the Greek *kylix*, denoting a two-handled wine cup with a foot. Balletic and beautifully balanced within its broad bowl, this couple would have been glimpsed when the wine was drunk. Greeks were never shown kissing, only just before or after the act. Here an amorous woman takes the initiative, reaching out to embrace a youth. Whereas the woman's body is seen through a transparent toga, the man reveals a forceful physique, having just drawn his drapery aside. For all its perfection, classical art communicates action with extraordinary vitality, as if set in an eternal present.

∧ **BARON ANTOINE-JEAN GROS**
A Man and a Woman Embracing, n.d.
Pen and brown ink with brown wash over black chalk; 7⅞ × 5½ in. (20 × 14 cm)

> **ATTRIBUTED TO THE KISS PAINTER**
Fragment of a kylix (drinking cup)
Greek, Attic, Archaic; ca. 510–500 BC
Terracotta; overall 6 × 4¹³⁄₁₆ in. (15.3 × 12.2 cm)

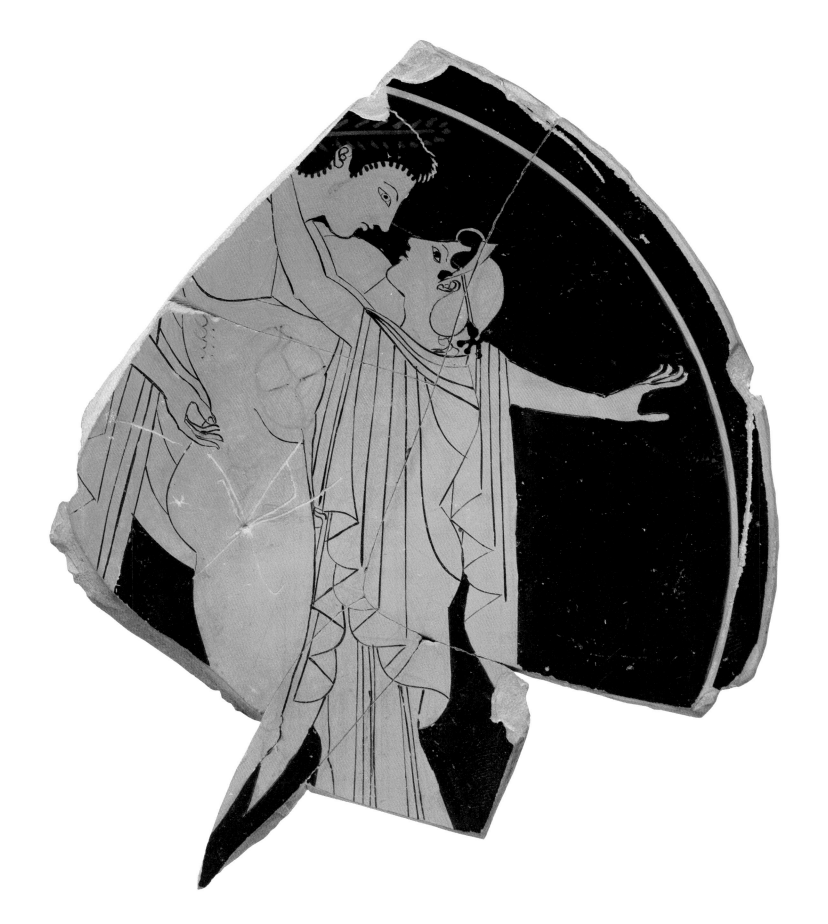

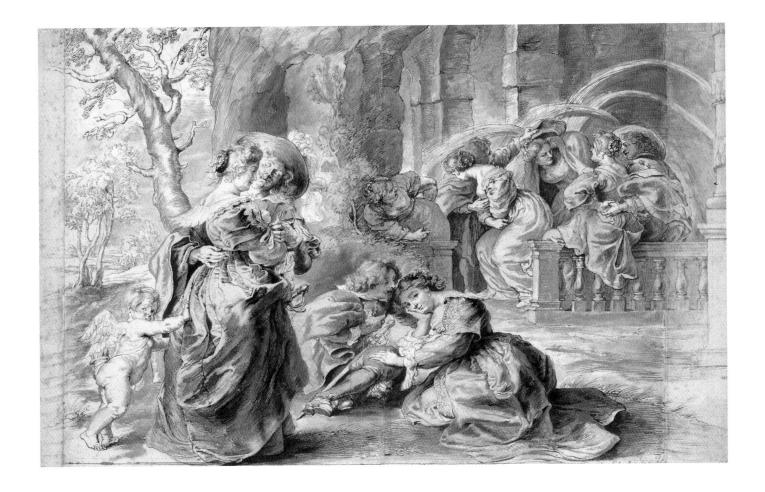

Love, nature, and art meld in the late works of Peter Paul Rubens, whose grand painting *The Garden of Love* (ca. 1630) in the Prado, Madrid, is the source for the drawing reproduced here. At the left Rubens depicts himself with his young bride, Helena Fourment, as if gently urging her to join in the pleasures of the garden, in which the other young couples are already vigorously engaged. ✣ Though Édouard Manet is often credited with a vibrant, original realism, a strong undercurrent of fantasy underlies many of his works, as seen in this painting, which borrows — and transforms — elements from Rubens's celebrated land-scape with a rainbow in the Louvre. For example, where Rubens and his new wife stroll, Manet portrays himself and his companion, Suzanne Leenhoff, whom he would marry in October 1863. And as in Rubens's canvas, a rainbow, symbol of hope and promise, rises above a scene depicting nature's bounty, represented by fishermen filling their nets. A few years earlier, in 1856, Antonin Proust accompanied Manet to visit Eugène Delacroix and recorded the elder painter's advice to the younger: "Look at Rubens, draw inspiration from Rubens, copy Rubens. Rubens was God."

∧ **PETER PAUL RUBENS**
The Garden of Love (left portion), 1630s
Pen, brown ink, gray-green wash over traces of black chalk, touched with indigo, green, yellowish, and white paint on paper; 18¼ x 27¾ in. (46.3 x 70.5 cm)

> **ÉDOUARD MANET**
Fishing, ca. 1862–63
Oil on canvas; 30¼ × 48½ in. (76.8 × 123.2 cm)

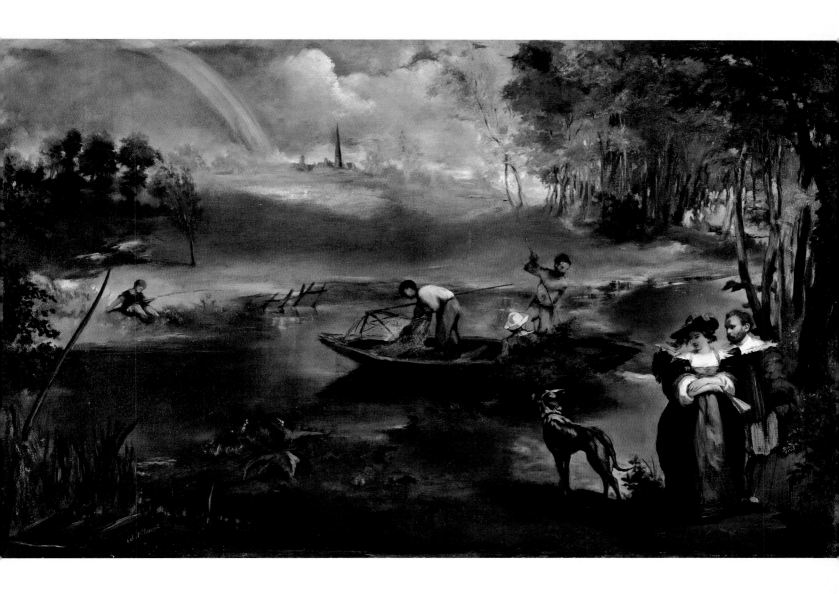

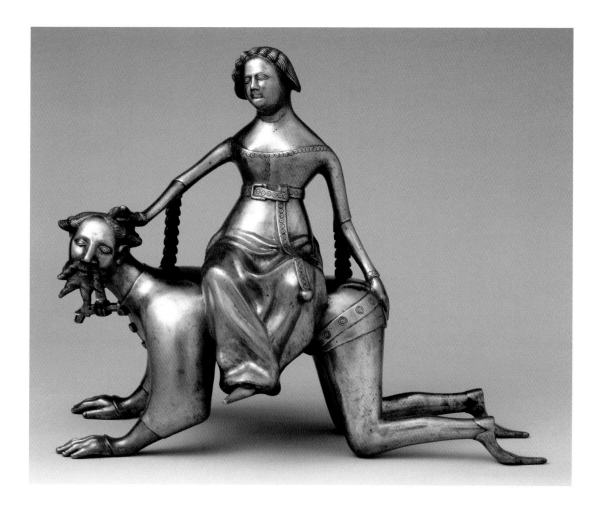

Few quasi-classical subjects were more pleasing to viewers in the late medieval period than the theme of Aristotle's willing acceptance of abuse from Phyllis, the mistress of his student Alexander the Great. Aristotle claimed that he allowed himself to be humiliated by the seductive Phyllis as a lesson to the young ruler, who had succumbed to her wiles and neglected the affairs of state. The subject is depicted here in the form of a bronze aquamanile, a footed water container for washing hands over a basin. On a medieval banquet table, this one would have doubled as an object to entertain guests.

Humorous domestic violence decorates a plate of *dinanderie*, a type of brassware named for the Belgian town of Dinant. The object at the left in the plate's image is a type of fixed distaff, commonly used to hold unspun flax or wool. The husband, whose hat is flying off, holds a cross-reel for spinning fiber by hand. The wife appears to be punishing the poor man for making a bad job of woman's work. To 15th-century viewers, the reversal of roles and his humiliation would have been a pointed satire of married life. The plate, made using the traditional method of brass beating, could have served as a charger or water basin and would have been prominently displayed.

22 **^ AQUAMANILE WITH ARISTOTLE RIDDEN BY PHYLLIS**
South Netherlandish, late 14th century
Bronze; ht. 13¼ in. (33.7 cm)

> PLATE WITH WIFE BEATING HUSBAND
Netherlandish, ca. 1480
Copper alloy, wrought; 3⅞ × 20¼ in. (9.8 × 51.5 cm)

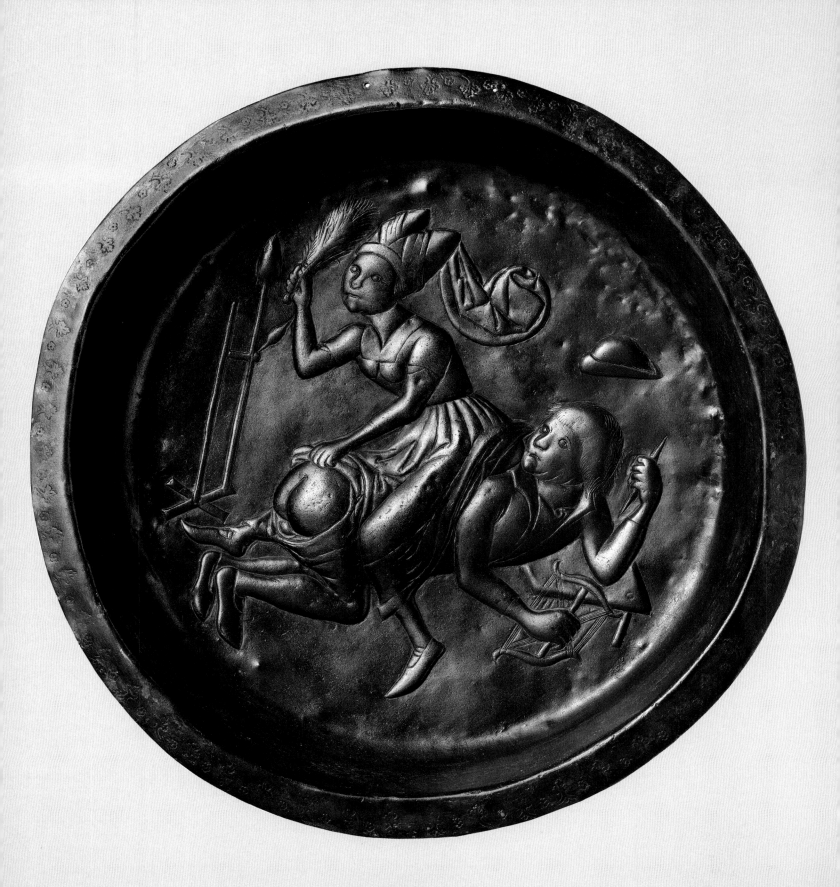

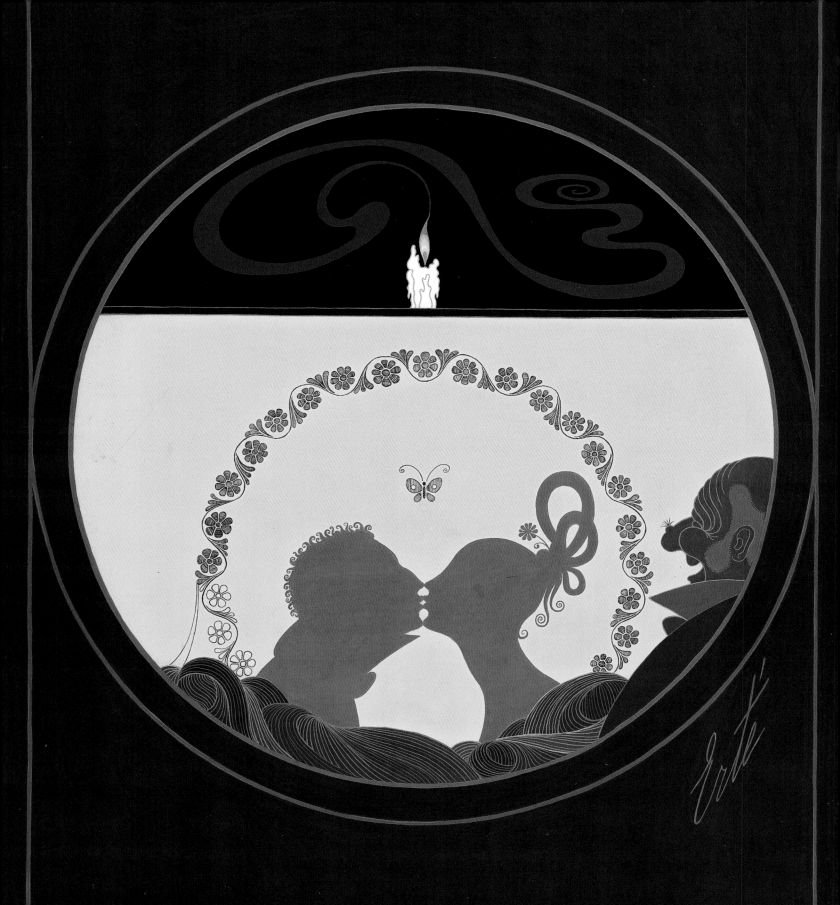

Having fled Saint Petersburg for Paris in 1910, the aristocrat Romain de Tirtoff used the French pronunciation of his initials "R. T." — Erté — to invent a name for himself in his new career as a designer. He became famous for his infectious magazine covers for *Harper's Bazar* (later *Bazaar*), creating more than two hundred of them between 1915 and 1937, and also provided illustrations for *Vogue* and many other periodicals. *The New Penelope*, a ballet of 1847 by the Danish choreographer August Bournonville, inspired this 1921 cover. Kissing lovers and an old man looking on with startled delight are silhouetted in profile, as if seen through a scrim. A burning candle and a butterfly represent the couple's passion. ❧ Shadows are a repeated motif in the work of poet and cinéaste Jacques Prévert, who wrote the screenplay for one of the great classics of French prewar cinema, *Le Quai des brumes* (Port of Shadows). Jean-Michel Folon's romantic urban view, recalling the tradition of the illustrated song sheet, is based upon Prévert's ballad "Les Ombres" (The Shadows):

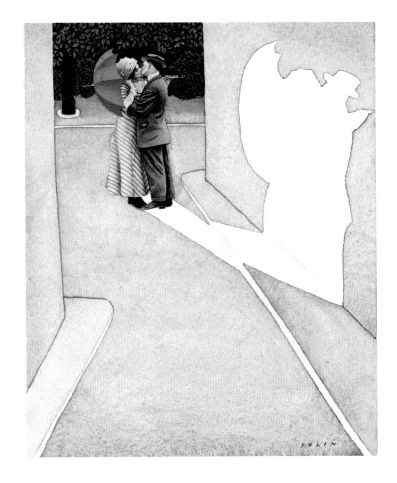

Tu es là	You're there
en face de moi	in front of me
dans la lumière de l'amour	in the light of love
Et moi	And me
je suis là	I'm here
en face de toi	in front of you
avec la musique du bonheur	with the music of happiness
Mais ton ombre	But your shadow
sur le mur	on the wall
guette tous les instants	watched every moment
de mes jours	of my days
et mon ombre à moi	And my shadow and I
fait de même	doing the same,
épiant ta liberté . . .	keeping an eye on your freedom . . .

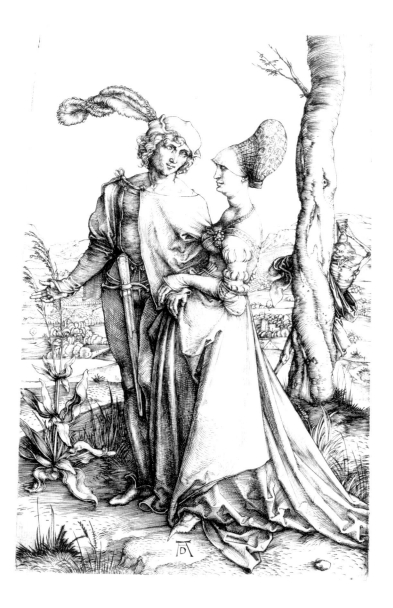

One might almost imagine it to be the same tree behind the couples in these two compositions, made a few centuries apart. One is not certain whether fashionable headgear has evolved in the interim. Dürer, often ambivalent when it came to love, tended toward the sour rather than the sweet. This engraving shows a dashing young man courting a matronly figure in the woods, away from the confines of an ever-watchful urban setting. She is in the attire of a married woman, indicating that this is an illicit affair, to be punished in the next life, if not this one. A gleeful skeleton, hiding behind the tree and brandishing his hourglass overhead, suggests that retribution will take place all too soon.

Few English mid-19th-century pictures of contemporary narratives proved as popular as William Frith's panoramic *Derby Day*. In this preparatory study for the huge composition, showing a richly dressed romantic couple, Frith reveals his awareness of French 18th-century painting. The ambitious panorama took two years to paint, from 1856 to 1858. After being exhibited at the Royal Academy, where a special protective railing had to be installed, it was presented to the recently founded Tate Gallery. Far milder a satirist than his contemporaries, such as William Thackeray, Frith depicted the entire range of spectators at the Derby, the major horse race of the season, from the socially prominent to criminal types.

∧ **ALBRECHT DÜRER**
The Promenade, ca. 1498
Engraving; sheet 7¹¹⁄₁₆ × 4¾ in. (19.5 × 12.1 cm)

> **WILLIAM POWELL FRITH**
Study for the two central figures of *Derby Day*, 1860
Oil on canvas; 18 × 12½ in. (45.7 × 31.8 cm)

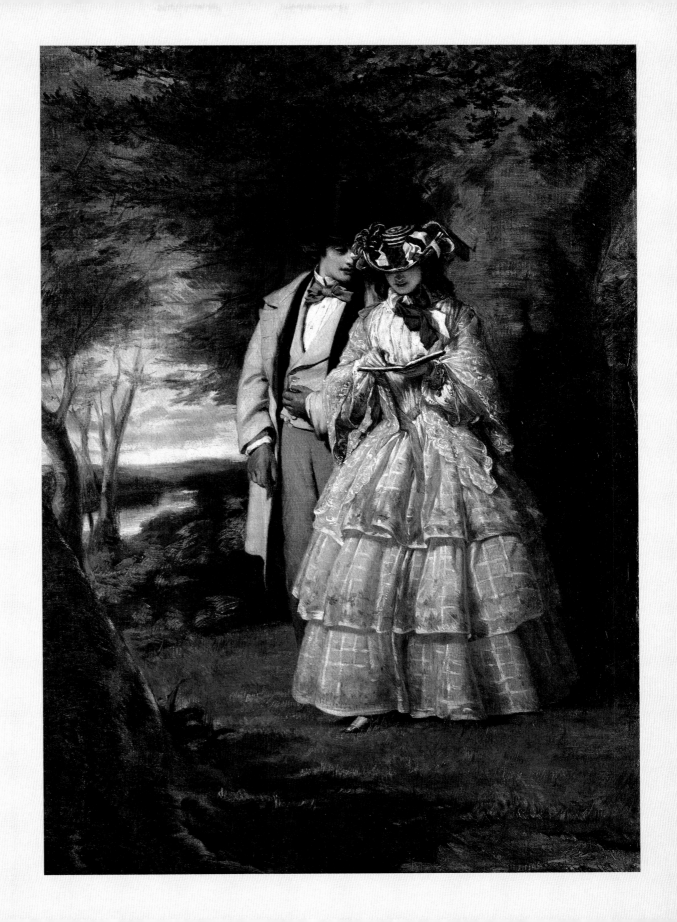

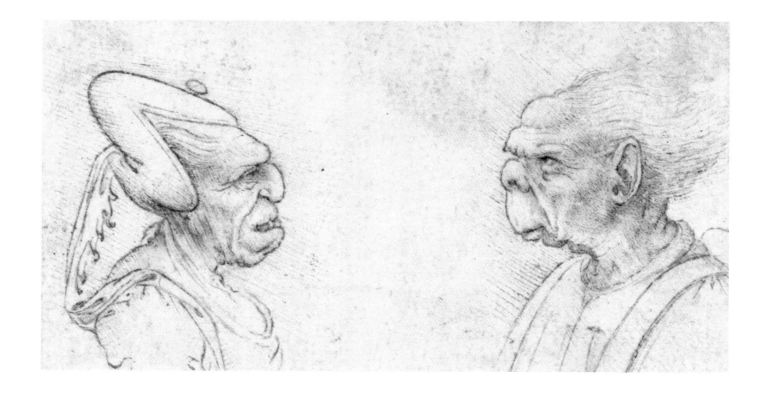

While perfect beauty can bore, ugliness seldom fails to fascinate. Leonardo da Vinci, a pioneer in the exploration of caricature as he was in so many other areas, knew this odd truth well. Attributed to one of Leonardo's student-followers, Francesco Melzi, this drawing shows an old couple staring at each other in mutual disgust, as if wondering what the attraction ever could have been. Is time the culprit, creating the painful changes they recognize only in each other but never in themselves? 🦋 Japanese men's attire did not have pockets, so containers for pipes, tobacco, and money were linked by netsuke to a man's sash or belt. Largely dating from the Edo period (1515–1868), they are virtuosic little sculptures carved of hornbill, ivory, amber, or fossilized wood, among other materials. The finest, most intricate ones were sculpted to be "read in the round, visible to the touch." The subject of this example is a legend about the 11th-century warrior Omori Hikoshichi, who rescues Princess Chihaya, daughter of a former enemy whom he has just defeated. As he carries her across a river, he sees reflected in it that she has changed into a demon aiming to revenge her father's death, and he then must slay her. Does the figure's inextricable duality point to the mutability of passion, of love that may suddenly turn to hate?

∧ ATTRIBUTED TO FRANCESCO MELZI
Two Grotesque Heads: Old Woman with an Elaborate Headdress and a Man with Large Ears, 1491/93–1570
Pen and brown ink; 2⅛ × 3⅞ in. (5.4 × 9.9 cm)

> NETSUKE WITH OMORI HIKOSHICHI
Japanese, 18th century
Ivory; ht. 6 in. (15.2 cm)

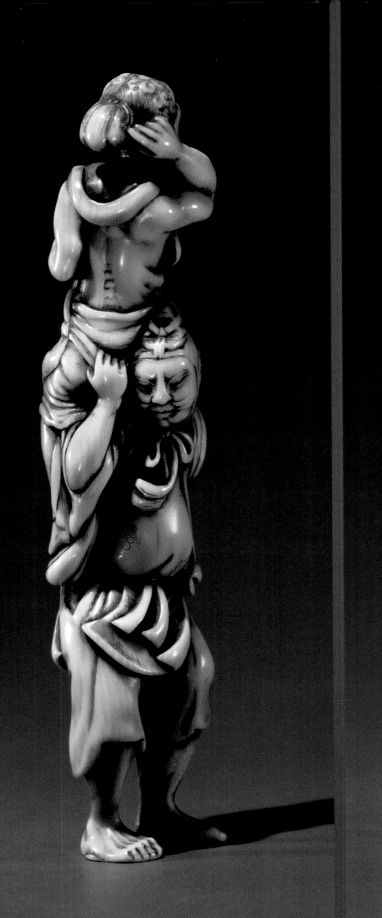
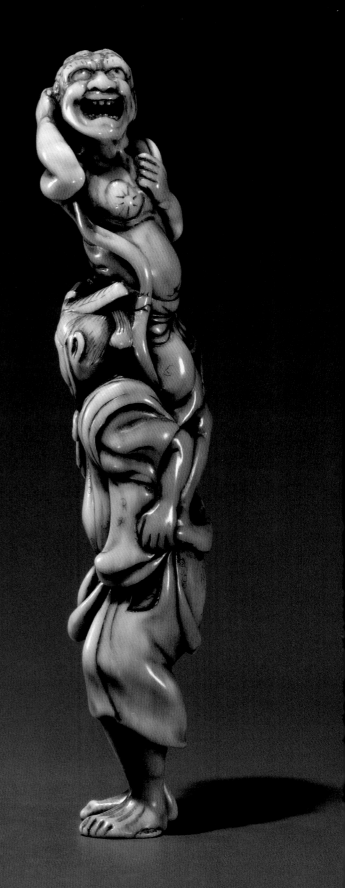

HARPER'S
AUGUST

A bored couple sits on the sand. What is, or is not, going on between them? Is she pouting because she's forgotten her copy of *Harper's*, or is it because she is stuck wearing all those clothes to the beach while her companion sports a bathing costume? ❧ How happy is the couple with the cake? As a child, Southern California artist D. J. (Debra Jane) Hall escaped family troubles by creating what she has called "an illusion of reality." She looked forward to birthday parties at her grandmother's house, where people gathered at the pool and posed for pictures with happy grins. The artist became known for images of a "sun-soaked world of swimming pools, bright blue skies, and ladies of leisure who flaunt big sunglasses and dazzling smiles," as a reviewer put it. In this exclusive party, the taller and possibly senior figure wears a heart-shaped pendant, an emblem of her love, while the other leans against her. In Hall's work food tends to convey sexual allusions. The cool cocktail rhymes with the taller figure's polo shirt, while the warm tones of the cake and candles represent her partner — underscoring the double entendre of the title.

∧ **EDWARD PENFIELD**
HARPER'S cover, August 1896
Commercial lithography; gray, yellow, red, and black;
18⅝ × 13⅝ in. (47.3 × 34.6 cm)

> **D. J. HALL**
Piece of Cake, 1987
Colored pencil on paper; 30 × 39½ in. (76.2 × 100.3 cm)

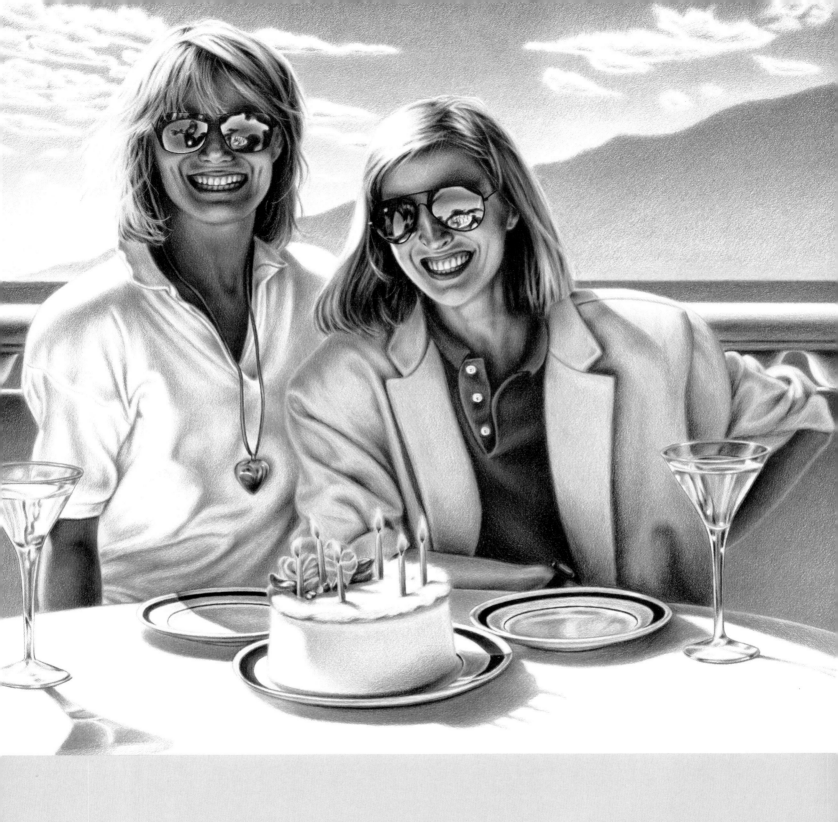

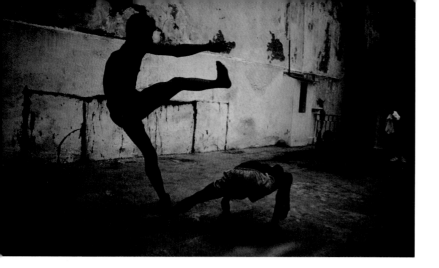

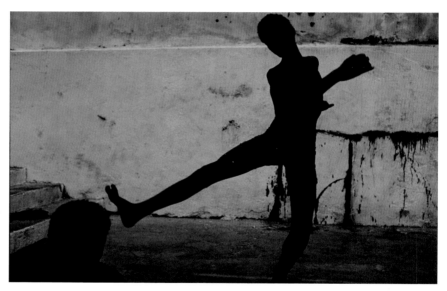

I n this cinematic series of images by the Brazilian photographer and filmmaker Miguel Rio Branco, two scrawny young guys from Rio's *favelas* engage in capoeira, a stylized martial-art form that brings together almost balletic dance movement with karatelike action. The blue wash of the silver-dye bleach prints provides a shimmering background that suggests the city's beautiful bay and beaches, far from the squalor in which many teenagers like these live.

MIGUEL RIO BRANCO
Blue Tango, 1984
Silver-dye bleach prints, from a suite of nine; 17⁵/₁₆ x 23⅝ in. (43.9 x 60 cm) each

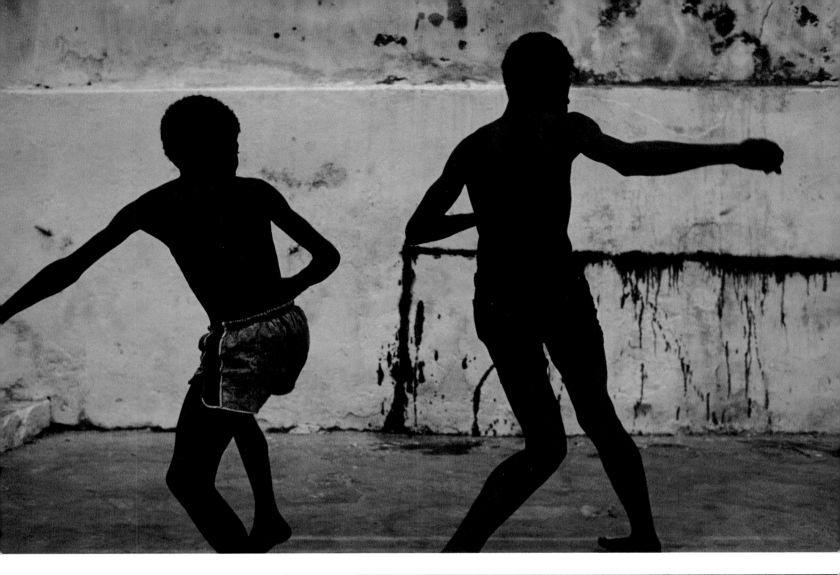
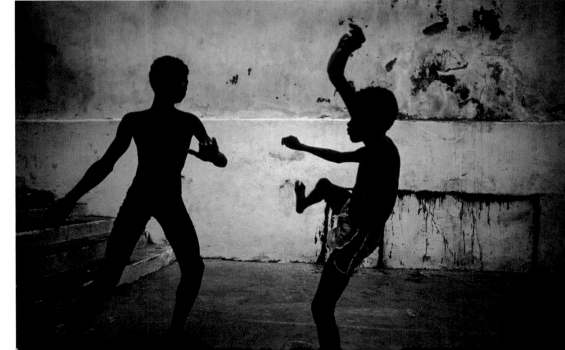

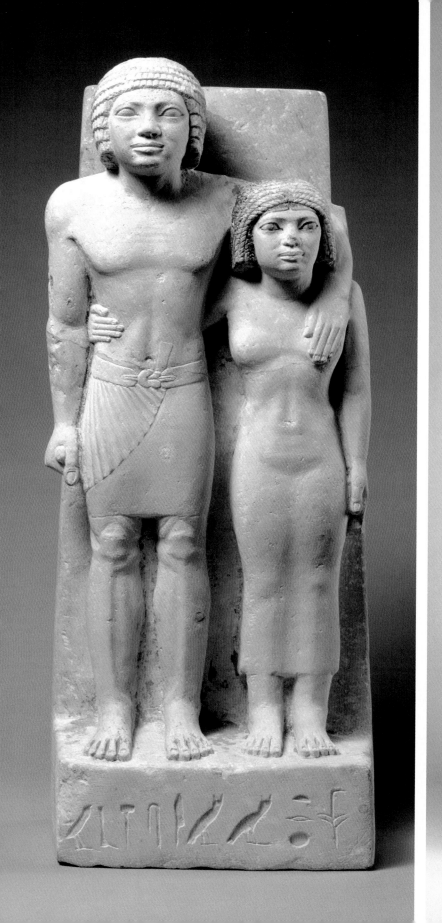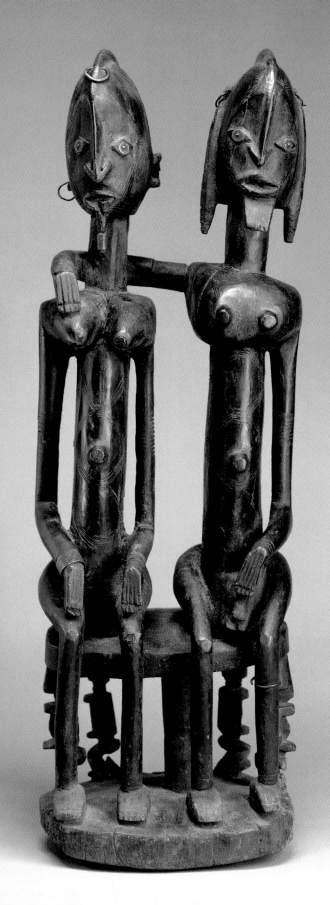

The extraordinary continuity of art in Africa is revealed in these two works. Through the matchless authority of sculptors working near the Nile, or through the skill of much later carvers in other African regions, there is a sense of the spirit of the dead watching over the living. The inscription on the front of the Egyptian statue identifies the couple as the Royal Acquaintances Memi and Sabu. They are probably husband and wife, as is common for pair statues. Memi is returning Sabu's embrace by draping his arm around her shoulders. Egyptians believed that the spirit of the deceased could use the statue as a home and enter it in order to benefit from gifts of food that were placed in the tomb. ✢ The high level of finish of this Dogon sculpture, its smooth surfaces, intricate detailing in the face and hair, and lack of sacrificial material, indicate that it was intended not for an ancestral shrine but for display at a funeral. The virtually identical forms of the male and female figures reflect Dogon attitudes toward marriage as a partnership of independent equals. The male figure has a beard extending from his chin while the female figure, whose elongated breasts droop from suckling children, wears a labret, an ornament in the lip. On the reverse side, the female carries a baby on her back, the male a quiver. With one hand on his genitals and the other protectively draped across her shoulders and resting on her breast, the male emphasizes their mutual roles in procreation and nurturing.

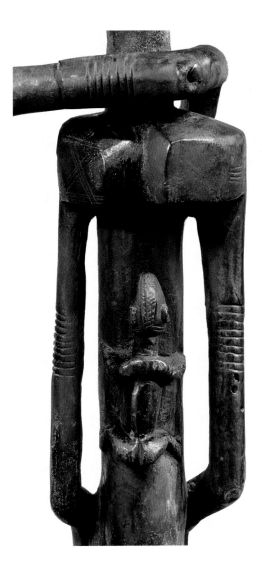

<SEATED COUPLE
Dogon peoples, Mali; 18th–early 19th century
Wood, metal; 28¾ × 9⁵⁄₁₆ in. (73 × 23.7 cm)

< THE ROYAL ACQUAINTANCES MEMI AND SABU
Egyptian, probably Giza; ca. 2575–2465 BC
Limestone, paint; 24⁷⁄₁₆ × 9⅝ × 6 in. (62 × 24.5 × 15.2 cm)

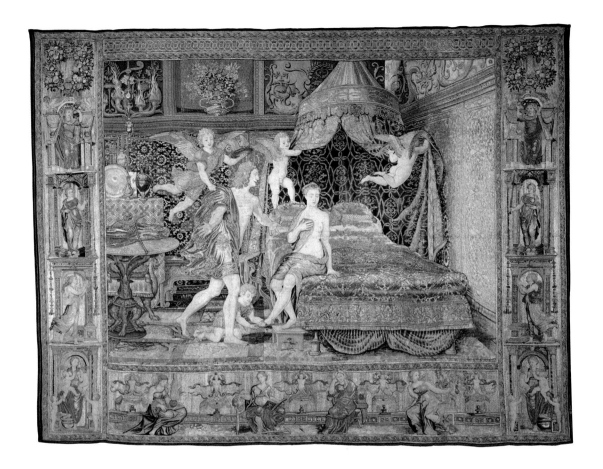

This brilliantly preserved tapestry, woven of wool and silk with silver and silver-gilt threads, retains much of its magically shimmering surface after almost five hundred years. It depicts a scene from Ovid's telling of a story of Mercury, son of Jupiter and messenger of the gods, and his beloved Herse, one of the three daughters of Cecrops, a mythical king of Athens. Mercury — in a hurry as usual — rushes to consummate their marriage, as she, posed like a beauty from the contemporary court of Fontainebleau, awaits him on the edge of her bed. Putti make matters easier by removing Mercury's cloak, drawing back the bed curtains, and slipping off Herse's footwear. The scene, however, never actually takes place. It is instead a vision that Envy conjures up in the imag-

ination of Herse's jealous sister, Aglauros, who, in another tapestry in the series, is conveniently turned to a black stone statue when she tries to oppose Mercury's visit to her sister's bedchamber. The design for the original cycle of eight tapestries, which would have transformed a palace stateroom into a magnificent interior, has been attributed to Giovanni Battista Lodi da Cremona. His composition and the figure of Herse are based on a print after Raphael's *Marriage of Alexander and Roxana*. The tapestries were woven in Brussels in the workshop of Willem de Pannemaker, whose weavers' virtuosity is displayed in the interior's elaborately patterned wall hangings and bed furnishings.

THE BRIDAL CHAMBER OF HERSE
From a set of eight tapestries depicting the story of Mercury and Herse, ca. 1550
Design attributed to Giovanni Battista Lodi da Cremona
Wool, silk, silver, silver-gilt thread; overall 172 × 213 in. (436.9 × 541 cm)

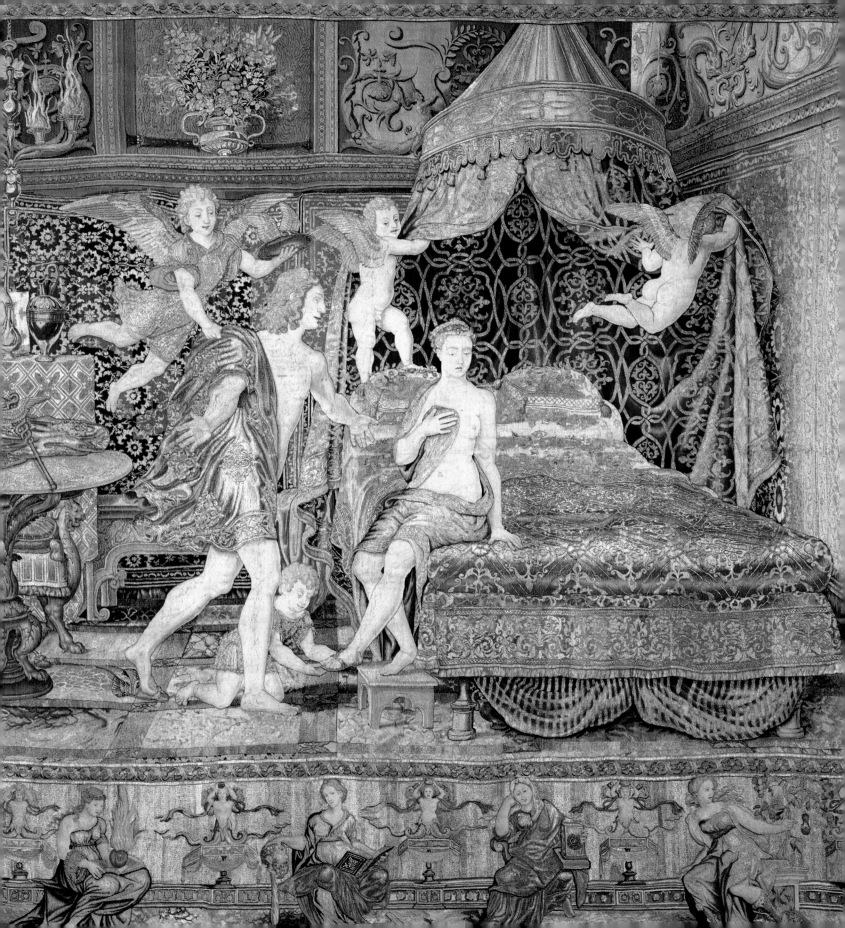

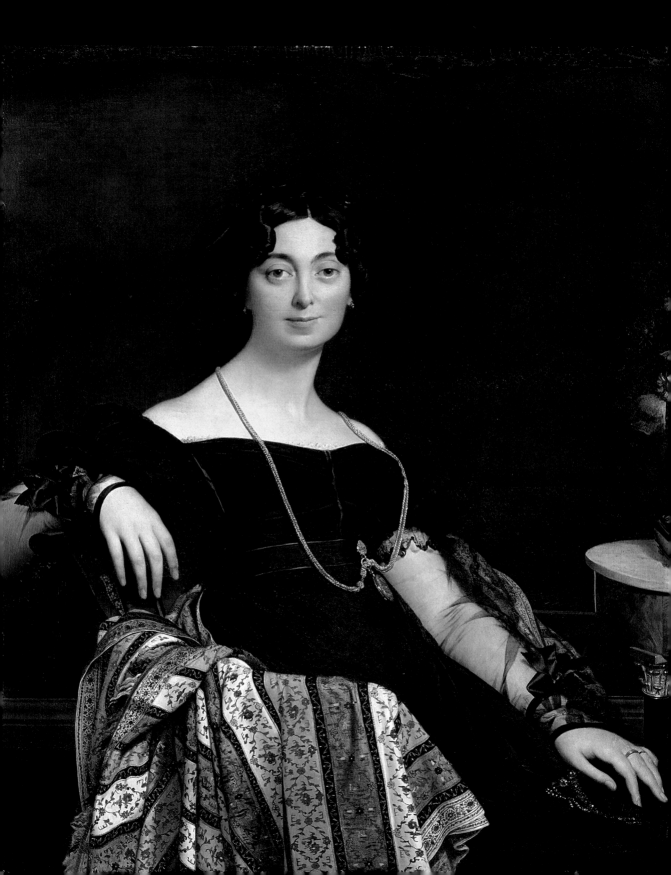

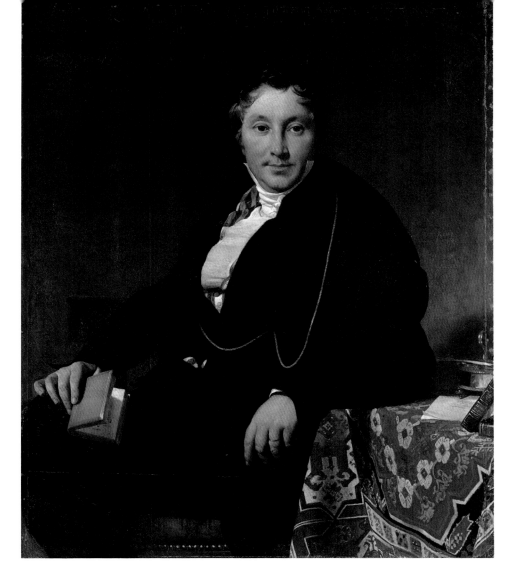

Among the most monumental yet still intimate of pendant portraits is that of Jacques-Louis Leblanc and his wife, he a rich Frenchman, formerly attached to the Napoleonic court in Tuscany, who remained in Florence after the empire's fall. As a young student at the French Academy in Rome, Ingres had supported himself by drawing hundreds of tourists' portraits. Worked in graphite, these exquisite likenesses caught resemblance quickly and "all in a line," with the most economical of graphic means. Though his later likenesses could be larded with the pomp and circumstance of French imperial self-importance, the best of Ingres's portraits stem from the restrained insights of his early manner, as seen in the handsome Leblancs, painted with such skill that the pictures were bought by one of the artist's greatest admirers, Degas. They were probably intended to hang facing one another, since the light falls differently in each, but they are unified by the visual harmony of hands, gold chains, and rich textiles that enhance the couple's black clothing. A tailor's son, Ingres never lost a feeling for the vital role played by textiles, buttons, and bows, as found here, where the shawl at her side and the tablecloth at his do much to balance the images.

JEAN-AUGUSTE-DOMINIQUE INGRES
Madame Jacques-Louis Leblanc and *Jacques-Louis Leblanc*, 1823
Oil on canvas; Mme Leblanc: 47 × 36½ in. (119.4 × 92.7 cm);
M Leblanc: 47⅝ × 37⅝ in. (121 × 95.6 cm)

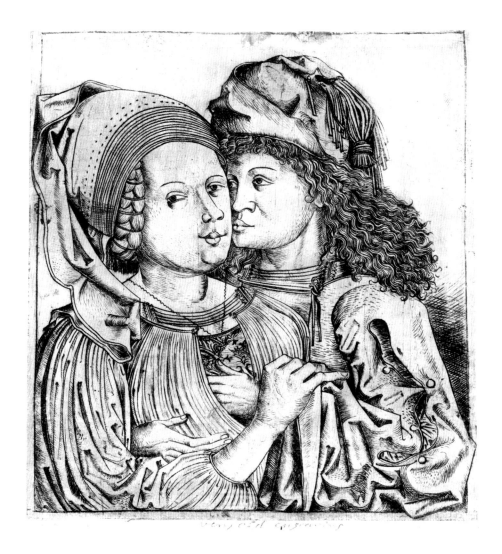

"Very old engraving" someone has written in the bottom margin beneath this late-15th-century image of an amorous couple. Indeed. It is by an artist known to us only by his monogram, "b x g." The sumptuous, fashionable clothing they wear might seem to place the couple in a courtly setting, but it is not a noble ideal of love that animates the young man's hand as it travels under her overdress toward her breast. Nor does she appear to object.

Not wanting to miss anything, the young man in this illustrated cover plate for a Persian album sends an improbably long arm around the neck of his beloved to stroke her breast and slides his other hand beneath her dress. Made in Qazvin possibly in the second half of the 16th century, when the city was briefly the capital of Persia, it exemplifies the new taste for pictures collected in albums like the one whose cover is graced by this illumination.

∧ **MASTER B X G**
The Lovers, late 15th century
Engraving; 7⅛ × 6¼ in. (18 × 15.8 cm)

> **YOUNG LOVERS EMBRACING**
Iranian, Qazvin; 16th century
Watercolor, opaque watercolor, ink, silver, and gold on paper;
overall 14⁵/₁₆ × 9½ in. (36.4 × 24.1 cm); drawing 3¾ × 2³/₁₆ in. (9.5 × 5.5 cm)

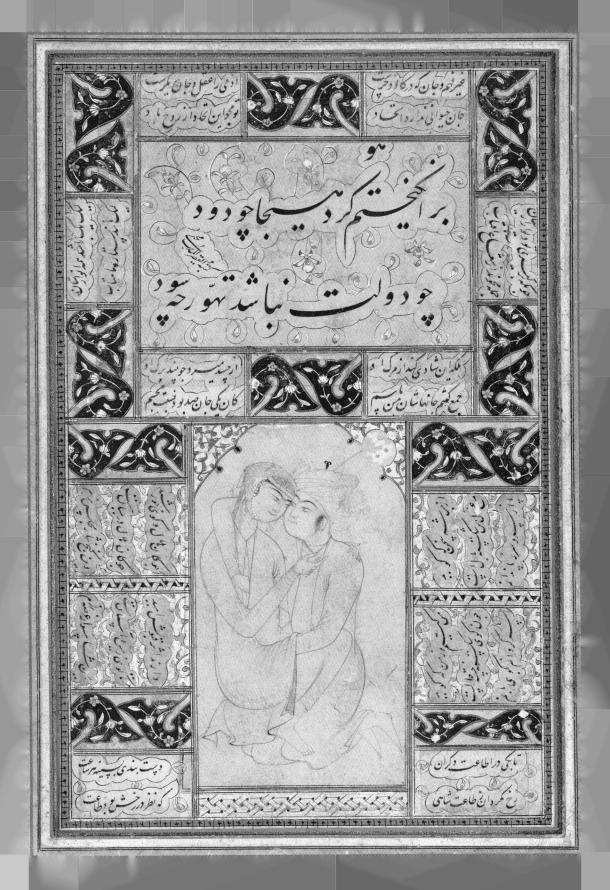

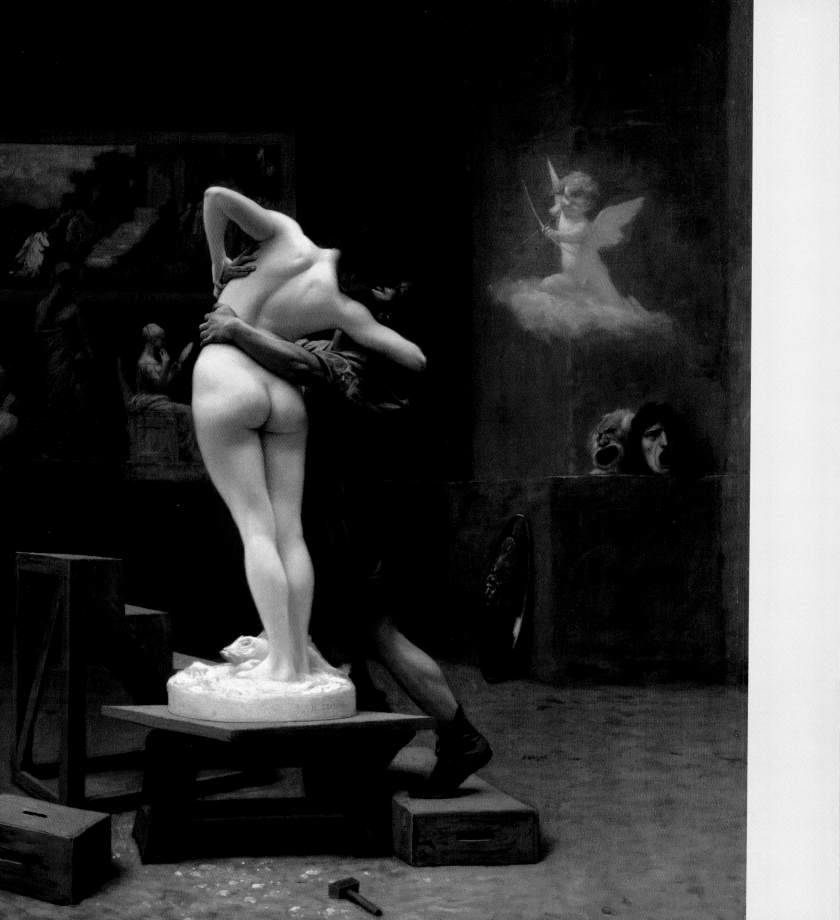

Divine inspiration is personified in Ovid's account of the Greek sculptor Pygmalion and his beautiful statue of Galatea. The artist fell passionately in love with his masterpiece, imploring Venus to transform the cold marble into living flesh. Upon his embrace, the statue yielded to his touch and came alive. In the myth, the sculptor is divinely graced, his studio a center for magical creativity. Jean-Léon Gérôme, who turned to the medium of sculpture late in his career, painted and sculpted variations on this theme; in this depiction of the mythological fantasy, he signed his name on the base of the sculpture, so proclaiming his talents in both mediums. ✤ Bourgeois eroticism in the guise of classical subject matter, a staple of 19th-century academic art, was grist for Daumier's satirical skills. His lithograph, one of a series devoted to deriding the French passion for ancient history, reduces the sculptor's embrace to sheer burlesque.

Oh, triumph of arts! What was your surprise,
Great sculptor, when you saw your marble come alive,
And with a chaste and gentle manner lean forward
To ask for a pinch [of snuff].

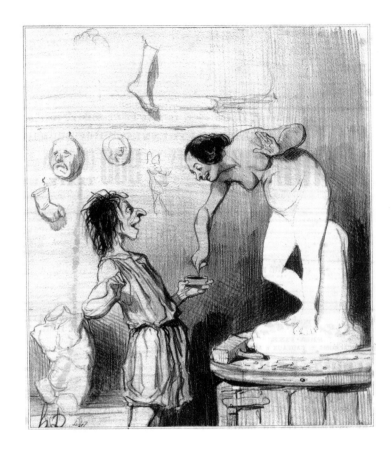

< **JEAN-LÉON GÉRÔME**
Pygmalion and Galatea, ca. 1890
Oil on canvas; 35 × 27 in. (88.9 × 68.6 cm)

∧ **HONORÉ DAUMIER**
Pygmalion, 1842
Lithograph; 9⅛ × 7½ in. (23.1 × 19.1 cm)

The more distinguished of only two known portrait paintings by Fra Filippo Lippi, this depiction of a woman facing a man at a casement window is the earliest surviving Italian double portrait. It may show Lorenzo Scolari and his wife, Angiola di Bernardo Sapiti, who were married in 1436, and commemorate the birth of their first child in 1444. As a soldier Lorenzo served with the famed *condottiere* Pippo Spano, who named him and his brothers as his heirs. It is a small maze of gazes, as she looks through the window at (or past) her husband, he looks at his wife, and we look at them and past them through a window toward a miniature, well-ordered landscape. Most 15th-century portraits of a husband and wife were conceived as diptychs or pendants and are painted on separate panels; this one seems transitional, the portrait of a woman into which a secondary male figure has been introduced. Nevertheless, we cannot help but read it as a unified scene. Her prominence relative to her husband shows that she is the controlling figure within the house, while his realm is the world beyond it. She wears the richest headdress portrayed in any Tuscan mid-15th-century painting, set off by a jewel above her forehead. Her neck is encircled by a string of pearls. Her overdress, with a jeweled brooch at the shoulder, is cut away at the sleeve to reveal an opulent underdress of velvet, its edges trimmed with fur. On her cuff is an inscription in gold thread and seed pearls: *LEALT[À]* — loyalty.

FRA FILIPPO LIPPI
Portrait of a Woman with a Man at a Casement, ca. 1440
Tempera on wood; 25¼ × 16½ in. (64.1 × 41.9 cm)

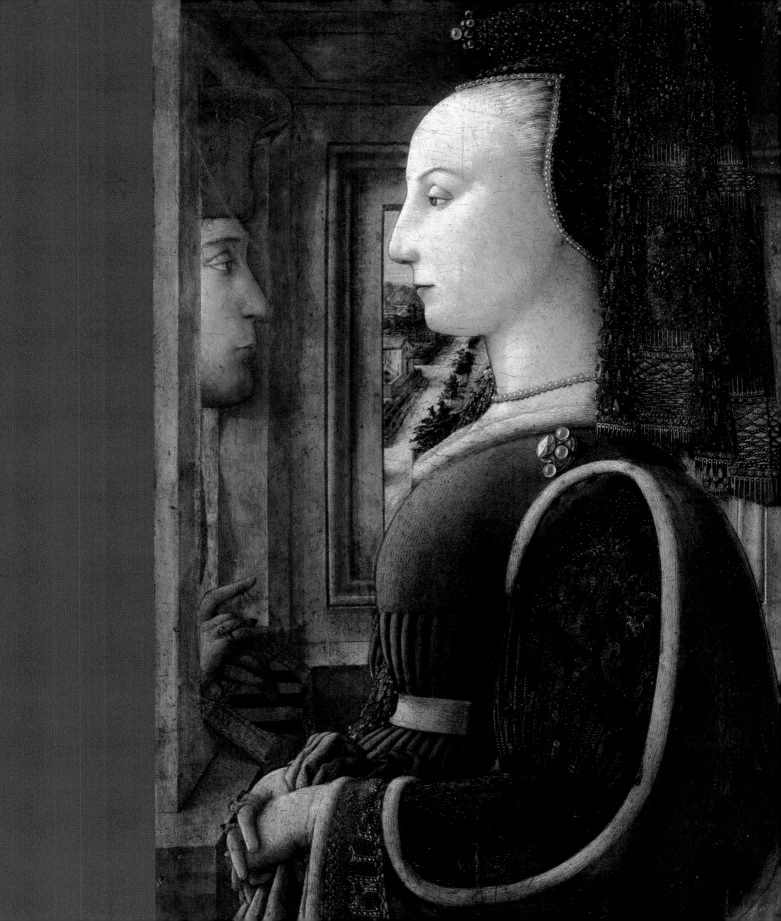

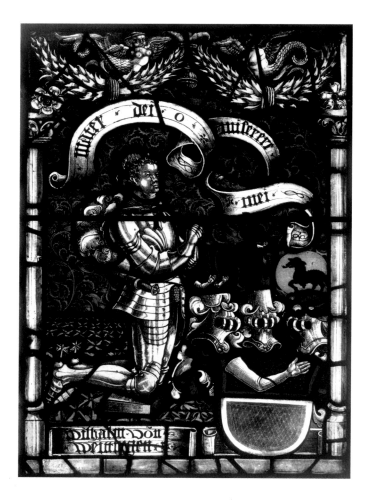
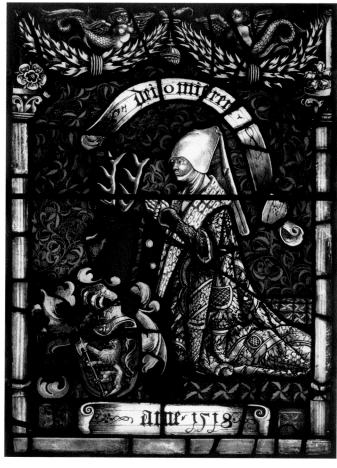

Brilliantly colored, these stained-glass portrait panels in the Middle Rhenish style of the late 15th century are characterized by bold, graphic design and a painterly quality reminiscent of panel painting. They were probably installed in the couple's family chapel near their future burial place. Both kneel below Latin speech scrolls inscribed with prayers for divine mercy, his to the Virgin, hers to God. A magnificent family coat of arms identifies each partner, Wilhelm's topped by three fanciful helmets. He is clad as the proverbial "knight in shining armor," with an elaborate plumed hat slung over his back. Barbara, too, is very richly clothed, with a Swabian headdress. Her lavish fur-trimmed collar and costly brocade gown proclaim her to be of noble birth. She says her prayers with the help of a huge string of rosary beads, as much a sign of wealth as of piety.

PANELS OF WILHELM VON WEITINGEN AND BARBARA VON ZIMMERN
German, 1518
Pot-metal glass, white glass, vitreous paint, silver stain, and colored enamel;
overall: 24 × 16½ in. (61 × 41.9 cm)

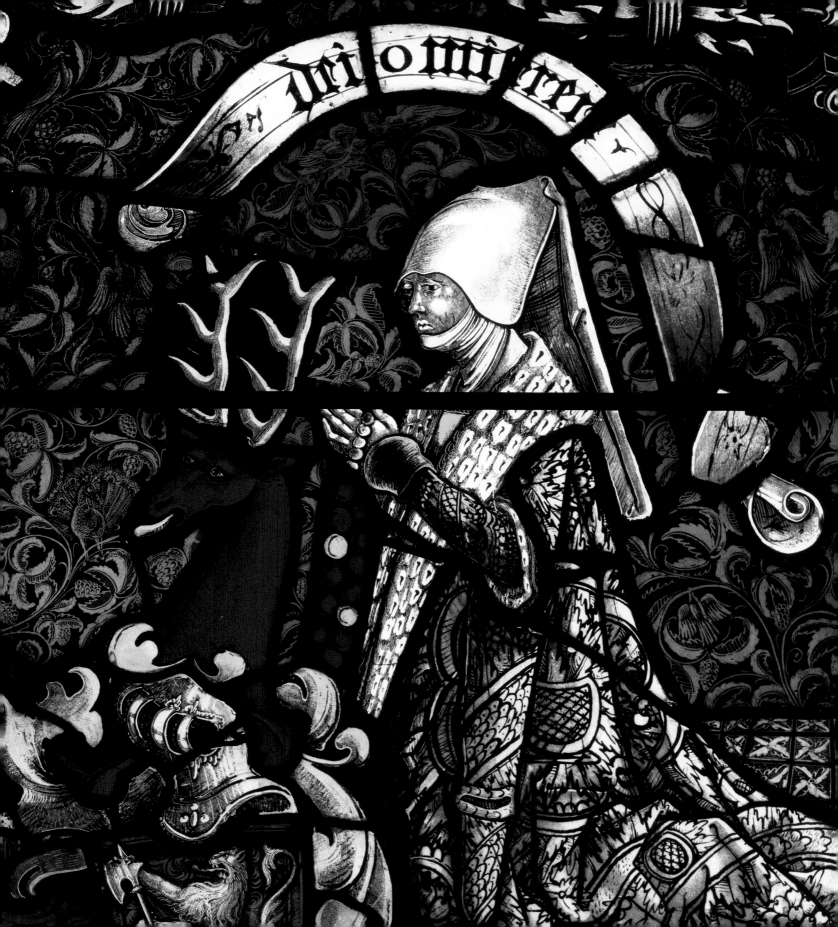

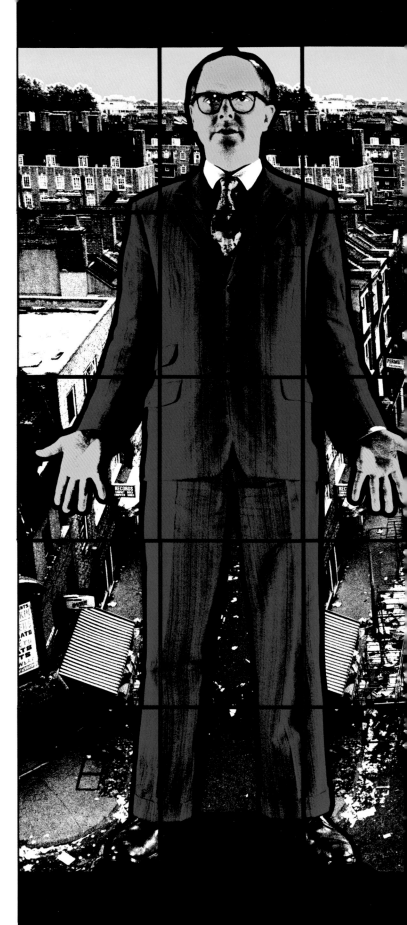

Among the most enduring of creative partnerships is that of Gilbert & George, beginning with their meeting in 1967 at the Saint Martin's School of Art in London. Determined to make "art for all," they place themselves at the center of their art, aiming to reach beyond the narrow confines of the art world. They find nearly all of the imagery that appears in their art, including perhaps this picture, in London's East End, within walking distance of their home. Instantly recognizable, they depict themselves wearing conservatively buttoned suits, beautiful neckties, white-collared shirts, and a variety of expressions, but here there is a sense of despair in their open-handed appeal to the viewer. In what is literally Gilbert & George's night *on* the town, they superimpose themselves upon the decaying cityscape, as if to say, Attention must be paid!

GILBERT & GEORGE
Here, 1987
Mixed mediums; overall 119 × 139 in. (302.3 × 353.1 cm)

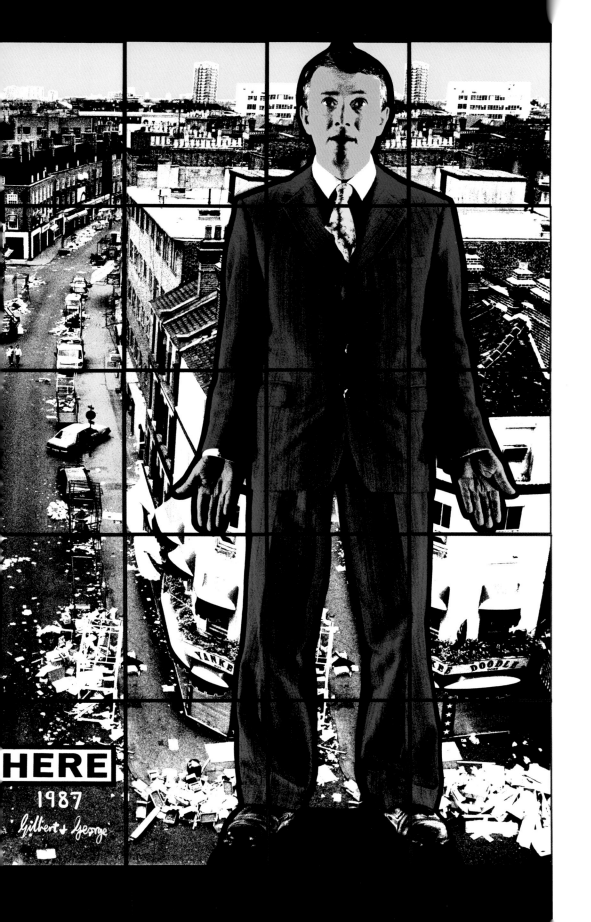

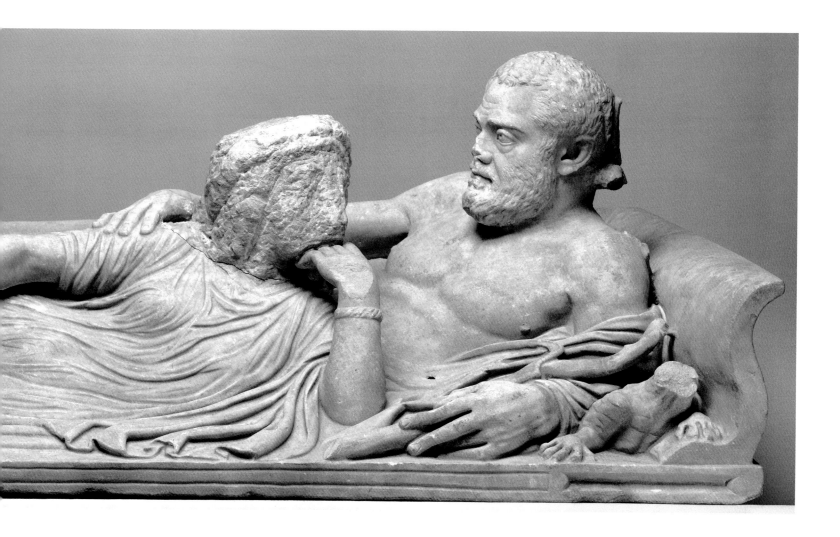

Caught in a pensive, eternal embrace, this Roman couple reclines on a sarcophagus lid in the form of a couch with S-shaped sides, a type of funerary monument borrowed from the neighboring Etruscans. He poses as a river god while she, holding a wheat sheaf, takes on the fertile attributes of the earth goddess Tellus. A little Eros is at her feet, astride a furry animal. The woman's head is left unfinished, suggesting that the husband predeceased her. Did the sculptor die? Did she fail to pay him? The condition of the head lends the work a special pathos, recalling the deliberately unfinished state of many of Michelangelo's marbles.

🐾 Gender dominance is reversed in Will Barnet's enigmatic portrayal of Frederick Kiesler and his second wife, Lillian, occupying opposite ends of a sofa. Kiesler, a theater designer, artist, and architect remembered for his collaborations with Marcel Duchamp, appears lost in a book, while Lillian engages the viewer's eye as she brandishes an apple, perhaps symbolizing knowledge deeper than that of books. The cat framing the head of Kiesler stretches to rub Lillian's hand, making the sole connection between them. This painting may be seen as a combined wedding and funerary portrait, for it was painted in the year when the couple married and when Kiesler (and his first wife) died.

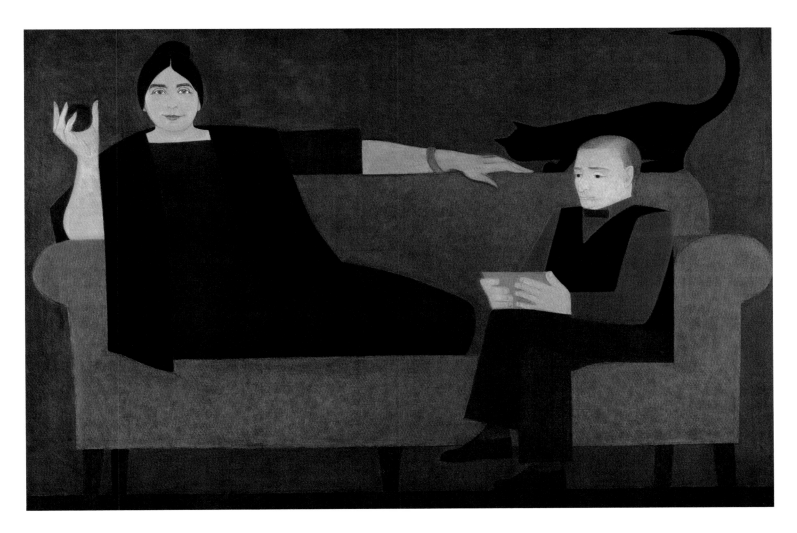

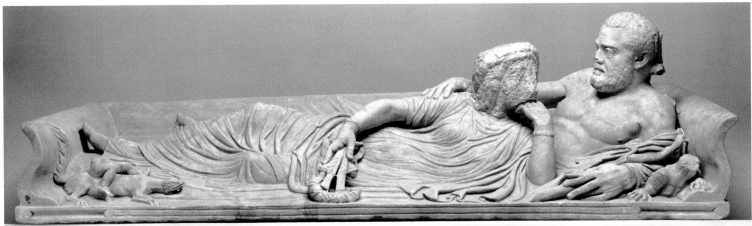

^ **WILL BARNET**
Kiesler and Wife, 1963–65
Oil on canvas; 48 × 71½ in. (121.9 × 181.6 cm)

^ **MARBLE SARCOPHAGUS LID WITH RECLINING COUPLE**
Roman, Imperial, Severan; ca. 220 AD
Marble; l. 91 in. (231.1 cm)

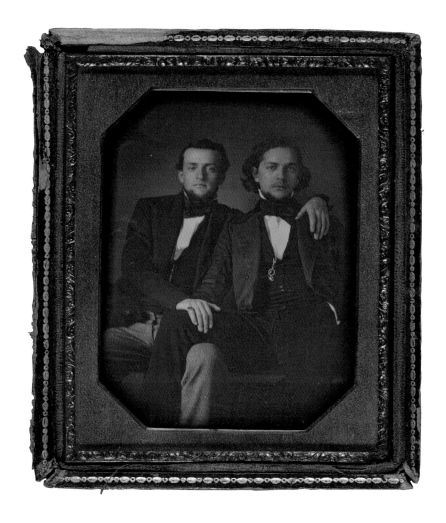

Photography's invention had momentous implications for social history, as persons who would not have been represented by "official" portraiture now became visible to posterity, though they typically have remained anonymous. This image is remarkable for its frank proclamation of mutual affection, as the man in dark trousers slings his right thigh over the left one of the other, who places a hand protectively upon it, while embracing his partner's shoulder. Are they lovers? Possibly, but in photographs of the pre-Freudian era it was not uncommon for men to display a natural and unselfconscious intimacy.

Riza ʿAbbasi worked for Iran's Shah Abbas (reigned 1588–1629), revolutionizing Persian painting and drawing with his development of the calligraphic line and an innovative palette. The lovers here are bound together by a rhythmic outline that merges them into a single volume. His right hand caresses her chin while his left hand slips into her robe to touch her exposed midriff. She places a flower in his turban with one hand and offers fruit with the other. A wine cup resting on her knee and a bottle on the ground allude to pleasure and temptation, alcohol still being mostly forbidden in Safavid Iran.

∧ **TWO YOUNG MEN**
American, ca. 1850
Daguerreotype; image 4¼ × 3¼ in. (10.8 × 8.3 cm)

> **RIZA ʿABBASI**
Two Lovers, AH 1039 / AD 1630
Opaque watercolor, ink, and gold on paper; 6⅞ × 4⅜ in. (17.5 × 11.1 cm)

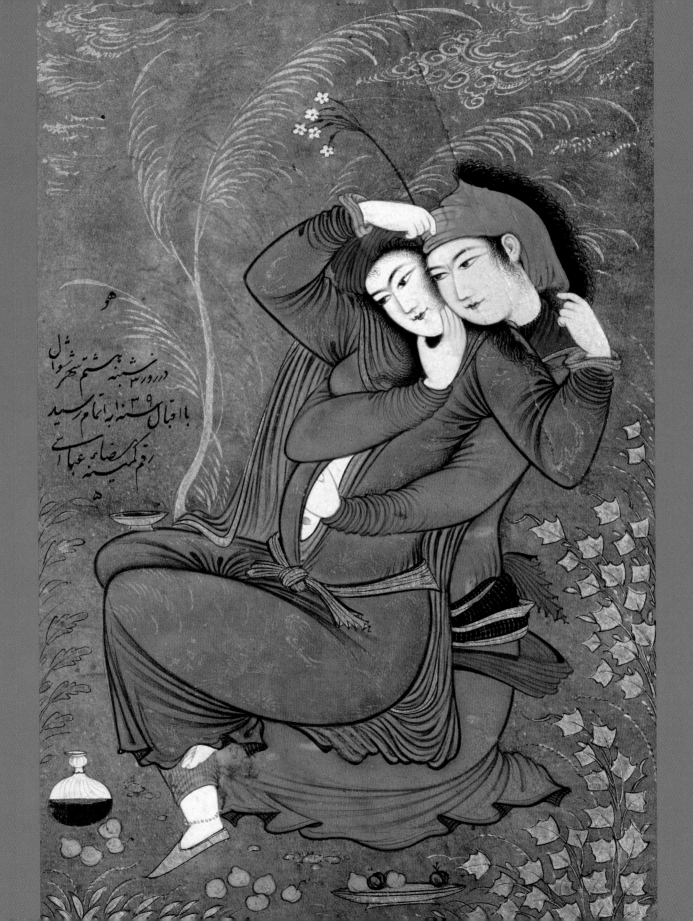

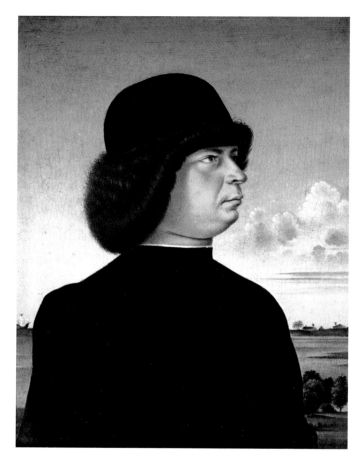 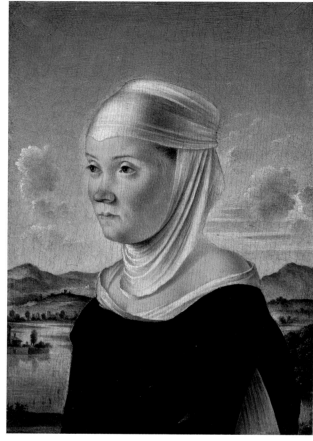

Among the very smallest pictures reproduced in this volume, these Venetian pendant portraits of the late 15th century show busts of a couple against a brilliant blue sky with white clouds and a lagoon below. No other surviving Renaissance paired portraits on so small a scale are painted with such brilliance. They are so precise in their execution that they were once ascribed to a Northern artist, Hans Memling. Avoiding convention, their painter has placed the man, possibly Alvise Contarini, in profile and his pensive partner in three-quarter view. Her expression, an odd mix of recollection and resignation, is radically different from his forthright, all consuming stare, conveyed despite the profile's limitation. It has been suggested that she is Alvise's widow.

She is described in a near-contemporary document as a nun of the Benedictine convent of San Secondo, located on an island near Mestre. If her chic outfit is a nun's habit, the convent may be imagined as a place for the comfortable retirement of ladies freed by a husband's premature death from the cares of domesticity. The two portraits are described in that account as having had a stamped leather cover, suggesting they may have been kept together as a memento. Reinforcing this view is the image on the verso of Alvise's portrait, which shows a young roebuck chained beneath a round shield with the Greek word *AIEI* (forever). The roe, singled out for its monogamous behavior, had been a familiar image of love since the days of Solomon.

JACOMETTO
Alvise Contarini(?) (recto) and *A Tethered Heart* (verso), ca. 1485–95;
and *A Woman, Possibly a Nun of San Secondo*, last quarter of the 15th century
Oil on wood; Alvise recto: 4⅛ × 3⅛ in. (10.6 × 7.9 cm); Alvise verso: 4⅜ × 3⅛ in.
(11 × 7.9 cm); woman: 3¾ × 2½ in. (9.5 × 6.4 cm)

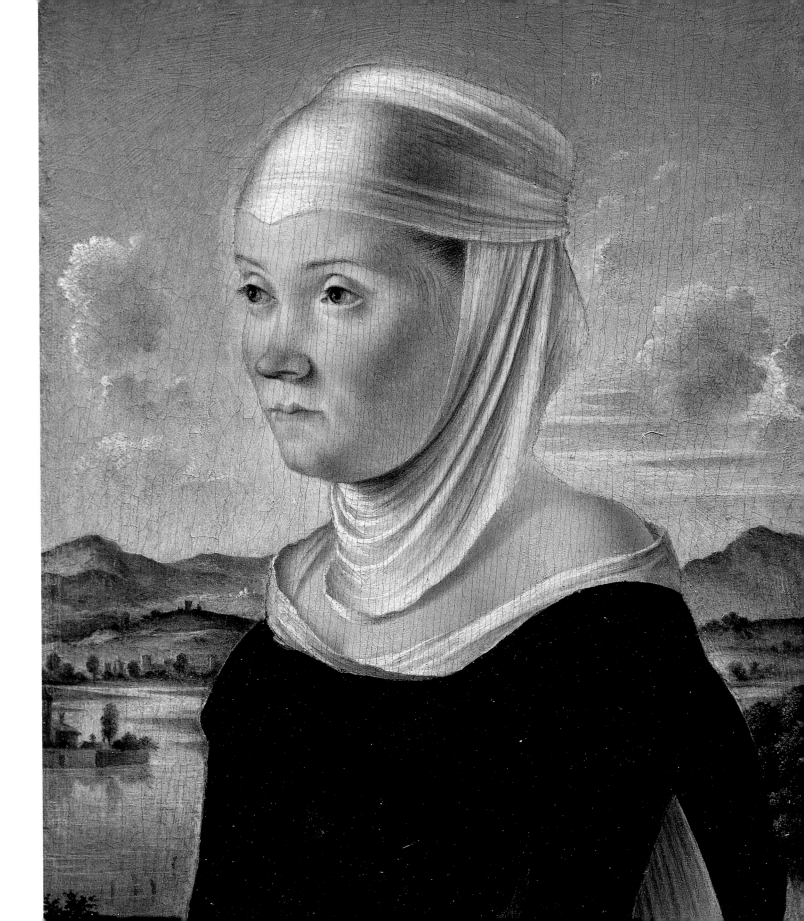

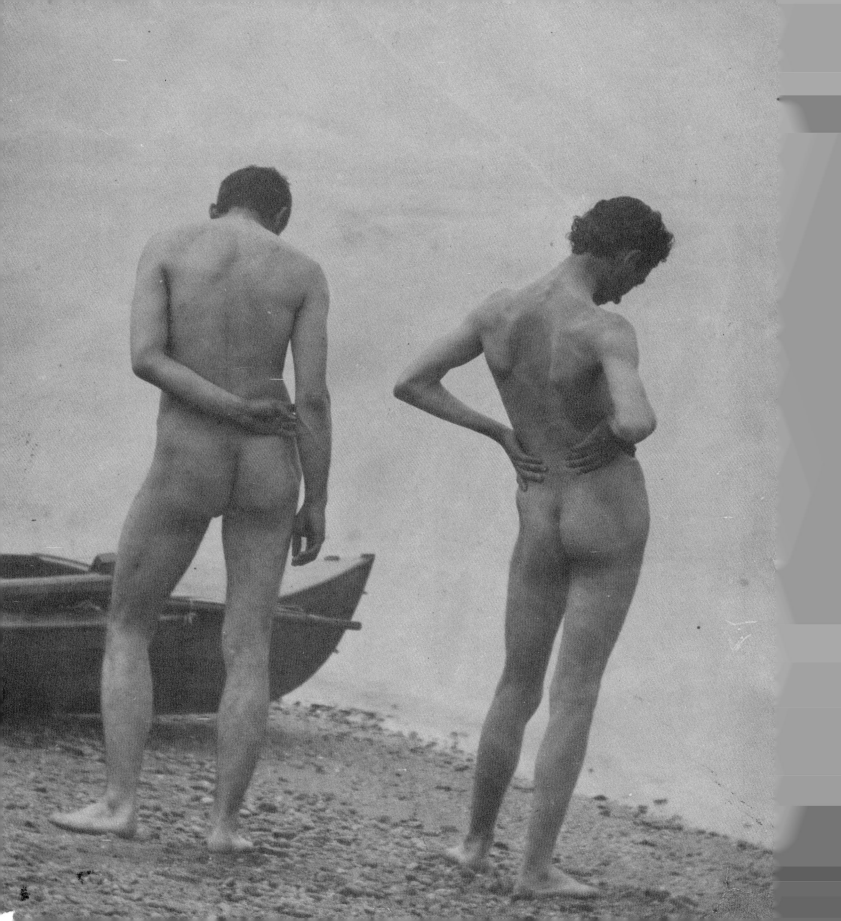

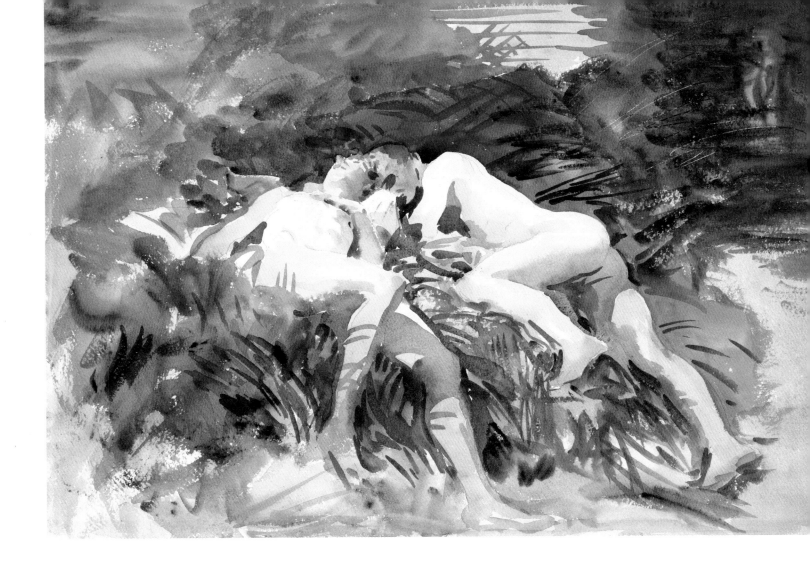

As a teacher at the Pennsylvania Academy of the Fine Arts, Thomas Eakins photographed himself and his students in the nude as a means to study the human form — and was dismissed from the school in 1886 for using a nude model in a class. In this photograph, probably made during the summer of 1883 at Manasquan Inlet in Point Pleasant, New Jersey, the ungainly painter and his faunlike student John Laurie Wallace affect the elegant contrapposto stances of classical sculpture. The setting reflects the myth of a pastoral paradise that was so important to Eakins, who shared with his friend Walt Whitman a devotion to an Arcadia where masculine virtues are celebrated.

In the summer before World War I ended, John Singer Sargent depicted young Guards Division "Tommies," a term for soldiers in the British Army, bathing near Arras, in northern France. He had been commissioned by the British Ministry of Information and captured scenes from the war in paintings such as *Gassed* (1918) and in many watercolors. Sargent, then in his early sixties, shows a keen appreciation for the relaxed sensuality of the young men resting in the tall grass after bathing. He seems to share the Tommies' innocent pleasure, sketching them as they enjoy a precious few moments of freedom before being sent off once again to battle.

< **THOMAS EAKINS**
Thomas Eakins and John Laurie Wallace on a beach, ca. 1883
Platinum print; 10 1/16 × 8 1/16 in. (25.5 × 20.4 cm), irregular

∧ **JOHN SINGER SARGENT**
Tommies Bathing, 1918
Watercolor and graphite on white wove paper; 15 5/16 × 20 3/4 in. (38.9 × 52.7 cm)

Julia Margaret Cameron is rightly admired for her magnificent command of Victorian portraiture, but she also was a commercially successful pictorial photographer, copyrighting her Pre-Raphaelite images. Many were based on the poetry of her illustrious friend and neighbor Alfred, Lord Tennyson, whose oeuvre she used "to ennoble Photography and to secure for it the character and use of High Art by combining the real and ideal, sacrificing nothing of Truth by all possible devotion to Poetry and Beauty." One of these photos is based upon the story of Guinevere in the bard's neo-medieval effusion *Idylls of the King*, a passage she copied out in her own hand:

And Lancelot ever promised, but remained,
And still they met and met. Again she said,
"O Lancelot, if thou love me get thee hence."
And then they were agreed upon a night
(When the good King should not be there) to meet
And part for ever.... Passion-pale they met
And greeted.

Cameron leaves out mention of the "lissome Vivien," of Arthur's court the "wiliest and the worst," who overhears the lovers' vow and dishes to Sir Modred, and . . . well, that's another story.

JULIA MARGARET CAMERON
The Parting of Lancelot and Guinevere, 1874
Albumen silver print from glass negative; image 13$\frac{1}{16}$ × 11$\frac{5}{16}$ in. (33.2 × 28.8 cm)

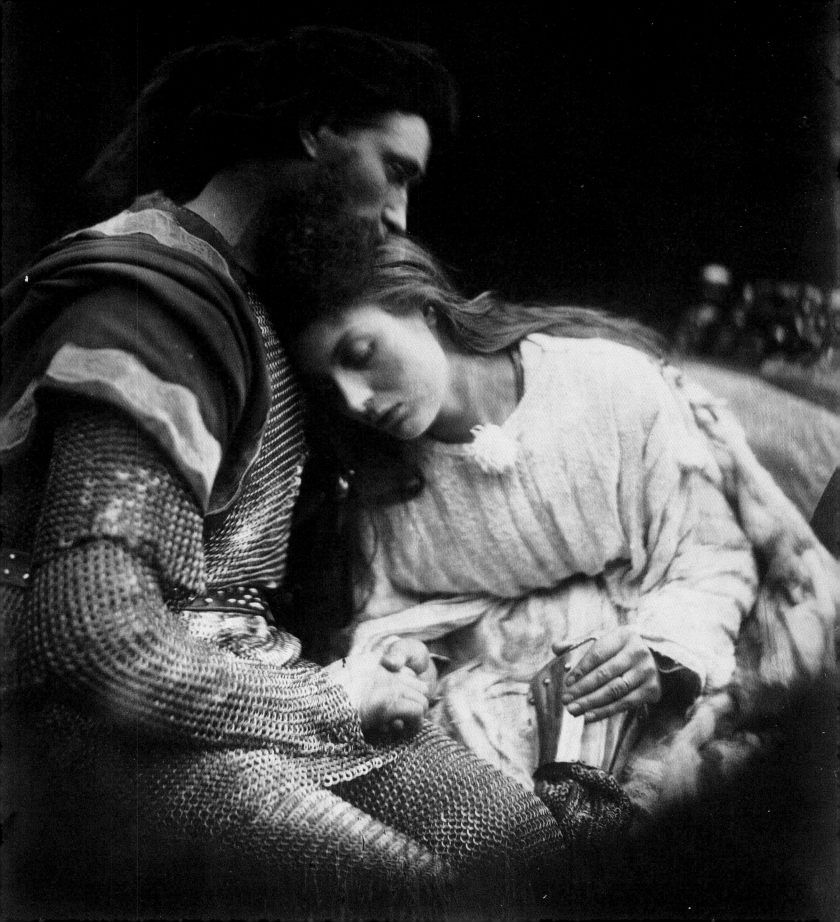

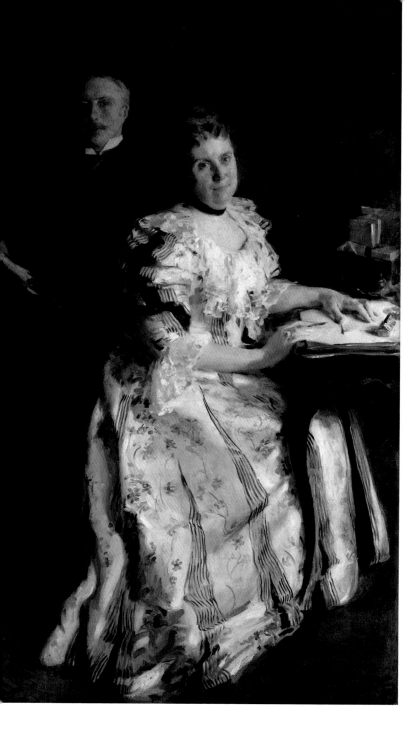

ithin a year of each other, Anson Phelps Stokes and Isaac Newton Phelps Stokes, a father and son from one of New York's first families, were depicted with their wives in double portraits by the leading American society portraitists — Cecilia Beaux and John Singer Sargent, respectively. Beaux, a successful and fashionable Philadelphia painter, showed her staid, elderly sitters in a suitably conventional way — indoors, against a dark background, he with his newspaper and she at her desk. The dour setting recalls the aesthetic of Edith Wharton's Old New York, in what the critic Lewis Mumford described as the "Brown Decades." A. P. Stokes, a multimillionaire banker and metal trader, is seated behind his wife, a position that obscures his recent loss of a leg, which was crushed against a tree by a spirited horse he was riding at his Lenox, Massachusetts, estate. ❧ Sargent painted the younger Stokeses against a simple background in informal, yet elegant, summer attire. Youthful, beautiful, and an heiress to a shipping fortune, Edith Minturn Stokes wears the au courant garb of a Gibson Girl, so named for the self-assured, independent, all-American woman popularized by the dashing illustrations of Charles Dana Gibson. Intended as a wedding gift from her prominent New York banker husband, the portrait was to have shown Edith seated in a green evening dress. After several sittings, Sargent happened upon her one morning fresh from playing tennis, wearing a mannish jacket, shirtwaist, and a full white skirt. Sargent instantly asked to paint her as she was. Edith faces the viewer, smiling confidently. Originally, she was to have stood with her hand resting on the head of her Great Dane; Sargent substituted the figure of her husband and the straw hat.

60 ∧ **CECILIA BEAUX**
Mr. and Mrs. Anson Phelps Stokes, 1898(?)
Oil on canvas; 72 1/16 × 39 7/8 in. (183 × 101.3 cm)

> **JOHN SINGER SARGENT**
Mr. and Mrs. I. N. Phelps Stokes, 1897
Oil on canvas; 84 1/4 × 39 3/4 in. (214 × 101 cm)

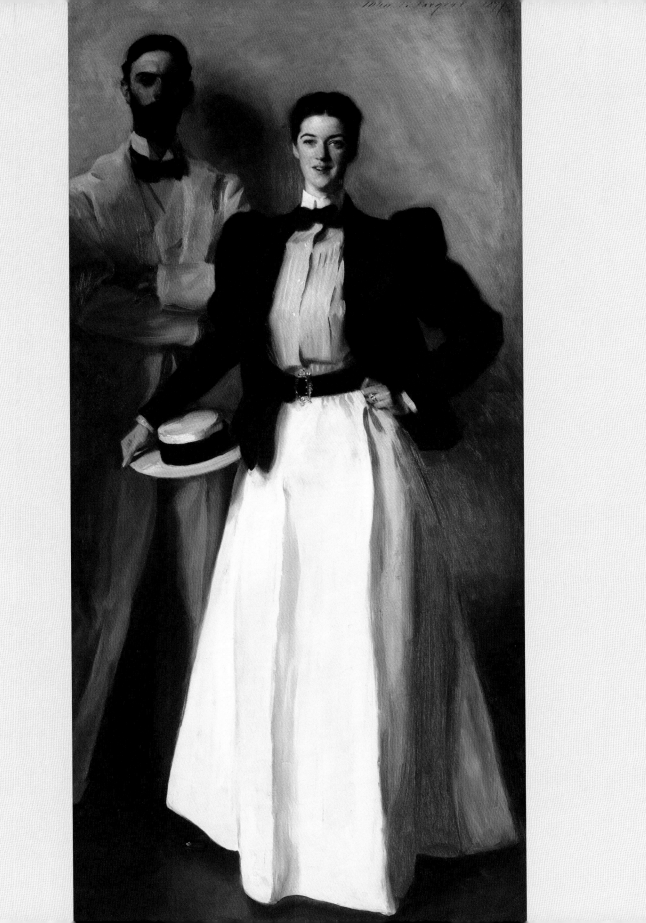

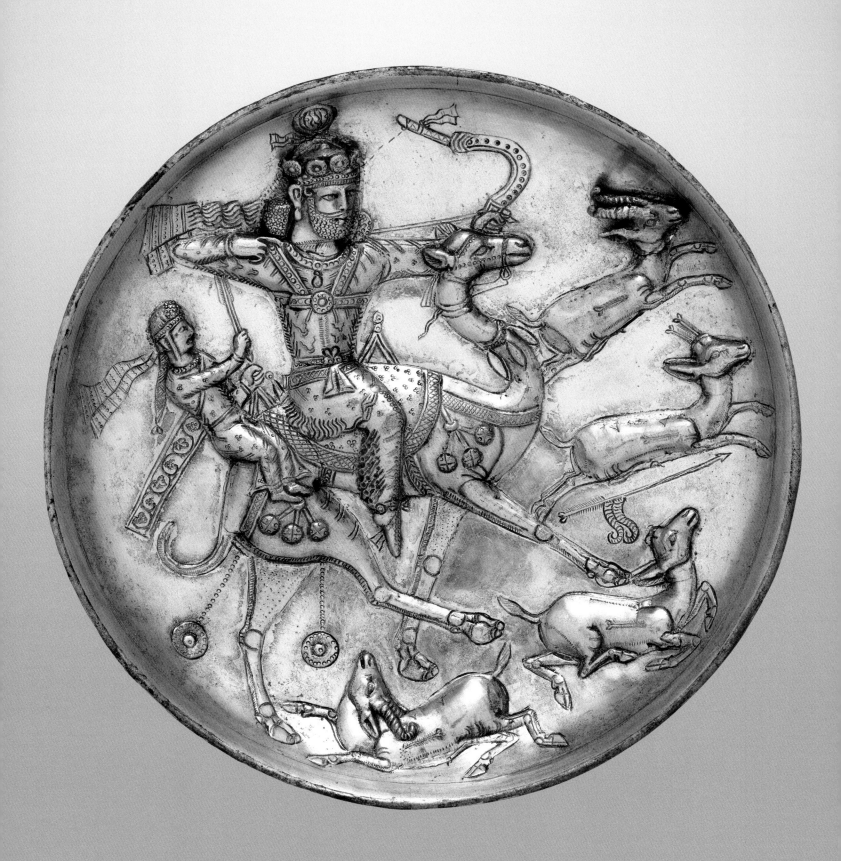

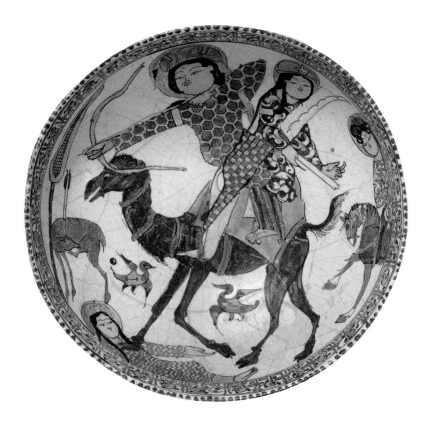

A silver plate richly worked in relief and a humbler painted bowl, made roughly seven centuries apart, depict an adventure of the great king Bahram Gur (reigned 421–438 CE). As recorded by Firdausi in the late 10th to early 11th century in the Persian epic *Shahnama*, or *Book of Kings*, Bahram Gur and the lyre-playing Greek slave girl Azadeh one day went out together on his racing camel. The contest between martial male skills and female wiles is represented by stringed instruments: a hunting bow and a lyre (or perhaps a harp, as depicted on the ceramic bowl). Until the discovery of this gilt-silver plate, the story, a favorite in the arts of Islam, was unknown on works of art from as early as the Sassanian period.

> "My pretty one, when I string the bow, which gazelle shall I bring down?" he asked as a herd approached.

> "My lion-hearted prince, men of war do not go in chase of gazelles," said she. "If you can convert the male to a doe and the female to a buck" — and perform several still more impossible tasks — "I will call you the world's most brilliant archer."

With a double-headed arrow, he shoots off the buck's horns, making him a "doe," and then sinks two arrows in the head of the doe, making her a "buck" — the dehorned buck and doe with arrows in her head are seen at the right of the silver plate. Azadeh weeps, perhaps believing that such supernatural skill could only be possessed by a devil. Bahram Gur throws her from the camel and tramples her, saying that her challenge has put him at risk of dishonor.

< **PLATE WITH A HUNTING SCENE FROM THE TALE OF BAHRAM GUR AND AZADEH**
Iranian, ca. 5th century AD
Silver, mercury gilding; ht. 1⅝ in. (4.1 cm); diam. 7⅞ in. (20.1 cm)

∧ **BOWL WITH TWO SCENES OF BAHRAM GUR AND AZADEH**
Iranian, 12th–13th century AD
Stonepaste; polychrome in-glaze and overglaze painted and gilded on an opaque monochrome glaze (*mina'i*); ht. 3⁷/₁₆ in. (8.7 cm); diam. 8¹¹/₁₆ in. (22.1 cm)

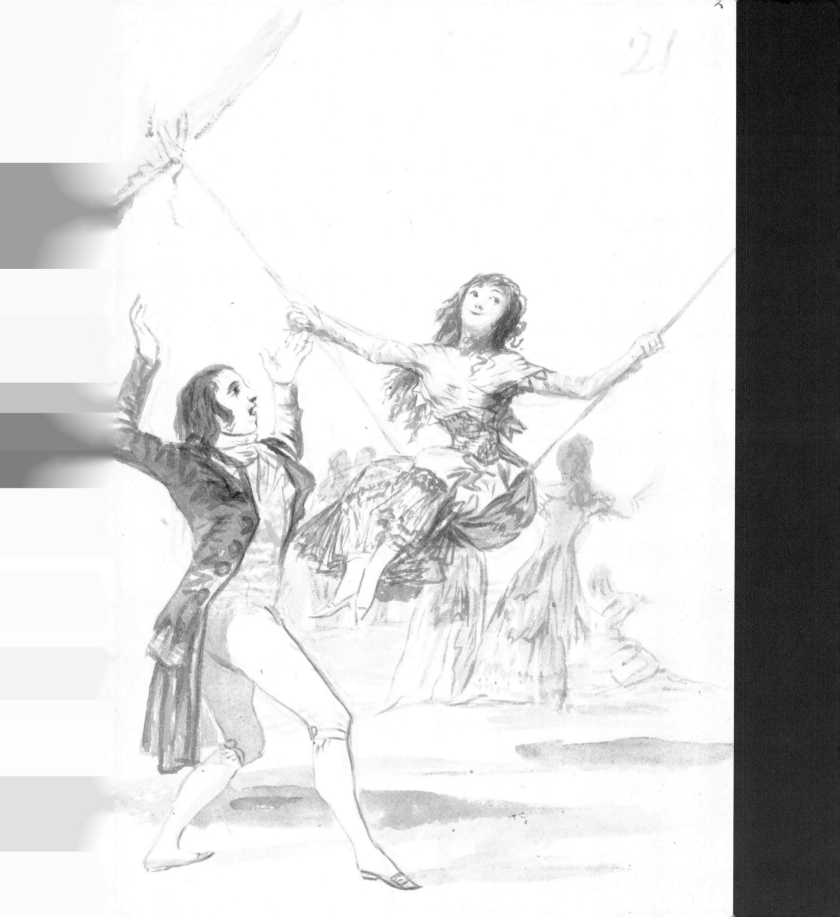

Goya's romantic couples wear the exaggerated, fashionable attire of the witty and insolent lower-class young *Madrileños* known as *majas* and *majos*. A *majo* wore tight knee breeches, an embroidered shirt, and a short jacket with many buttons, and he carried a folding knife, called a *navaja*, hidden in his sash. A *maja* usually carried a fan as she sashayed past, wearing a skirt of mid-calf length over white stockings, a bloom of petticoats, and a tight bodice, with braided hair set off by a lace mantilla — and maybe a sheathed poniard in the garter of the left stocking. Swings for grownups always signify erotic high jinks, as seen in the drawing opposite. At the right, the artist captures the intimate lovers pressed against each other, her profile visible through a transparent veil and a great swath of her drapery crossing his stocking-clad leg. Are these actual *majas* and *majos*, or are they noblemen and women playing at being them? Fashionable ladies and gentlemen in 18th-century Madrid copied the swaggering style and flamboyant fashions of the working classes. When Goya made these amorous sketches, along with others that filled a special album, he was romantically involved with the beautiful Duchess of Alba, one of richest and most attractive figures in Madrid society, in whose portraits the artist proclaimed their intimacy. Goya depicted her in the *maja* costume, which she loved to wear while mingling with working people in the city. About this time as well, Goya painted his famous *Naked Maja*, now in the Prado, Madrid, though whether the duchess was his model is hotly debated.

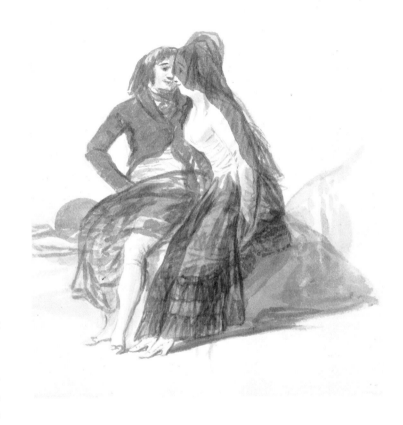

< **GOYA**
The Swing, 1796–97
Brush, India ink, and gray wash on laid Netherlandish paper;
9 × 5 in. (23.7 × 14.61 cm)

∧ **GOYA**
Lovers Sitting on a Rock, 1796–97
Brush and gray wash on laid Netherlandish paper;
9¼ × 5¾ in. (23.5 × 14.6 cm)

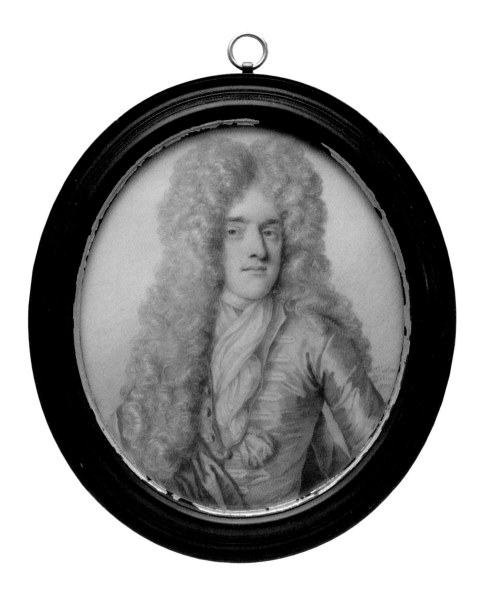

These waist-length miniatures of an unknown, fashionable English couple, probably but not certainly a pair, are by Thomas Forster, a London draftsman who was one of the last notable portraitists to work in black lead, or plumbago, on vellum, a tradition associated in England with artists such as David Loggan and Robert White, active a generation earlier. The man wears an elaborate wig in fashion at the time of William and Mary, but his wife's hair is unpowdered, in the new, more natural style. Forster posed his subjects in three-quarter view, suggesting their awareness of each other's presence as they gaze out at us. Our sense of the sinuous torsion of their bodies is reinforced by the man's remarkable twisted scarf. Anticipating Ingres's linear purity, Forster's fine hand is distinguished by attention to contour and to details such as curled wigs and mussed hair and intricate folds of drapery, all of which he employs to refresh the overused Baroque bust and half-length templates of his contemporaries.

THOMAS FORSTER
Portrait of a Man and *Portrait of a Woman*, 1700
Plumbago on vellum, oval; each 4⅜ × 3⅝ in. (112 × 92 mm)

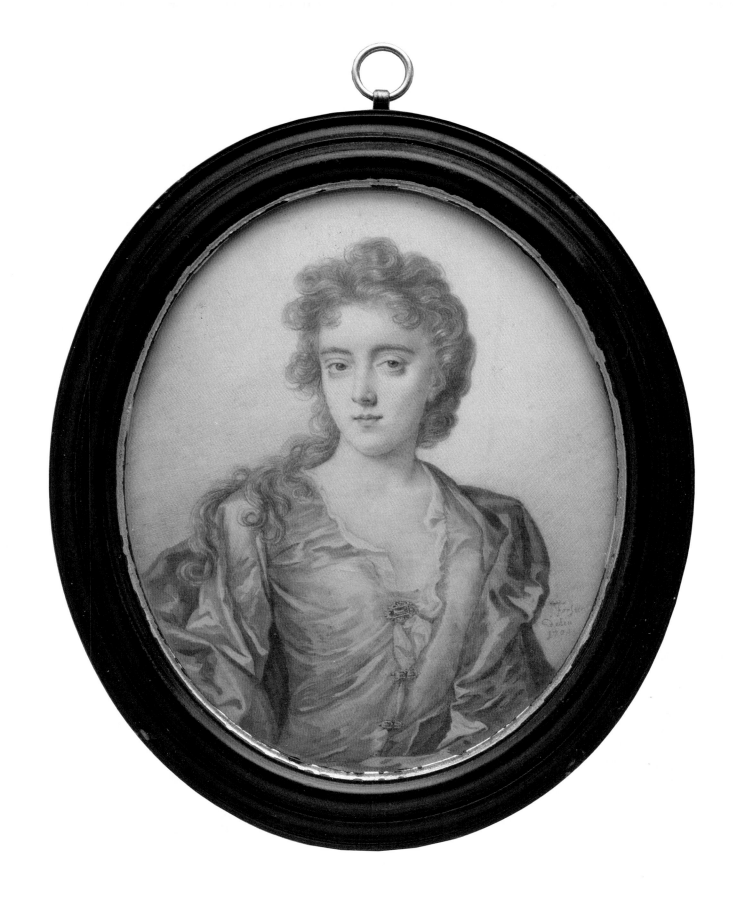

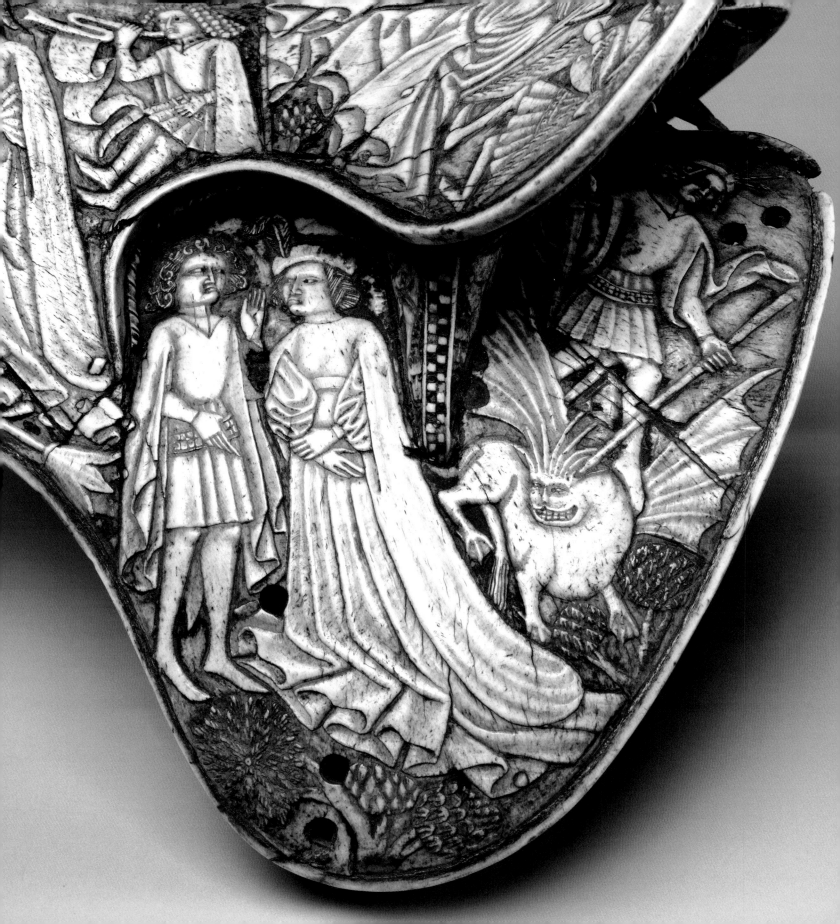

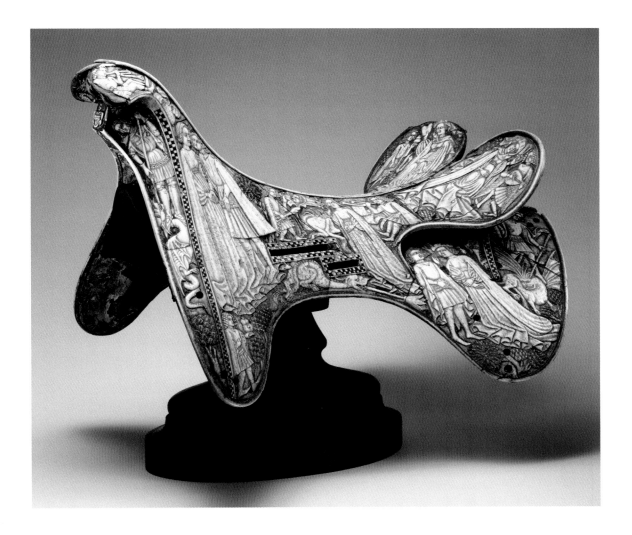

In the early 15th century, courtly decorative arts were at their height. Nowhere is this lavish trend more in evidence than in twenty or so surviving saddles of richly carved bone, linden, rawhide, and birch bark, possibly made in Bohemia. These intricately worked seats are covered with carvings of amorous couples, their flirtation so intense as to make them blissfully blind to monsters lurking just below. Some of the many figures were derived from contemporary engravings showing "gardens of love" and related scenes.

Prominent on these saddles is the chivalric figure of Saint George slaying the dragon, a ubiquitous image of the ideal knight. It is believed that the saddles may have been gifts from the German emperor Sigismund I to knights in the Order of the Dragon, which he had founded in 1408 to battle the Ottoman Turks. These decorative saddles were probably used in triumphal entries, when they would have been placed on unmounted horses for the admiration of crowds lining the streets.

SADDLE
Central European, ca. 1400–20
Bone, linden, rawhide, birch bark, and paint;
13⁵⁄₁₆ × 20½ × 13⅝ in. (33.8 × 52.1 × 34.6 cm)

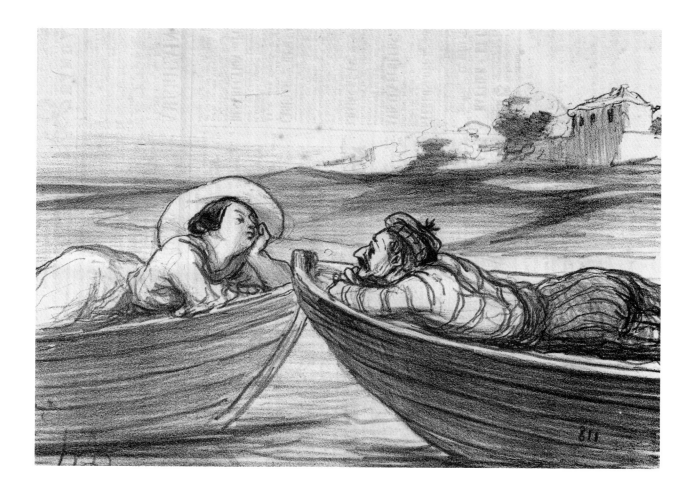

Daumier's lithographic production alternated between biting political caricature and satiric scenes of contemporary life, some gentle like this one, in which a couple of "freshwater philosophers" have found a "quiet way of descending the river of life." It appears that they may soon be in the same boat. It was published by the illustrated newspaper *Le Charivari*, to which Daumier contributed nearly four thousand lithographs and hundreds of woodcuts between 1833 and 1872. ✖ In the summer of 1874 Manet was staying outside Paris at Gennevilliers, not far from the house in Argenteuil that he had found for the Monet family. Though he had refused to participate in the independent exhibition organized in the spring by the newly dubbed Impressionists, this scene of a couple sailing shows Manet's keen interest in exploring the group's bright palette and use of emphatic brushstrokes. The radical composition excludes the horizon and crops most of the boat, recalling the flattened perspectives of the Japanese woodcuts popular among avant-garde artists at the time. In 1863 Manet had married Suzanne Leenhoff, his family's Dutch piano teacher, who may also have been his father's mistress. Suzanne is probably the woman in the boat; her brother, Rodolphe, is at the tiller, dourly playing the part of her swain.

∧ **HONORÉ DAUMIER**
Philosophes d'eau douce, from *Croquis Aquatiques*, 1855
Lithograph; 9⅝ × 14¹/₁₆ in. (24.5 × 35.7 cm)

> **ÉDOUARD MANET**
Boating, 1874
Oil on canvas; 38¼ × 51¼ in. (97.2 × 130.2 cm)

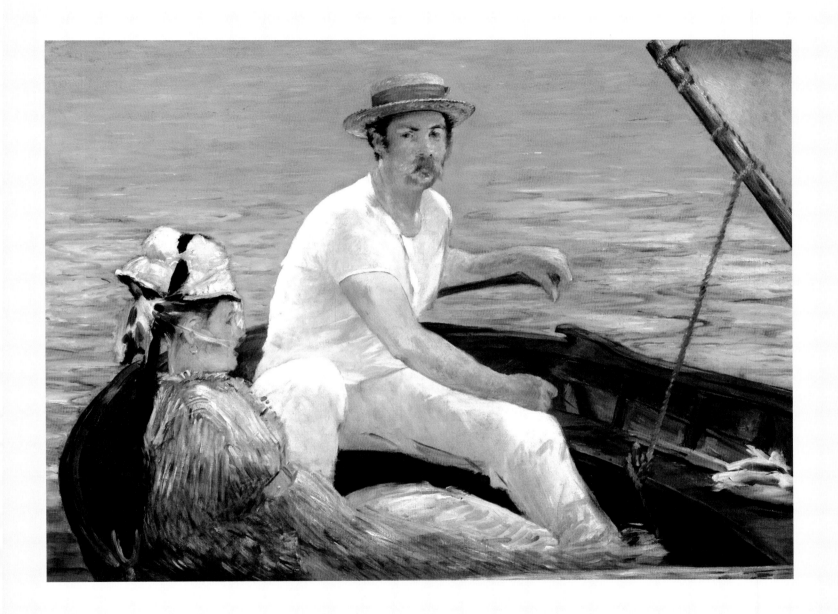

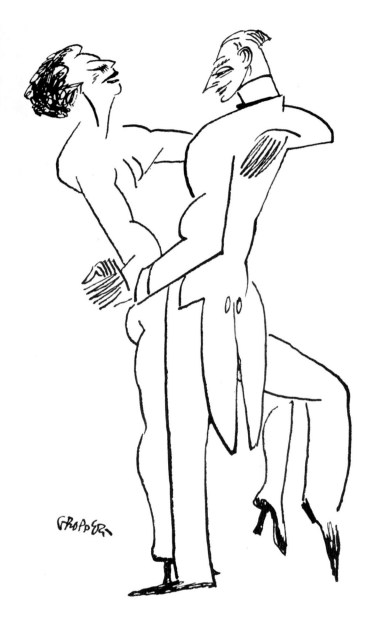

The exuberance of these graphic works belies the seriousness and even tragedy of the artists' lives. Johnson, a black artist who descended into madness in the mid-1940s, was not recognized widely in his lifetime. Gropper, famous as a left-wing activist, endured inquisition by the House Un-American Activities Committee in the 1950s. Though Gropper's 1920s dancers doing the Fox Trot are not unrelated to the painter's later, socially engaged caricatures, they are far more lighthearted, if still satirical. The figures are on point as they synchronize steps: pointy fingers, pointed toes, and a pointed predatory nose for him. She is depicted with dress undrawn — or no dress at all — in witty contrast to her partner's formal tailcoat. ✌ Few artists conveyed the spirit of jazz quite as directly as William Henry Johnson, who grew up in poverty in North Carolina. In the 1920s he studied in New York and then, like other African-American artists of the period, went to Paris. Johnson's works from the *Jitterbugs* series of the early 1940s are among his last. He depicts musical instruments as seeming partners of, not merely accompanists to, a dancing couple. Using some of the graphic conventions of Art Deco collage, the artist breaks down the borders between the animate and the inanimate, as dance sound and dance step become inseparable, a clever demonstration of the synergy between what you see and what you hear.

∧ **WILLIAM GROPPER**
Fox Trot, ca. 1922
Pen and graphite on paper; 12¼ × 9½ in. (31.1 × 24.1 cm)

> **WILLIAM HENRY JOHNSON**
Jitterbugs II, ca. 1941
Screenprint; 17 × 13¾ in. (43.2 × 34.9 cm)

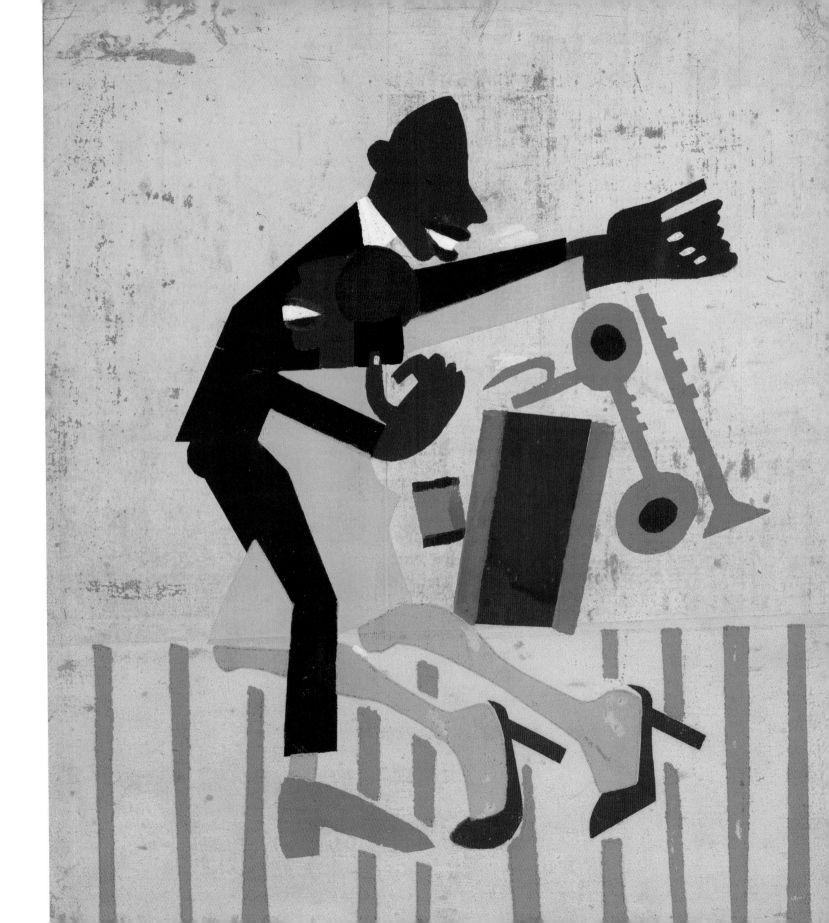

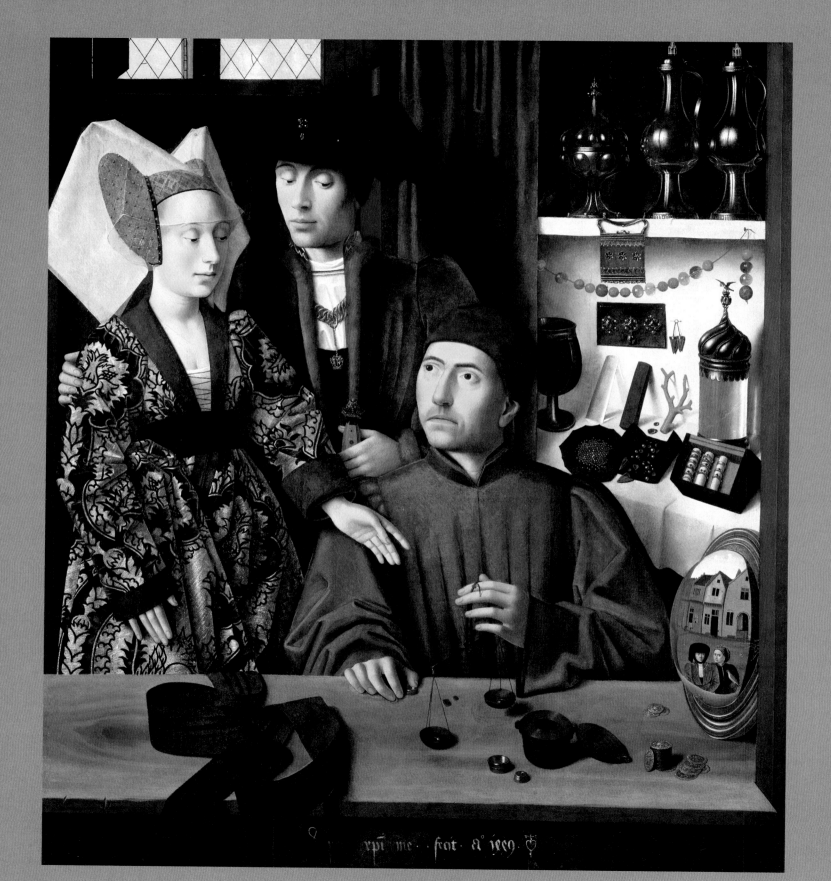

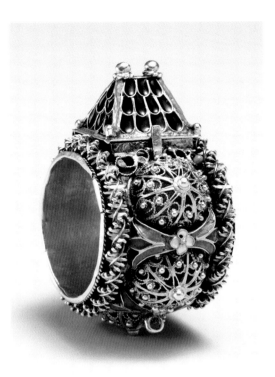

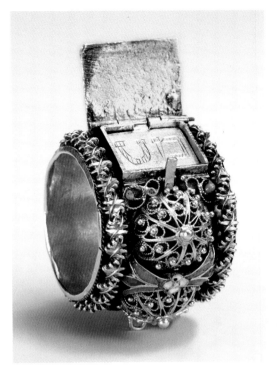

Among the most famous masterpieces of Northern Renaissance art, this scene by Petrus Christus, the leading painter of Bruges in the mid-15th century, shows an aristocratic couple watching closely as a goldsmith weighs a ring in a handheld scale. Once identified as Saint Eligius, who brought Christianity to Flanders, the goldsmith is now thought to have been a member of the Bruges gold-smiths' guild. The picture practically inventories his trade, with raw materials and finished jewelry on the shelf behind him and coinage of various realms on the table, alluding to his cos-mopolitan business. In 1449 Philip the Good, duke of Bur-gundy, commissioned from goldsmith Willem van Vleuten a gift for his niece Mary of Guelders, for her marriage to James II, King of Scots. That couple may be depicted here; or the young man, who wears on a gold chain the coat of arms of the duchy of Guelders, may be a family member. The goldsmith's well-ordered world of virtue and balance is contrasted with the distorted outside world reflected in a convex mirror, in which we see two idle, well-dressed young men. ✸ It was tradi-tional for the Roman bridegroom to give his fiancée a gold ring at the time of their engagement, a custom adopted by Jews in post-Talmudic times. By the 16th century, very elabo-rate rings of German or Flemish work were being made for Jewish ceremonies. In northern Italy, Germany, Bohemia, and southern Poland, the bride sometimes was lent a special ring, whose shape might resemble a synagogue or a palace, to wear during the marriage ceremony. Fashioned of gold filigree and brightly colored enamel, this example features the character-istic rooflike shape representing the shelter that marriage and family will provide. Inscribed within are the Hebrew letters for the words *mazel tov*, good luck.

< **PETRUS CHRISTUS**
A Goldsmith in His Shop, Possibly Saint Eligius, 1449
Oil on oak panel; 38⅝ × 33½ in. (98 × 85.2 cm)

⋀ **JEWISH BETROTHAL RING**
East European or Italian, 17th–19th century(?)
Gold, enamel; ⅞ × 1¾ in. (2.2 × 4.4 cm)

Music-making as a metaphor for romance and its physical consummation has ancient origins and many echoes in the Renaissance and after. Does love enter by eye or ear? So ran the Neoplatonic debate of seeing versus hearing as the primary means for perceiving beauty. The great Venetian painter Titian appears to award the palm to the eye in this typically resplendent canvas. While the young courtier's full view of Venus inspires his passion, she looks somewhat bored as she listens to him serenade her with his lute. A great swag of crimson silk curtain has been raised to reveal the intimate scene. Still, Cupid crowns his mother with a wreath of flowers, suggesting that perhaps the lute player's music will win her over. Romantic scenes such as this one were known as Titian's *poesie* — quasi-literary, classically inspired communications about life and love.

TITIAN AND WORKSHOP
Venus and the Lute Player, ca. 1565–70
Oil on canvas; 65 × 82½ in. (165.1 × 209.6 cm)

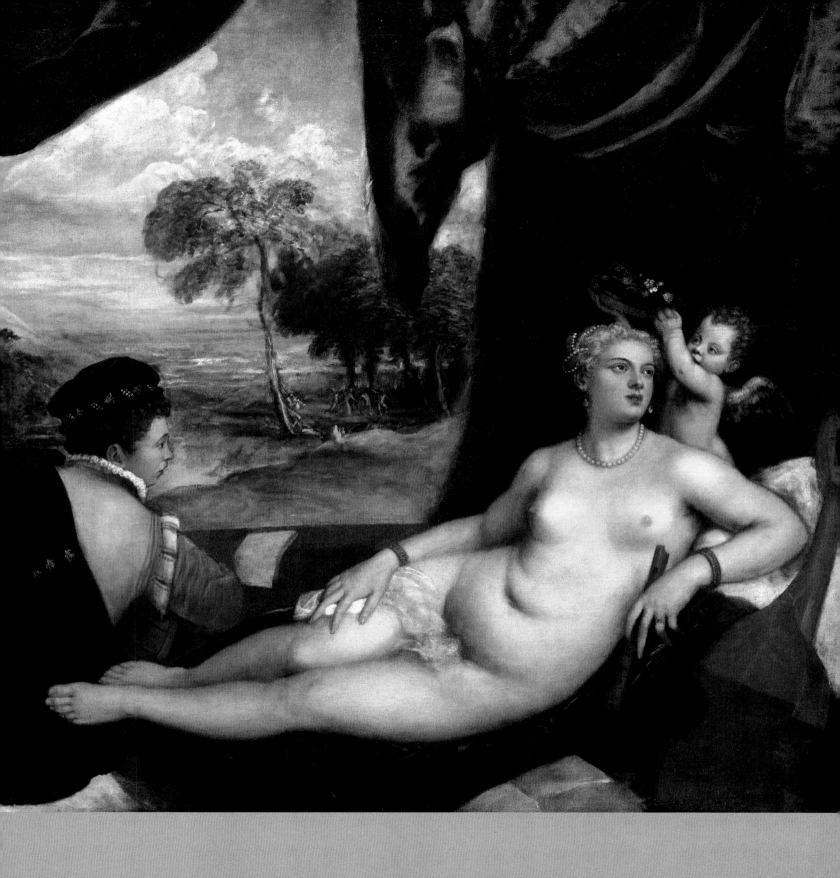

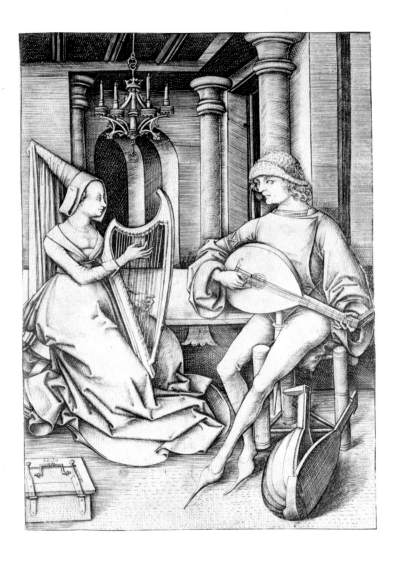

More than a generation older than Albrecht Dürer, Israhel van Meckenem was the most prolific printmaker of the 15th century, with more than six hundred engravings attributed to him. Notorious for copying other engravers' work, especially Master ES (see page 146), Van Meckenem in his original prints records contemporary manners and dress with a forthright humor. Several are devoted to the theme of musical harmony as a prelude to sexual harmony, like this scene of lovers making music; they reappear in a pendant image, seen on a bed. ✥ Sexual harmony is also the theme of *The Love Song*. Edward Burne-Jones, a leader of the "second Brotherhood," embraced the nostalgic, idealistic aesthetic of the Pre-Raphaelite Brotherhood, a mystical fraternity of English artists begun by Dante Gabriel Rossetti in 1848. The movement and its followers sought to reform the art of their time by looking to the past, which provided this painting with its figures, reminiscent of those of the 15th-century Venetian painter Vittore Carpaccio, and its Arthurian landscape bathed in evening light. One of several compositions by the artist based on an old Breton song, the picture can be read as an allegory of his overheated and rather complicated love life. The angel looks like Burne-Jones's Greek muse and model Maria Zambaco, with whom he had a passionate affair in the late 1860s and who continued to appear as a temptress in his art. Is the knight watching the chaste organist in white — or looking past her to the red-dressed angel powering the music?

∧ **ISRAHEL VAN MECKENEM**
Lute Player and Harpist, from *Scenes of Daily Life,* n.d.
Engraving; 6⁵/₁₆ × 4⁵/₁₆ in. (16 × 11 cm)

\> **SIR EDWARD BURNE-JONES**
The Love Song, 1868–77
Oil on canvas; 45 × 61⅜ in. (114.3 × 155.9 cm)

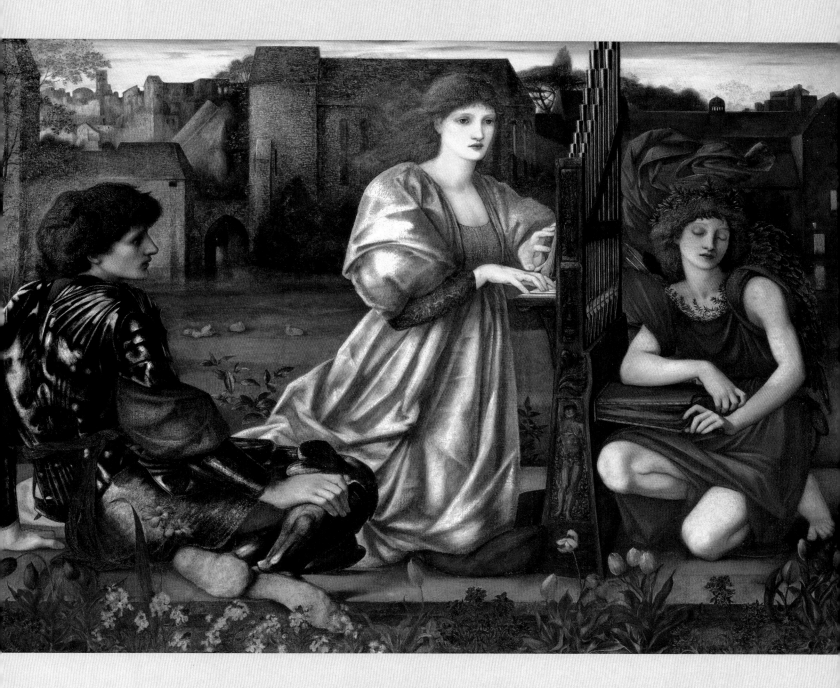

Hélas! je sais un chant d'amour, Alas, I know a love song,
Triste ou gai, tour à tour Sad or happy, each in turn

Old Breton song on which Burne-Jones based his painting

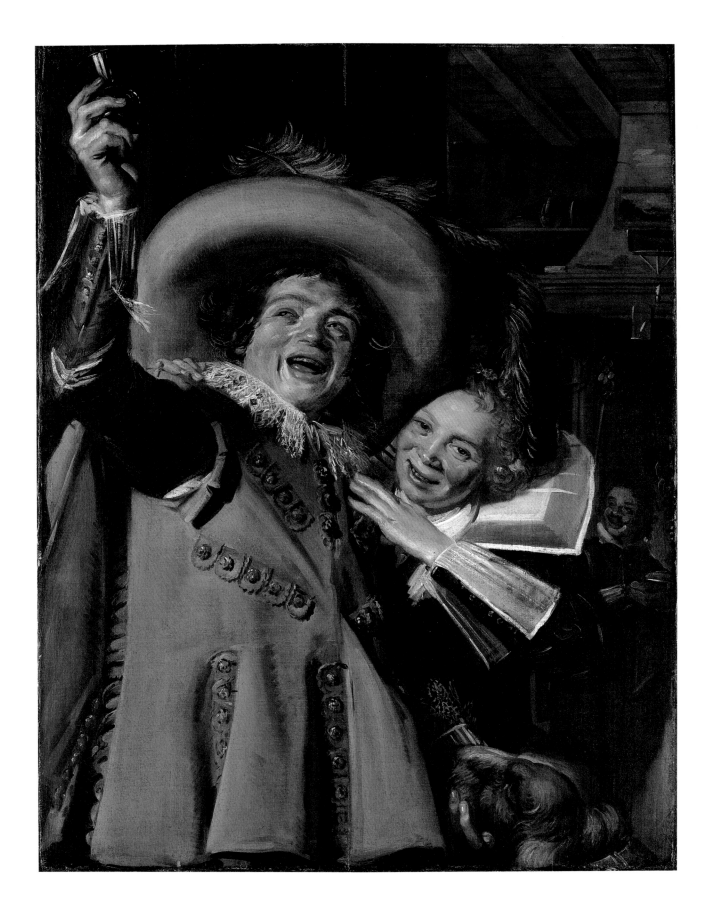

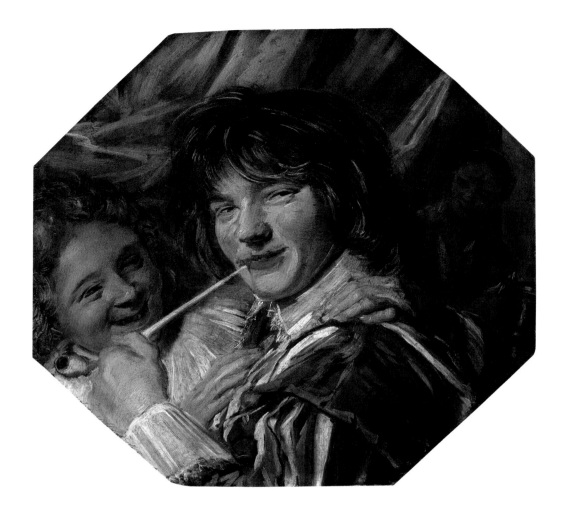

Few Western artists have captured and conveyed joy with as complete success as Frans Hals. Opposite, he pictures a young cavalier raising a glass of rum, sharing a toast with the girl who embraces him in the doorway of an inn. The man's free hand pats a dog, its presence symbolizing fidelity — or perhaps just spontaneous affection. Dashed off with the artist's characteristically free brushwork, the scene is realized with a panache that would return to painting in the late 19th and early 20th centuries, as Manet, a great admirer of Hals, and his followers rediscovered the spirited Dutch master's technical fireworks.

Many masters had their student followers. For Manet it was Berthe Morisot. For Hals it was Judith Leyster. Though *The Smoker* is considered a modest work by Hals himself, could she rather than he have painted it? In this scene, a woman embraces a man smoking a clay pipe, while a maid in the background offers a tankard of ale. Long before any knowledge of nicotine's pernicious effect, smoking stood for the transitory nature of love and life. That sentiment is echoed in the panel's tight framing within an unusual octagonal format, which makes the scene seem like a momentary glimpse in a mirror.

< **FRANS HALS**
Young Man and Woman in an Inn, 1623
Oil on canvas; 41½ × 31¼ in. (105.4 × 79.4 cm)

∧ **FRANS HALS**
The Smoker, ca. 1625
Oil on wood; octagonal, 18⅜ × 19½ in. (46.7 × 49.5 cm)

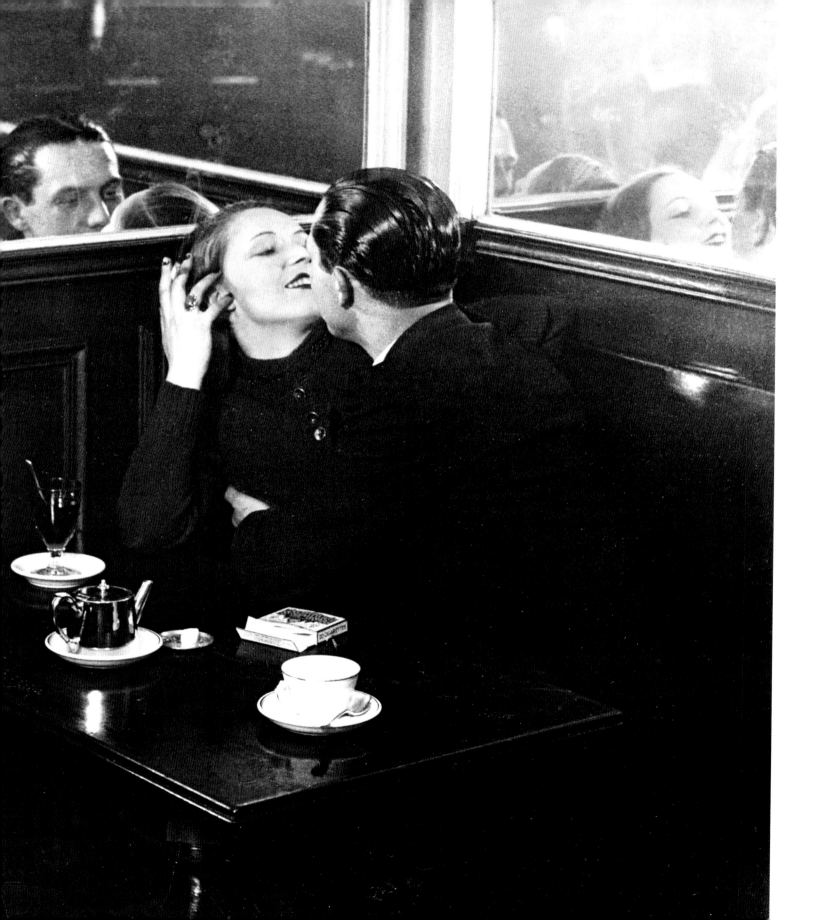

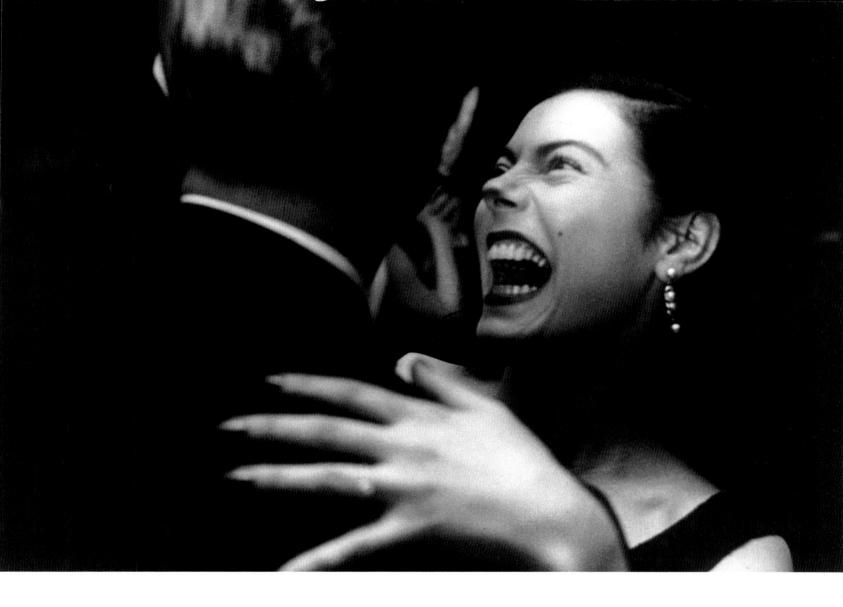

Reflecting upon private love in public places, Brassaï revels in the mirroring of lovers' gazes in the corner of a booth in a Parisian café. The elegant couple looks as if posed in a 1930s movie still. In contrast to the unifying linear perspective of art of the past, Brassaï here evokes a surreal multiplicity, as though we were watching four identical couples engaged simultaneously in *relations amoureuses*.

≫ The woman in this photograph, seeming about to devour her partner, recalls Garry Winogrand's witty pictures of animals in the zoo as much as his many images of beautiful women caught at odd moments. Taken in one of New York's most fashionable nightclubs, it captures the polite fervor of the 1950s. Exclusive clubs like El Morocco and the Stork Club made those crossing their sacred portals believe they had entered a very heaven of social desirability.

< **BRASSAÏ**
Couple d'amoureux dans un petit café, quartier Italie,
ca. 1932, printed mid-1960s
Gelatin silver print; 11⅛ × 8¹⁵⁄₁₆ in. (28.3 × 22.7 cm)

∧ **GARRY WINOGRAND**
El Morocco, 1955
Gelatin silver print; 9¼ × 13¼ in. (23.5 × 33.7 cm)

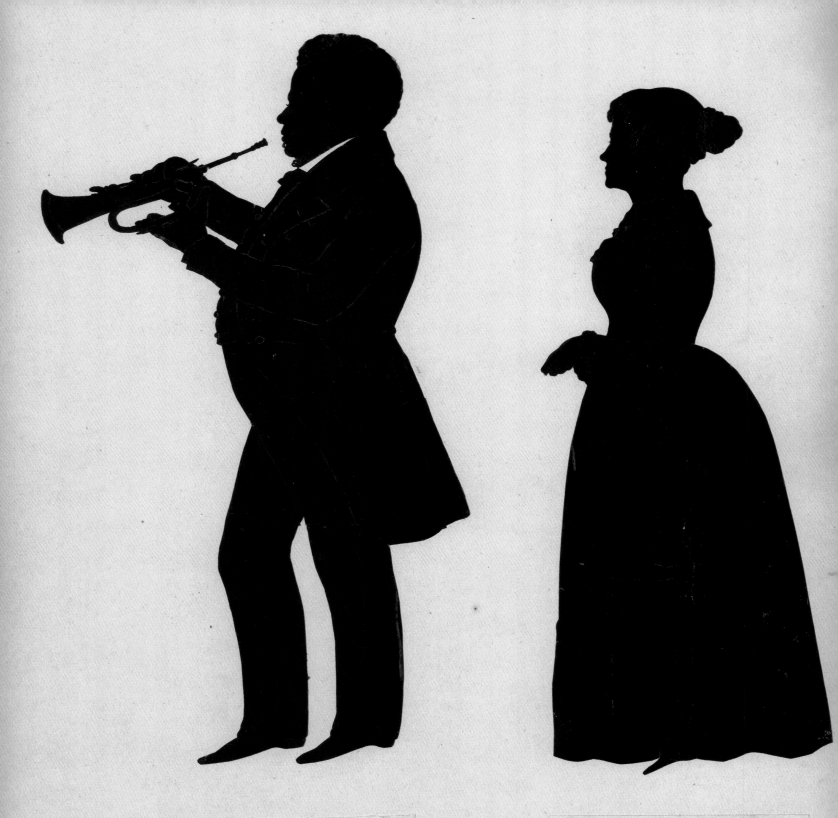

Frank Johnson. Philadelphi
Leader of the Brass Band.
of 128th Regiment.
Saratoga Aug 13th 1842.

Helen Johnson.
Philadelphia
Saratoga Aug 9th 1844

Legendarily, portraiture began with the loving labors of the Maid of Corinth, who outlined her beloved's profile on the wall before his departure for battle. With the help of a special device know as a physiognotrace, silhouette cutting and painting was revived in the late 18th and early 19th centuries. Thousands were made, first in England (there known as *shades*), then in the United States. This couple was delineated by a French practitioner, Auguste Edouart, who moved to New York in 1839 and became the most prolific silhouettist ever to work in the United States. In summer, at the popular resort of Saratoga, New York, he made numerous silhouettes of vacationers, always cutting one for the client and one for himself. Among the most unusual of his works are those showing an African American, Frank (Francis) Johnson, the leader of the brass band of the 128th Regiment in Saratoga, playing his trumpet, and his wife, Helen, a dressmaker and costumer. Her silhouette, mounted alongside that of her husband, as if she is walking behind him, was actually cut a year later. She and Johnson lived in Philadelphia, where he taught music. An unusually involving, empathic medium, silhouette-making is a forerunner of photography. Viewing them turns us all into Corinthian Maids, projecting life's colors and modeling onto shadow forms, thus bringing their subjects to life once more.

AUGUSTE EDOUART
Frank Johnson, Leader of the Brass Band of the 128th Regiment in Saratoga, with his wife, Helen, 1842–44
Cut paper silhouettes mounted on board; 11¼ × 9¼ in. (28.6 × 23.5 cm)

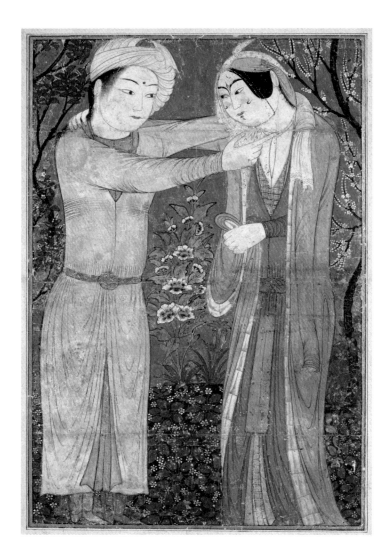

Among the most tender of all loving couples are those depicted in Islamic manuscript illuminations based on the famous *One Thousand and One Nights*, a collection of Middle Eastern and South Asian folktales framed by the story of Queen Scheherazade, who saves herself from her royal husband's murderous intentions by crafting romances and adventures for his eager ears. This image illustrates a 14th-century love story by Khwaja Kirmani incorporated into that collection. Seen against a bright blue sky and flowering garden, the Persian prince Humay embraces his Chinese princess Humayun. Persian illuminations like this one suggest an intimate world for lovers, a paradise all their own. Brilliant in color and almost abstract in outline, they were popular in the West and much admired by Matisse and his generation. ❧ The scene at right is derived from *Haft Paikar* (Seven Beauties), one of five epic poems combined to form the *Khamsa* (Quintet) of Nizami, a Persian poet of the late 12th century who greatly influenced the development of Persian literature. It depicts the Sassanid king Bahram Gur (also see page 63), a Persian cultural hero, visiting one of the seven princesses to whom he is married. They reside in separate pavilions within his palace, and with each one he spends one night of the week. The princesses represent the world's seven regions, seven colors, seven metals, and seven planets, as well as the days of the week and the levels of the soul's purification, and each tells the king a mystical allegorical tale that contributes to his spiritual enlightenment.

∧ **PRINCELY COUPLE**
Iranian, possibly Tabriz; AD 1400–5
Opaque watercolor and gold on paper; 19¼ × 12⁹⁄₁₆ in. (48.9 × 31.9 cm)

> **BAHRAM GUR IN THE WHITE PALACE ON FRIDAY FROM THE *KHAMSA* (QUINTET) OF NIZAMI (FOL. 235)**
Present-day Afghanistan, Herat; AH 931 / AD 1524–25. Calligraphers: Sultan Muhammad Nur, Mahmud Muzahib; artists: Sultan Muhammad, Shaykh Zada
Opaque watercolor, ink, and gold on paper; mat: 19¼ x 14¼ in. (48.9 x 36.2 cm)

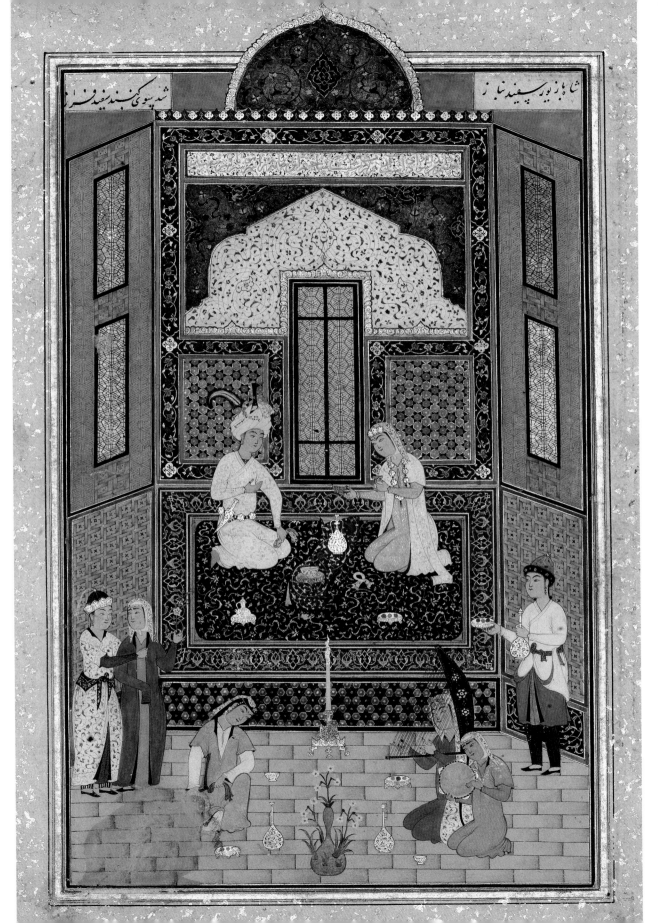

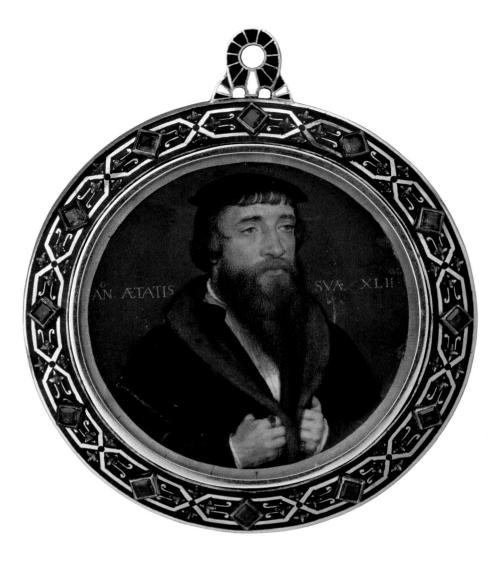

Among Hans Holbein the Younger's finest achievements are his many paintings and drawings of the family of Sir Thomas More. Shown with a book, her thumb holding her place as if she will resume reading in a moment, is Margaret (Meg), More's eldest and favorite daughter, renowned for her learning and active as a translator. Holbein, Henry VIII's German court artist, painted these miniatures of Margaret and her husband, William Roper, when he was forty-two and she thirty (as the gold inscriptions tell us), which dates them to within a year or so of the king's execution of More for opposing him in his dispute with the papacy. Roper lived in the More household for sixteen years prior to marrying Margaret, and his *Life of Sir Thomas More*, written about 1555, is the principal source of information about the sainted martyr. This is his only known portrait. The roundels exemplify the precision of a major master best known for works far larger in size. Painted on vellum, they are among his first miniatures, a skill acquired in London from a Flemish painter. Yet Holbein, like so many painters of the 15th and 16th centuries, was first trained in the skills of gold- and silversmiths, and he often worked in precious metals. He may have designed the miniatures' costly enamel enclosures, with hooks for neck or pendant chains.

HANS HOLBEIN THE YOUNGER
William Roper (1493/94–1578) and *Margaret More (1505–1544), Wife of William Roper*, 1535–36
Vellum laid on card; each, diam. 1¾ in. (4.5 cm)

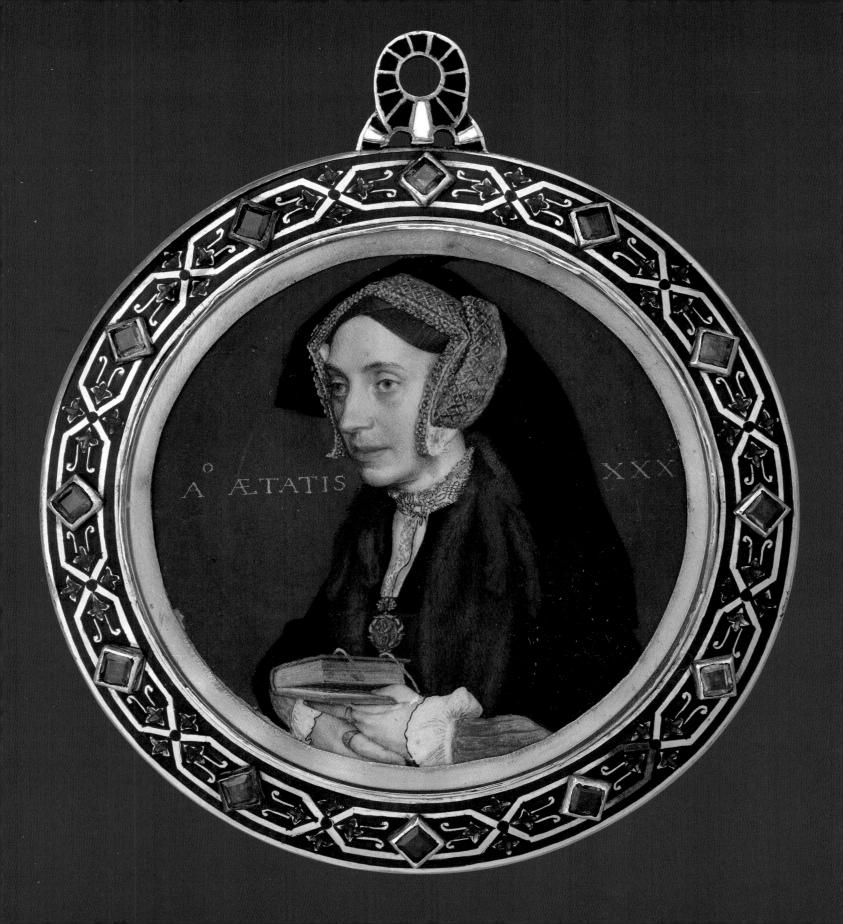

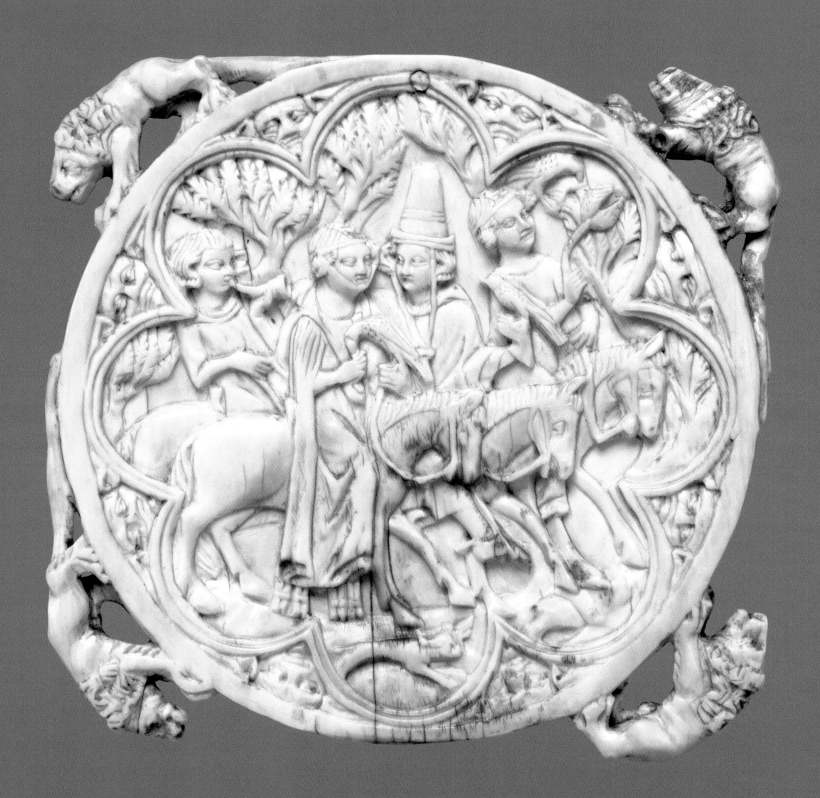

Made in Paris, this intricately carved ivory plaque depicts a courtly scene in a forest of a mounted couple hunting with falcons. The other side once contained a circular mirror, probably of highly polished steel. A woman owning such an elegant luxury, a forerunner of the modern compact, was certainly a member of the aristocratic elite. Four majestic lions stalk around the outer edge, as if to reinforce the social privilege conveyed by the object. The link between the sport of falconry and courtly romance, a frequent subject in medieval literature, suggests that the scene can be read as a hunt for love. ❧ A pair of fine steeds are replaced by a bicycle built for two in William Glackens's illustration, presumably for Maurice Thompson's novel *Sweetheart Manette*, announced on the magazine's cover. Set on the Gulf Coast, it is a romance between a wealthy Northerner and a charming Southern girl. Glackens, a cofounder of a group of urban realist painters known as The Eight in the early years of the last century, was a successful illustrator in the 1890s.

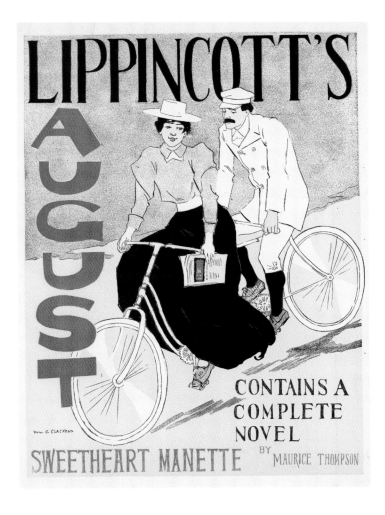

<MIRROR CASE
French, 1350–75
Elephant ivory; 4⅜ × 4⅛ × ⁷⁄₁₆ in. (11.1 × 10.4 × 1.1 cm)

∧ **WILLIAM JAMES GLACKENS**
LIPPINCOTT'S cover, August 1894
Commercial lithography; yellow, vermilion, and black; 17⁷⁄₁₆ × 12⁹⁄₁₆ in. (44.3 × 31.9 cm)

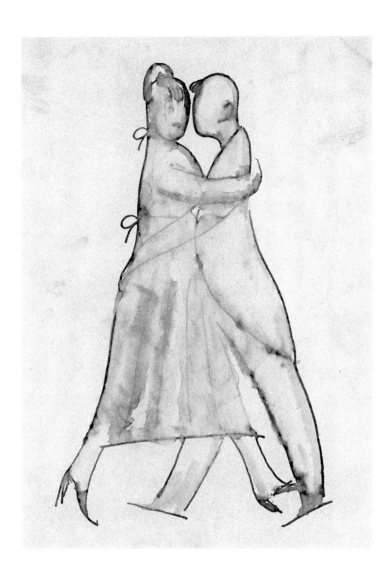

In *Tango*, Elie Nadelman eliminates the faces of his figures and lets the dancers' bodies, pressed against each other, convey the intimacy of the Latin American dance. Figures dancing are a constant theme in Nadelman's art, from those drawn in the Cubist-inflected classicizing style that preceded the more descriptive mode seen here to the folk-inspired wood sculptures begun a year or so later, for which he is now best known. Gradually his figures filled out until, by the late 1920s, he was making chunky ceramic circus figurines that anticipate Niki de Saint-Phalle's pneumatic "Nanas" and the tubby denizens of Fernando Botero's paintings. ⁂ Botero merged baroque fullness of form, the classicizing style of Picasso's rotund figures, and a storytelling tradition of his native Colombia that blossomed in the Magic Realism of contemporaries such as the writer Gabriel Garcia Marquez. He places his inflated figures somewhere in the Colombian countryside, perhaps near Medellín where he was raised, and in fashions of the 1940s, his teenage years. There is a whiff of Magritte-style Surrealism as well in this lively café, quite literally filled with music, as the musicians, with eerily similar faces, barely fit on the tiny stage. The child-size dancing couple perhaps feel like kids again, at play and carefree.

∧ **ELIE NADELMAN**
Tango, ca. 1917–18
Ink and wash on paper; 9½ × 6⅜ in. (24.1 × 16.2 cm)

> **FERNANDO BOTERO**
Dancing in Colombia, 1980
Oil on canvas; 74 × 91 in. (188 × 231.1 cm)

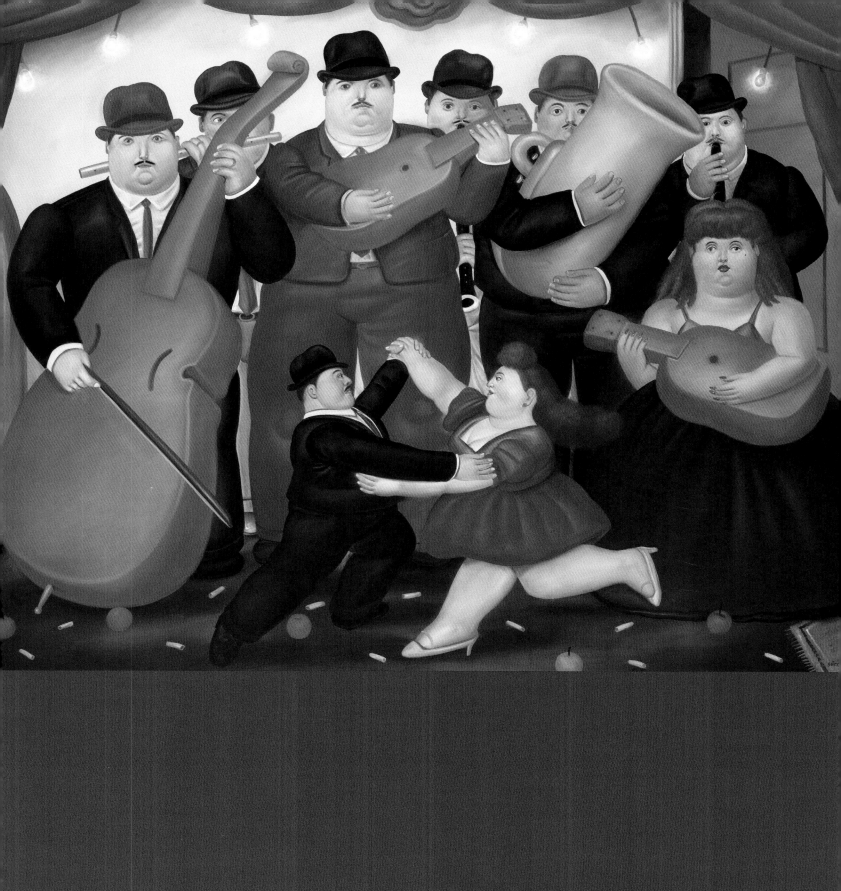

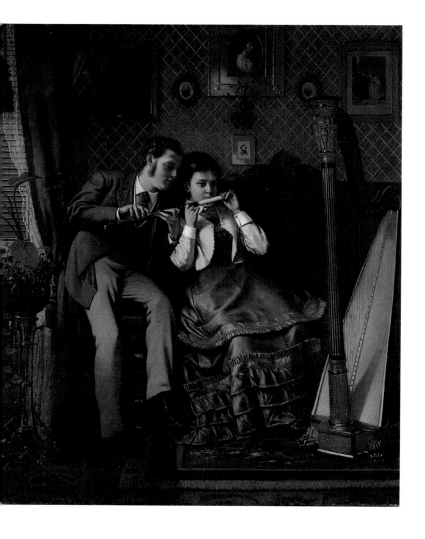

Scenes of couples making music together allude to romantic harmony. A middle-class Victorian parlor provides the setting for a courtship story in which a young man fingers a flute while closely observing his beloved's lips as she attempts to produce a tune. Brown, known as a specialist in depicting children, here celebrates romance and marriage through the metaphor of making music, an approved activity for courting couples. The harp, commonly a symbol of love; the haloed female figure in the print or painting on the wall behind them; and even perhaps the clinging ivy to their left all underscore the sentimental message. ❧ This tapestry fragment depicts a shepherd couple entertaining themselves with music, while three sheep from their flock graze in a rustic, flower-filled meadow. The shepherdess sings:

> *Chantons sur lerbette* Let's sing, on the grass,
> *Avec ta musette* with your bagpipe,
> *Quelque note double* a tune for two.

The shepherd, playing a bagpipe, responds:

> *Cuant est de georgette* When she sings
> *Elle a lavoix nette* her voice is fair:
> *Mes ie faiz le trouble* but I do the work

˄ JOHN GEORGE BROWN
The Music Lesson, 1870
Oil on canvas; 24 × 20 in. (61 × 50.8 cm)

˃ SHEPHERD AND SHEPHERDESS MAKING MUSIC
South Netherlandish, ca. 1500–30
Wool and silk; overall 92½ × 115 in. (234.9 × 292.1 cm)

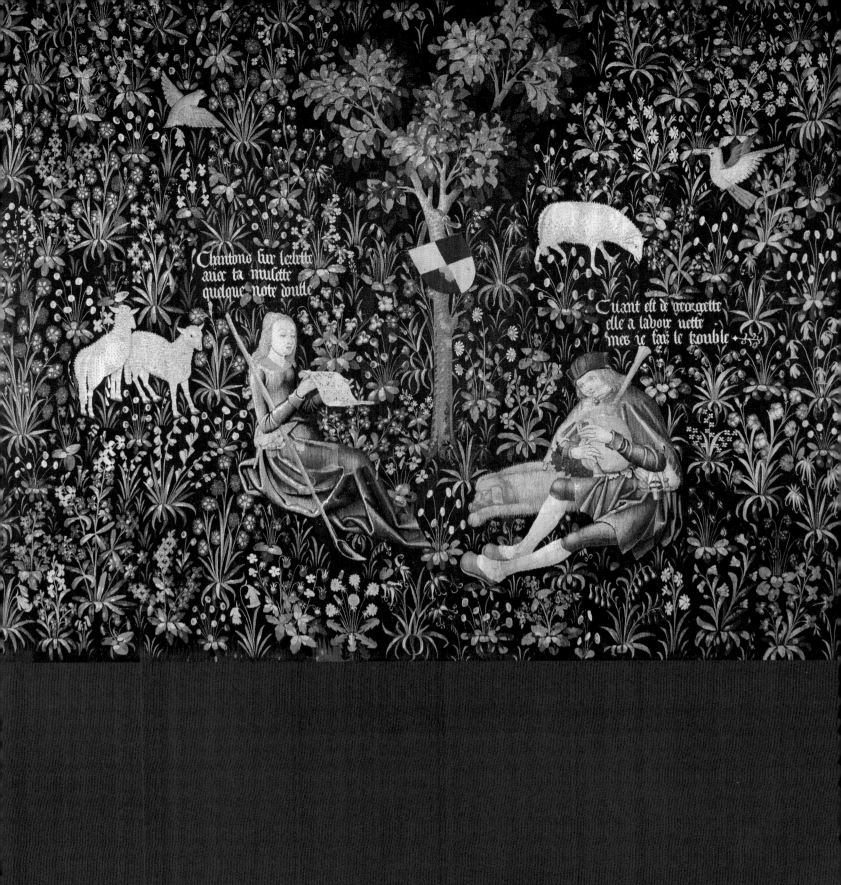

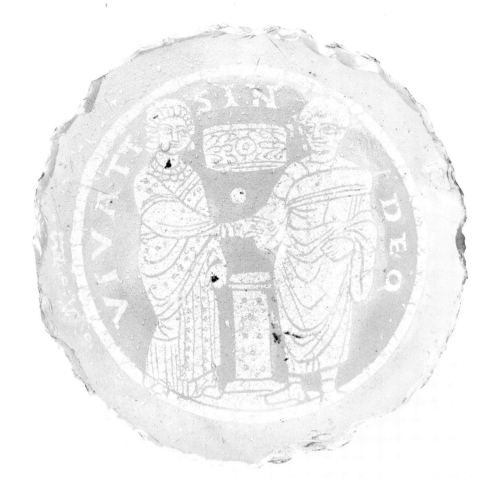

Originally the base of a bowl, perhaps a wedding gift, this late classical depiction of the Roman marriage ceremony echoes in a Renaissance scene of the marriage of the Virgin. The inscription *VIVATIS IN DEO*, "May you live in God," is addressed to a couple seen in the traditional pose *dextrarum iunctio*, the nuptial clasping of the right hands. A small altar is between them, and a large wedding ring occupies the place where, in many Roman marriage scenes, the *pronuba* (matron of honor), or a goddess representing her, would appear between the couple. In the ceremony itself, the ring was placed on the fourth finger of the left hand because it was believed that a vein there led directly to the heart. ❧ Of the great painter-illuminators who dominated Lombard art in the early 15th century, Michelino da Besozzo was the most famous, known for grace, naturalism, and humor. He depicts here a scene described not in the Gospels but in apocryphal writings and *The Golden Legend*. When the Virgin turned fourteen, the high priest gathered together the marriageable male descendants of David and ordered them to bring a rod. Mary would marry the suitor whose rod burst into flower, which the Holy Spirit, descending as a dove, has caused Saint Joseph's rod to do. Michelino contrasts the women on the right, intently watching the ceremony that follows this miracle, with the comically agitated, rejected suitors on the left, who have lost out to the graying Joseph. One breaks his stick in anger; another wonders where the bird came from; and another appears to be sucking on his stick in hope that the sap will rise.

< **MICHELINO DA BESOZZO**
The Marriage of the Virgin, ca. 1430
Tempera and gold on wood; 25⅝ × 18¾ in. (65.1 × 47.6 cm)

∧ **BOWL BASE WITH A MARRIAGE SCENE**
Roman or Byzantine, 4th–5th century
Glass, gold leaf; 3⁵⁄₁₆ × ³⁄₁₆ in. (8.4 × 0.5 cm)

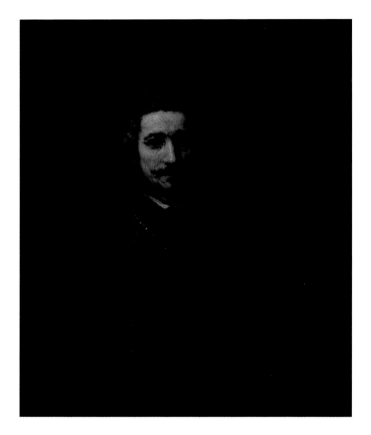
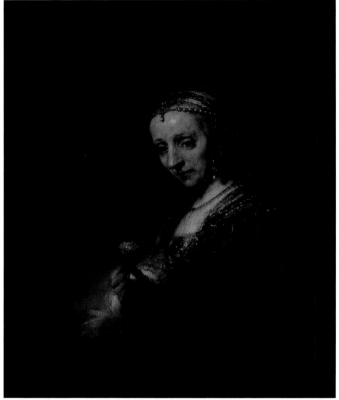

In middle age, a prosperous Dutch couple recalls their courtship, reflecting on some of the ceremonies and sentiments of that rich process, reliving the mingled commitments and expectations of marriage long after its initiation. She holds a pink (or carnation), a traditional symbol of love and marriage. Dark haired and with Latin features, the handsome husband holds a magnifying glass. He is thought to be Pieter Haringh, whose likeness is known from a portrait etching by Rembrandt of a few years earlier. A lawyer who tried to help Rembrandt keep his house when he declared bankruptcy, he would have regularly valued paintings and other luxury goods — hence the magnifying glass — such as the magnificent jewelry his wife is wearing. If he is correctly identified, she would be Elisabeth Delft, in her early forties when her picture was made. This couple was exceedingly fortunate in their choice of a painter, a master who could communicate their complex mutual perspective. These public and yet private portraits, among Rembrandt's last, are painted with daringly unconventional means, as the artist employs his full technical arsenal to create a rich poem of color and light.

REMBRANDT
Man with a Magnifying Glass and *Woman with a Pink*, ca. 1660–64
Oil on canvas; man: 36 × 29¼ in. (91.4 × 74.3 cm);
woman: 36¼ × 29⅜ in. (92.1 × 74.6 cm)

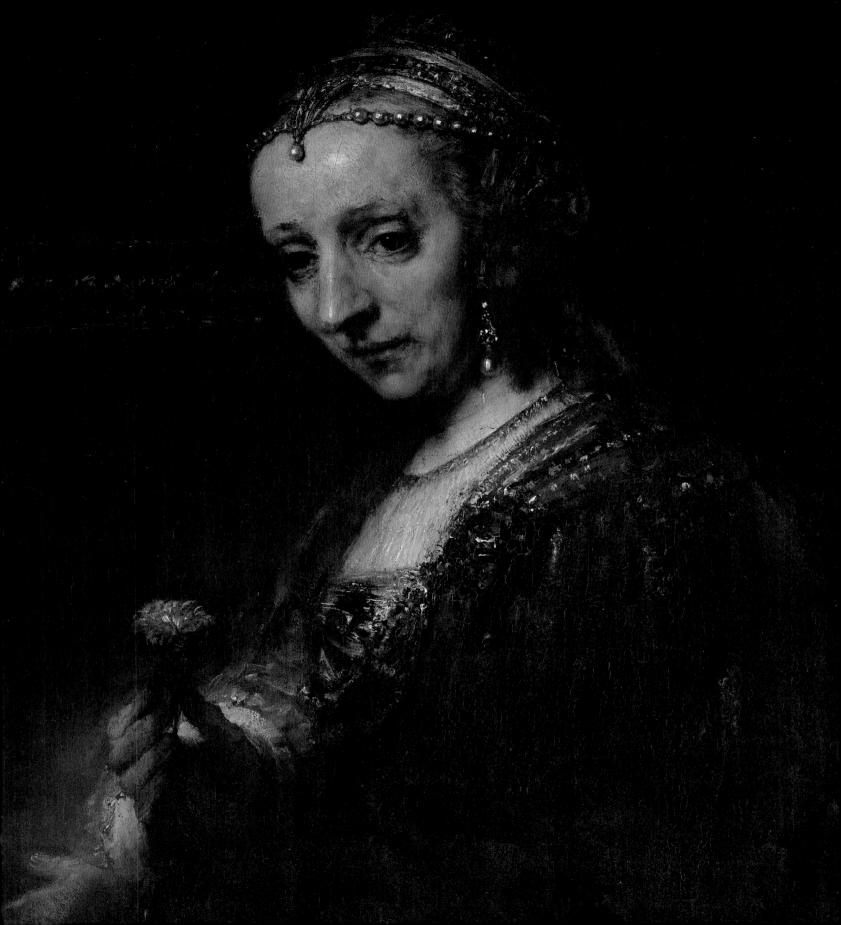

Théodore Chassériau had handsome, wealthy relatives and friends whose likenesses predominate among the portraits prepared during his short career. The gifted artist followed Ingres in a broader, more Romantic manner, as seen in his drawings of the philosopher Félix Ravaisson and his wife. In the early 16th century, aristocrats' "family albums" were prepared on paper, drawn by leading artists such as Jean Clouet and Hans Holbein the Younger, and tinted in pastel or watercolor. In 19th-century France such portrait drawings came back into favor, most notably those by Ingres and Chassériau. Working in graphite on fine papers, these artists created likenesses with shimmering, mirrorlike surfaces marked by subtle illumination, bringing to mind the effect of a daguerreotype, the dominant photographic medium at the time these drawings were made.

THÉODORE CHASSÉRIAU
Portrait of Félix Ravaisson and *Portrait of Madame Ravaisson*, 1846
Pencil on white wove paper darkened to buff; each 13⅛ × 10 in. (33.3 × 25.4 cm)

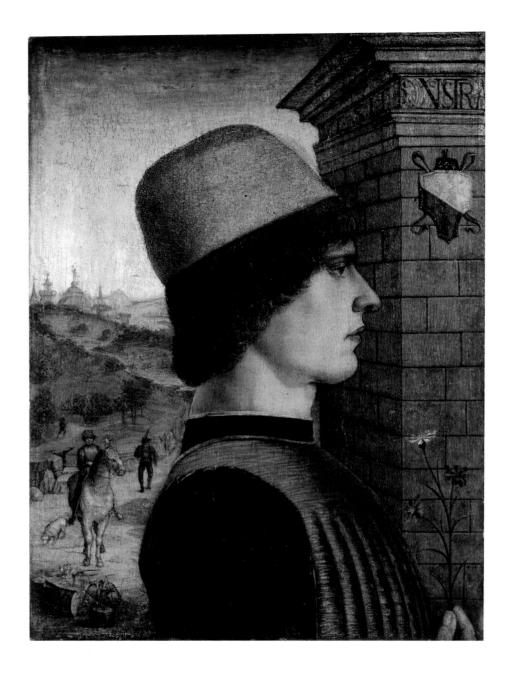

Following the 15th-century formula, he on the left, she on the right, these pendants probably show the couple as engaged or recently married. The balanced likenesses are like a pictorial contract, he holding the usual pink of engagement and she, more unusually, a fruit, representing marriage. The partners look each other in the eye, pointing to equality of class. The coat of arms present in both panels is that of the Gozzadini of Bologna, and the couple have been tentatively identified as members of that family, but the name of their painter has eluded us. The landscape

102 **ATTRIBUTED TO THE MAESTRO DELLE STORIE DEL PANE**
Portrait of a Man, possibly Matteo di Sebastiano di Bernardino Gozzadini; and
Portrait of a Woman, possibly Ginevra d'Antonio Lupari Gozzadini, ca. 1485–95
Tempera on wood; man: 19⅜ × 14 in. (49.2 × 35.6 cm); woman: 19⅛ × 14⅛ in.

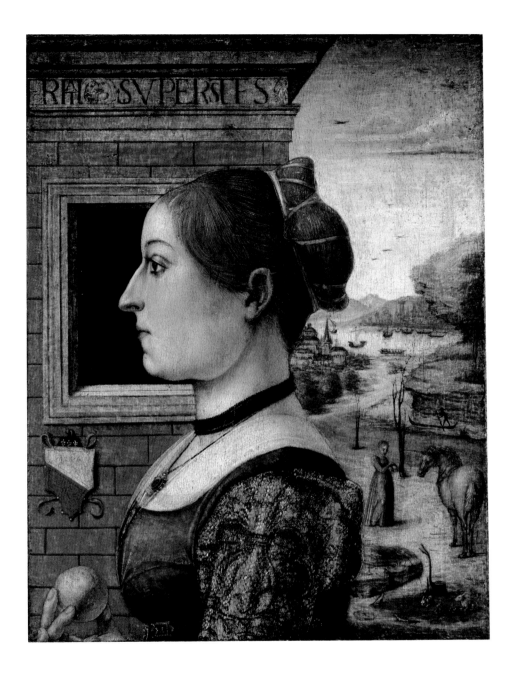

behind each of them is full of symbols of marital virtues, fecundity, and prosperity. His includes halberdiers; a falconer with a hunting dog; a pelican, symbolizing piety and self-sacrifice; and a phoenix, representing resurrection. Her panel includes two symbols of chastity, an ermine and a unicorn, along with a pair of rabbits for the opposite quality. It is not only what they brought to the marriage but also their youthful likenesses that they wish to preserve, as we learn from the Latin inscription that runs across both paintings, which translates, "In order that our features may survive."

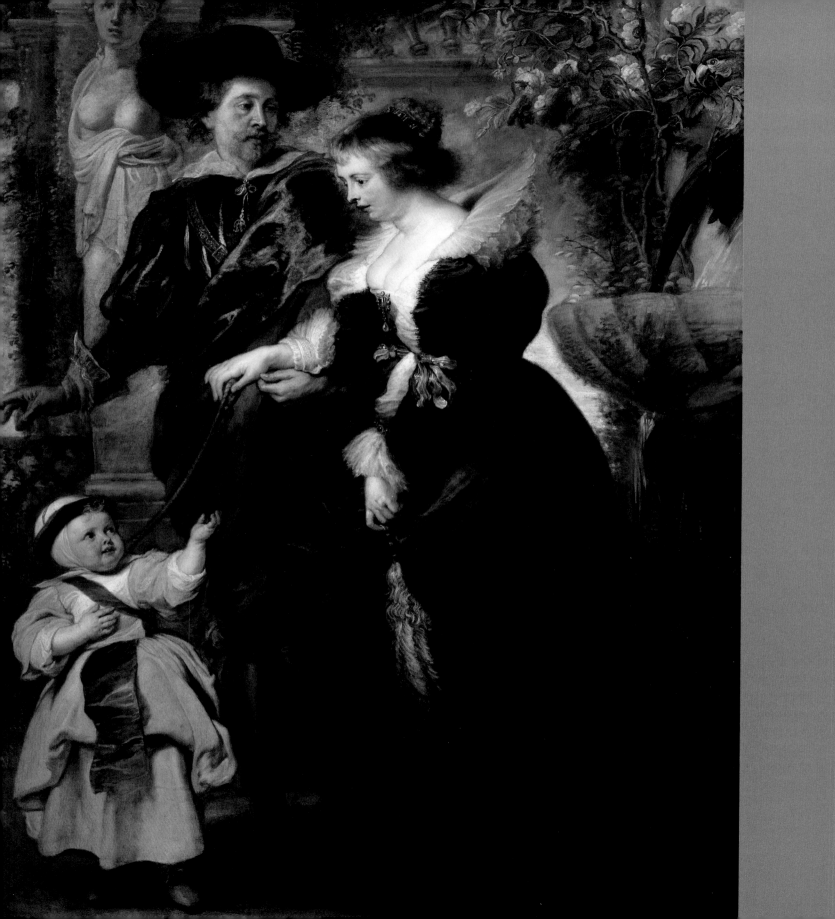

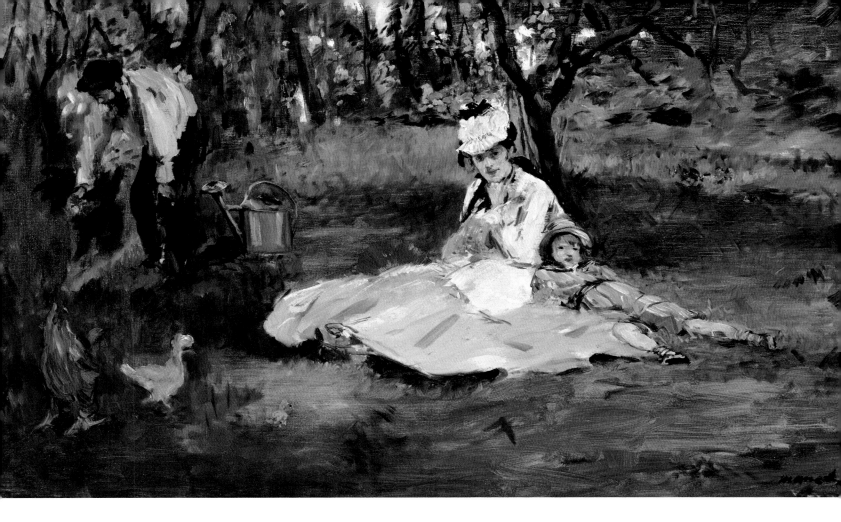

eter Paul Rubens married his second wife, Helena Fourment, when he was fifty-three and she sixteen. They are seen here with a son, either Frans (born 1633) or Peter Paul (born 1637). Rubens may have intended the pyramidal composition to echo that of the many Renaissance paintings of the Holy Family. The imposing work seems intimate, as the gazes of the figures bind them together like the laces of an elegant shoe; Rubens looks adoringly down on Helena, as she focuses intently, even anxiously, on their son, who glances confidently back at her. The interaction of mother and child define the principal axis of the picture, reinforced by the leash with which she keeps him in tow.

The large picture's formality contrasts strikingly with Manet's casual portrayal of Claude Monet's family in 1874 — the year when the term *Impressionist* was first used to describe such paintings, made outdoors rapidly and decisively. The painting seems expansive despite its size, spreading outward like the dress worn by Camille Monet at the center of the composition. Depicting very different garden settings, these two paintings set a 17th-century ideal of aristocratic leisure against a progressive 19th-century notion of rural labor as moral virtue. Rubens's brilliantly colored, emblematic parrot signifies mimesis, while Manet's humble chicken and duckling suggest dinner.

< **PETER PAUL RUBENS**
Rubens, His Wife Helena Fourment (1614–1673),
and One of Their Children, mid- to late 1630s
Oil on wood; 80¼ × 62¼ in. (203.8 × 158.1 cm)

∧ **ÉDOUARD MANET**
The Monet Family in Their Garden at Argenteuil, 1874
Oil on canvas; 24 × 39¼ in. (61 × 99.7 cm)

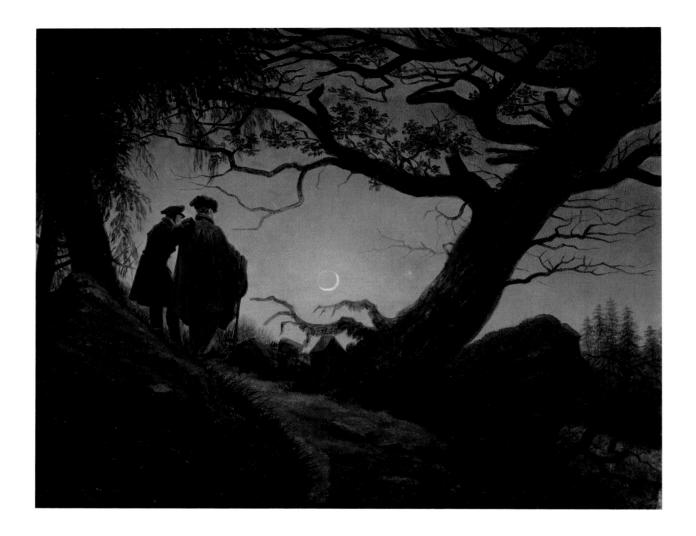

Caspar David Friedrich's evocative scene of two moon watchers, one leaning on the other's shoulder, epitomizes the German Romantic period's portrayals of friendships, often among painters. Friedrich (on the right) and his young colleague August Heinrich share friendship's mystical bonds, forged during the frisson of gazing at the moon. They are seen from the back so that the viewer may imagine participating in their communion with nature, which the Romantics saw as a manifestation of the Sublime.

❧ Many friendships are fixed by common ground, as was true for author John Nilsen Laurvik and photographer George Seeley, whose writings and pictures appeared in publications of the pugnacious, voracious New York art and photography impresario Alfred Stieglitz. As satirized by one of the brightest artists in Stieglitz's stable — the Mexican caricaturist Marius de Zayas — Seeley and Laurvik are affectionately yet accurately depicted as all too moonstruck by the art in front of them.

∧ **CASPAR DAVID FRIEDRICH**
Two Men Contemplating the Moon, ca. 1825–30
Oil on canvas; 13¾ × 17¼ in. (34.9 × 43.8 cm)

> **MARIUS DE ZAYAS**
George H. Seeley and J. Nilsen Laurvik, 1910
Ink and metallic paint on paper; 17⅜ × 11¼ in. (44.1 × 28.6 cm)

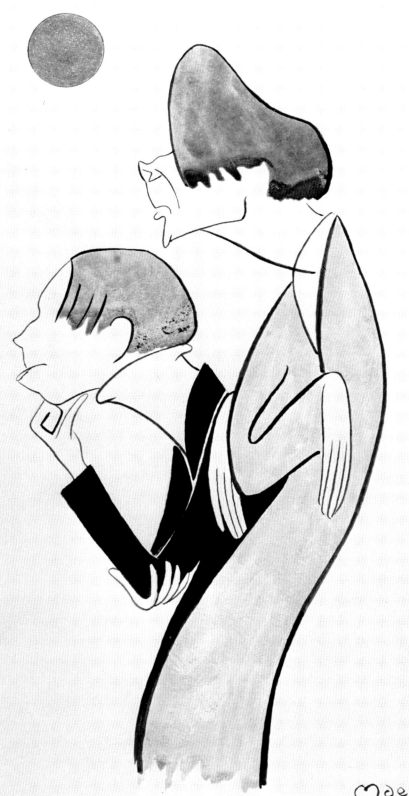

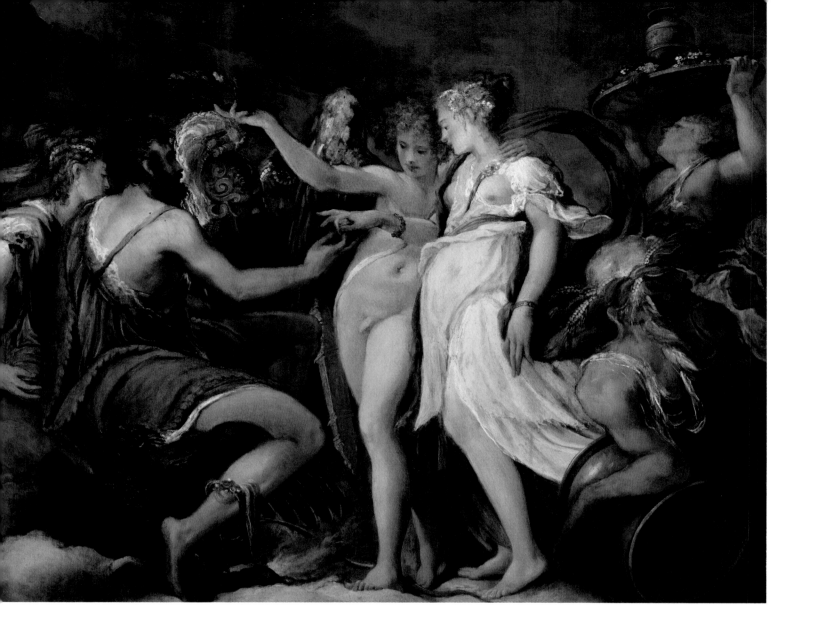

The romance of Cupid and Psyche was most vibrantly recounted by the Roman writer Apuleius in his *Golden Ass*, a labyrinthine tale of love, envy, adventure, and misadventure. Jealous of Psyche, Venus sends Cupid, made invisible, to pierce the sleeping Psyche with his arrow, which will make her fall in love with the first person she sees. But Cupid makes a hash of Venus's evil mission: overwhelmed by Psyche's beauty, he shoots his arrow and barely scratches her. Awaking, she falls in love with him. Renaissance readers found it the quintessential romance, culminating in the lavish wedding depicted in scenes such as this painting by Andrea Schiavone, a freely brushed canvas that was set into a ceiling near Venice.

∧ **ANDREA SCHIAVONE**
The Marriage of Cupid and Psyche, ca. 1550
Oil on wood; 50½ × 61½ in. (128.3 × 156.2 cm)

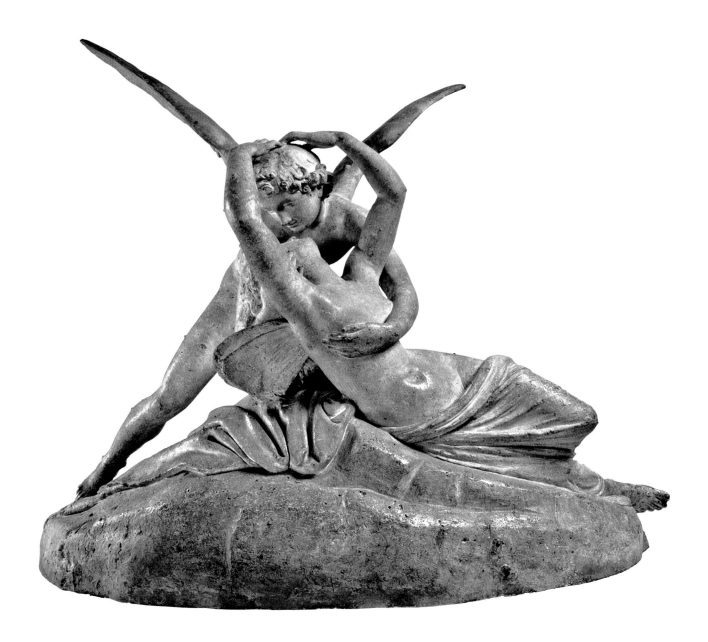

The accidental discovery of a Roman fresco of Cupid and Psyche in the excavation of Pompeii, beginning in 1748, revived the romantic couple as a subject. Neoclassical sculptors and their followers found it an irresistible topic. With its balletic union of motion and emotion, Canova's plaster has a startlingly contemporary look; it is the modello for his marble version, in the Louvre. Just which account of the romance the Venetian sculptor chose for his monumental work is uncertain. Perhaps as an artist he was attracted to the Orpheus-like story in which Cupid may only make love by night to Psyche, who is forbidden ever to see him. When she cannot resist looking, Psyche, about to be horribly punished, is rescued by Cupid's love.

∧ **ANTONIO CANOVA**
Cupid and Psyche, 1794
Plaster; 53 × 59½ × 32 in. (134.6 × 151.1 × 81.3 cm)

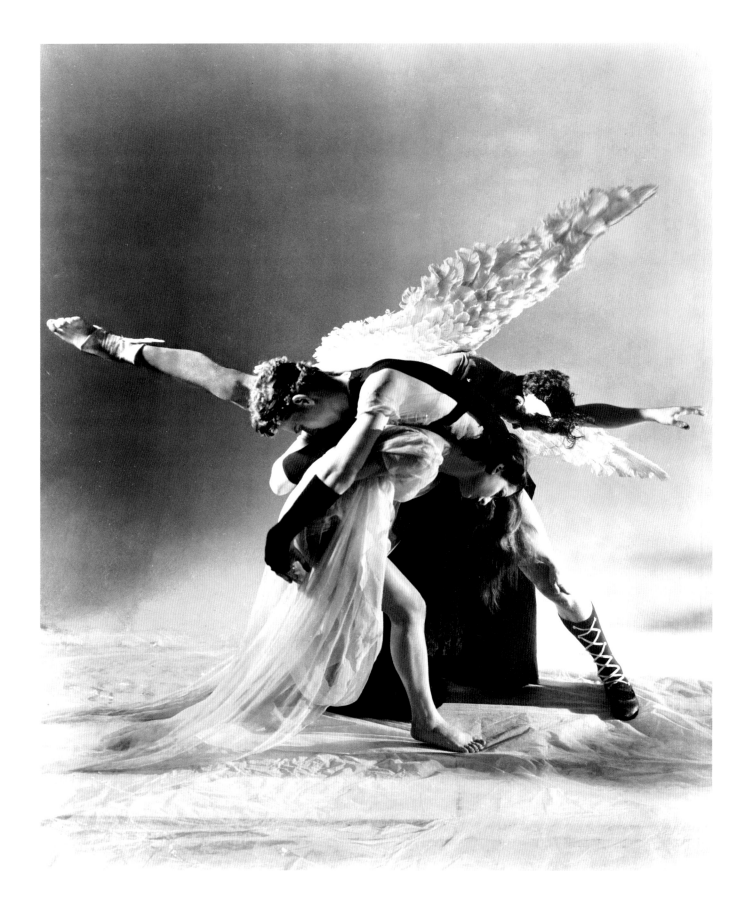

George Balanchine and Lincoln Kirstein created the American Ballet, a professional company that made its debut in 1935. After a handful of summer performances, a projected tour collapsed, but the troupe remained together as the resident ballet company at the Metropolitan Opera where, in 1936, Balanchine mounted a dance-drama version of Gluck's *Orpheus and Eurydice*, for which the singers were relegated to the pit while the dancers appeared on stage. This photo documents that controversial production. *Time* called it a "travesty," mentioning the "muscular" William Dollar as Amor (Love), and "half-clad" Daphne Vane as Eurydice. George Platt Lynes, the pioneering photographer of the male nude, was often commissioned by Kirstein to document Balanchine's productions, which in turn gave Lynes ready access to attractive models. ✣ The amorous couples of Auguste Rodin, whether *The Kiss, Pygmalion and Galatea, Orpheus and Eurydice, Adam and Eve*, or countless other pairs inspired by biblical, classical, or medieval texts, certify him as art's most successful and popular apostle of love. Italian artisans carved the master's plaster models in snowy white Carrara marble, a medium so unyieldingly "pure" as to modify the sexual messages of the originals, but the immaculate stone surfaces didn't quite succeed in dampening the pulsating desire that enlivened most of Rodin's primal plasters and waxes.

< **GEORGE PLATT LYNES**
Lew Christiensen, William Dollar, and Daphne Vane performing in the opera *Orpheus and Eurydice*, 1936
Gelatin silver print; 13⁹/₁₆ × 10⅝ in. (34.4 × 27 cm)

∧ **AUGUSTE RODIN**
Orpheus and Eurydice, 1893
Marble; 50 × 30 × 28 in. (127 × 76.2 × 71.1 cm)

This double portrait must have struck many a viewer for the difference in age between its subjects. An aged Dutch nobleman, Jan, count of Egmond, gazes with a certain seasoned fondness — or is it calculating admonition? — toward his younger wife the countess, Magdalena van Werdenburg. In 1484, the same year that Jan was appointed mayor of Holland, Zeeland, and Friesland, he had married Magdalena, a quarter-century younger than he. His was a rising star: Archduke Maximilian appointed Jan first count of Egmond two years later. Although the double portrait was prepared late in the couple's marriage, Magdalena holds a pink, symbolically alluding to her marriage vows, which tilts downward as if in submission to his will. He grasps tightly erect in his hand a small folded document; one imagines that an entire novel could be built from this moment and that mysterious note.

112 **NORTH NETHERLANDISH PAINTER**
First Count of Egmond (Jan, 1438–1516) and *Countess of Egmond*
(Magdalena van Werdenburg, 1464–1538), ca. 1510
Count: oil on canvas, transferred from wood; overall, with arched top, 16¾ × 10¼ in. (42.5 × 26 cm);
Countess: oil on wood; overall, with arched top and engaged frame, 19¼ × 12½ in. (48.9 × 31.8 cm)

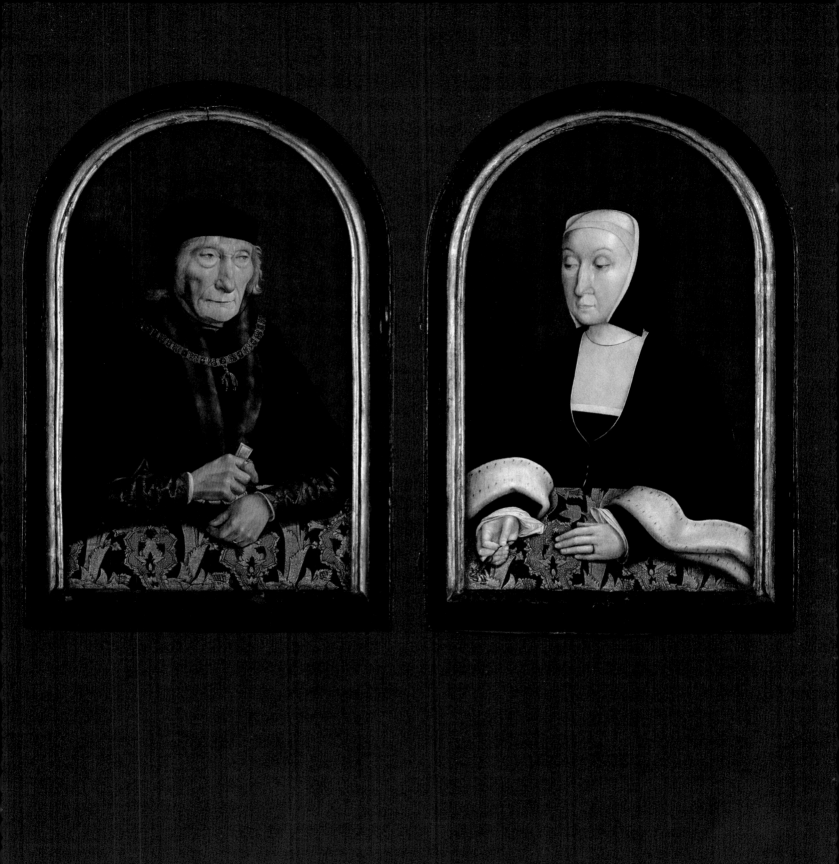

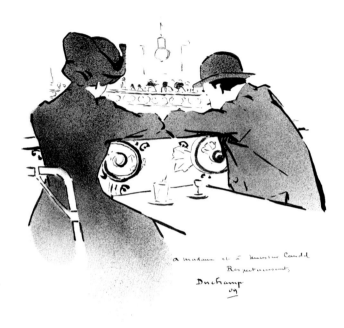

a madame et à monsieur Candel
Respectueusement,
Duchamp
09

[She:] *tu vois, on porte beaucoup de
tricorne cette année.*
*Lui — Oh! tu sais, a une corne près, c'est
toujours la mode*

[She:] You see how many people are
wearing tricorns this year.
He — Oh! You know, a horn or two
is always in fashion

- tu vois, on porte beaucoup le tricorne cette année
lui - oh! tu sais, a une corne près, c'est toujours la mode

Charged with making a painting to be seen through the murky atmosphere of the Montmartre bar called Au Lapin Agile, Picasso takes his cue from Henri de Toulouse-Lautrec's famous poster of Jane Avril, though he casts himself in the leading role, as a gaunt Harlequin wearing a *bicorne*, and reduces the woman to a pouting presence *en profil* beside him. In a gaudy ensemble, she is Germaine Pichot, a model and notorious femme fatale. Unrequited love for her drove Picasso's close friend Carlos Casagemas to suicide four years earlier, a melodrama contributing, perhaps, to Picasso's theatrically melancholy pose. Behind her playing guitar is Frédéric (Frédé) Gérard, owner of the café, which is still in business. ✷ Duchamp, coming a bit later, adopts a mocking stance in contrast to Picasso's lugubrious romanticizing. In this sketch, a couple watching the action at a Parisian ice-skating rink exchange observations. A reassuring comment is made to the effect that her hat — a *tricorne* — is still very much à la mode, with the implication that his cuckoldry (*corne*) is, too.

∧ **MARCEL DUCHAMP**
At the Palais de Glace, 1909
Ink with splatter on paper; 17 × 12 in. (43.2 × 30.5 cm)

> **PABLO PICASSO**
At the Lapin Agile, 1905
Oil on canvas; 39 × 39½ in. (99.1 × 100.3 cm)

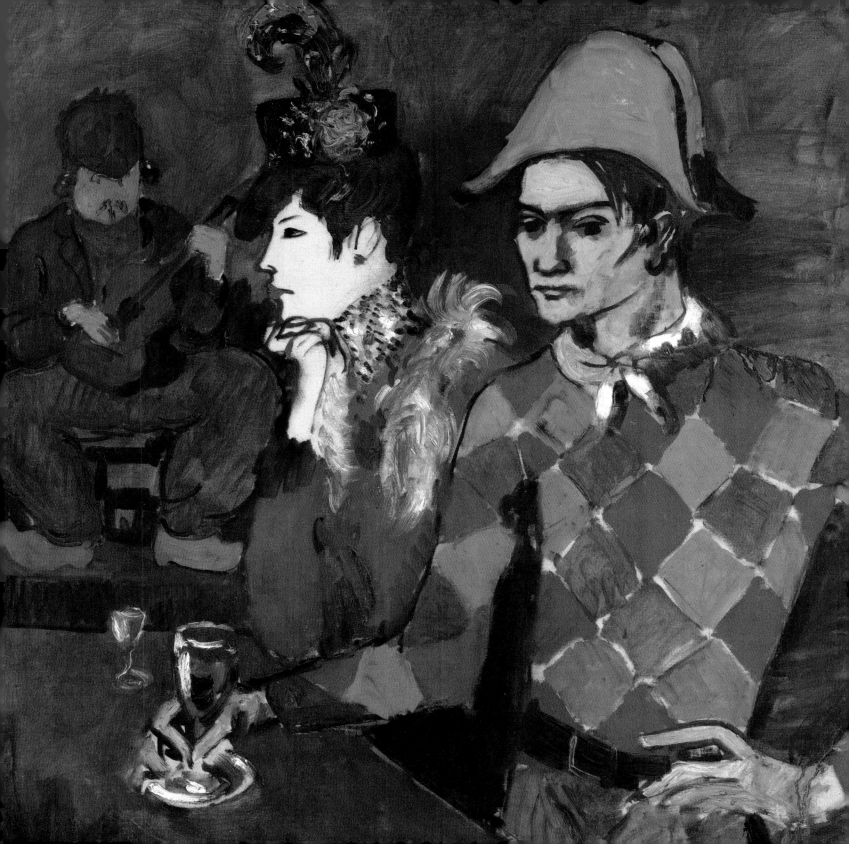

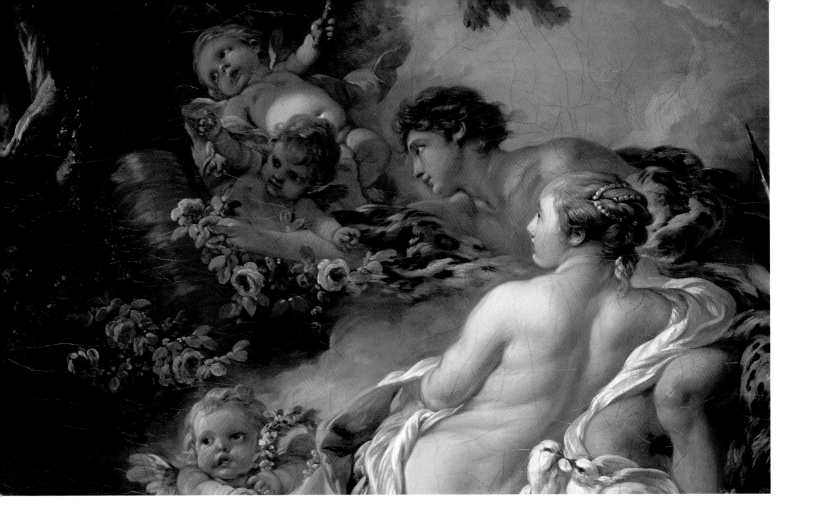

S exy confections were the specialty of the Rococo, the fashionable artistic style of the Enlightenment. Whether in porcelain or on canvas, frivolous, amorous scenes became popular among the rich. François Boucher's oeuvre shows a special genius for the ingenuous — seemingly innocent while simultaneously conveying opposite qualities. Here one work (opposite, above) illustrates Ovid's story of how Jupiter, in love with Callisto, one of Diana's nymphs, takes on the form of Diana herself to seduce the virgin. Callisto greets the false Diana as "greater than Jove, even if he himself should hear it," at which Jupiter secretly chuckles, pleased to be preferred to himself. As he begins to give her kisses such as a virgin goddess would not bestow, Callisto understands, too late, what is going on and, despite strenuous resistance, he has his way. A pendant canvas (opposite, below, and detail, this page) may depict a passage from Ariosto's epic *Orlando Furioso* in which Angelica, daughter of the king of Cathay, and her lover Medoro, the Saracen champion she has fallen for, are carving their initials on a tree (one of many they deface). Indistinct initials, possibly reading *M / A*, may be glimpsed on the bark. The scholar Rensselaer Lee has suggested that the Medoro figure, grasping a spear, and his companion may, in fact, have been Venus and Adonis before Boucher, ill and unable to produce new work for the Salon of 1765, borrowed the painting from its owner and retitled it for the exhibition.

FRANÇOIS BOUCHER
Jupiter, in the Guise of Diana, and Callisto, ca. 1763; and *Angelica and Medoro*, 1763
Oil on canvas, oval; *Jupiter*: 25½ × 21⅝ in. (64.8 × 54.9 cm);
and *Angelica*: 26¼ × 22⅛ in. (66.7 × 56.2 cm)

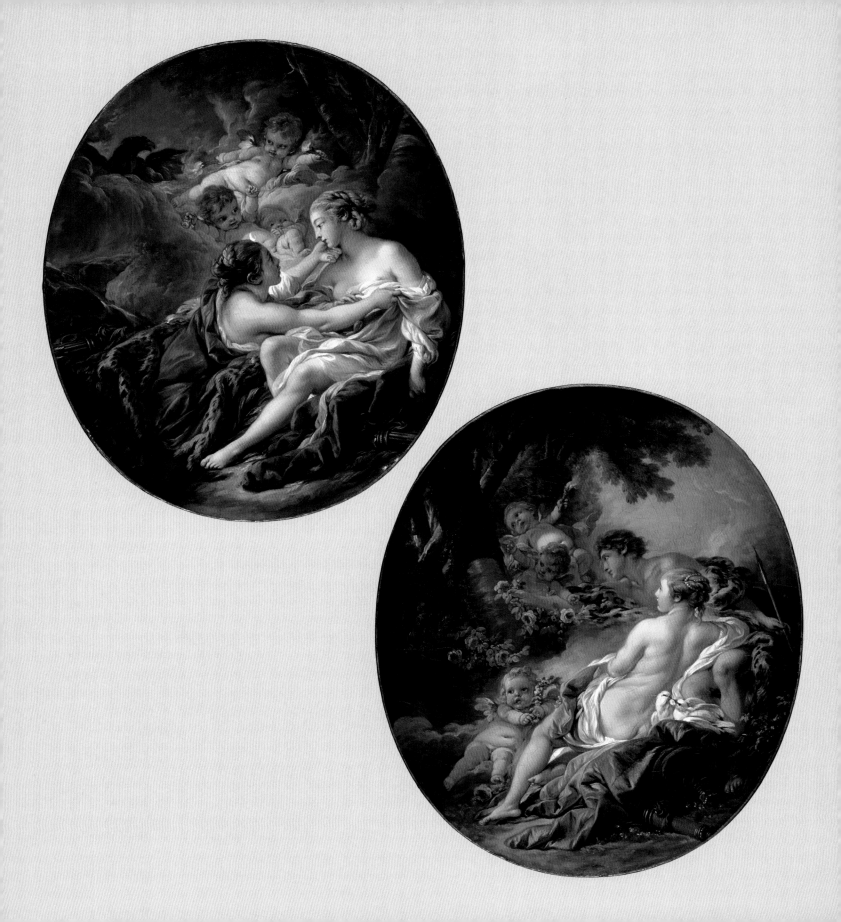

Gothic life and art are too often seen as relentlessly pious. Adventure, romance, and an interest in classical mythology were all aspects of medieval times, as reflected by this tiny ivory writing tablet with scenes of courtship seen through trefoil arches. On one side, an idealized couple kneels below a conventionalized tree to receive the benediction of the god of love, Cupid, who is about to cast his arrows down upon these willing targets. On the other side, the young man has received a coronet from his lady and reciprocates by crowning her, the victor who won his love. He is depicted on both sides holding a falcon, a sign of upper-class status and an emblem of the hunt — for love as well as game. Such scenes are among the stages of love described in the popular — and controversial — *Roman de la rose* (written in two stages, ca. 1230 and ca. 1275), one of France's most widely read works from the 13th through the 15th century. Plaques like these, made to cover writing tablets, were deluxe Parisian products in that period. A lover might inscribe an amorous poem or message to his or her beloved on the wax that filled smooth, recessed sheets of ivory within.

118 **COVER OF A WRITING TABLET**
French, ca. 1325–50
Ivory; 3¹¹/₁₆ × 2⁵/₁₆ × ⁵/₁₆ in. (9.3 × 5.9 × 0.8 cm)

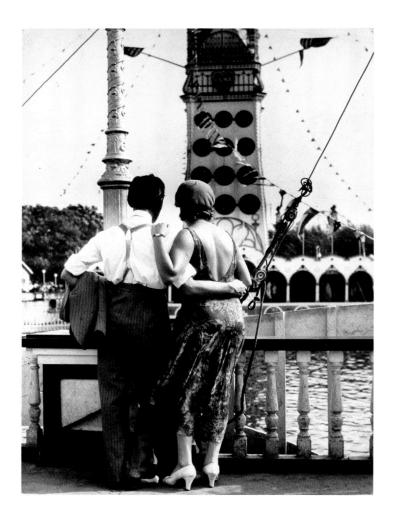

W alker Evans would say in later years that his real career began in 1928, the year he moved to Brooklyn and captured this couple gazing at an artificial moon — the word *LUNA* in a big heart gracing the Electric Tower, the architectural centerpiece of Coney Island's Luna Park. An inveterate student of structure, Evans is enchanted by the extraordinary play of upright elements — the tower, balusters, columns, and the man's body, reinforced by a lamppost — and angles — nautical cables and ropes with gaily fluttering pennants, as well as the cable rising from her hip, giving it a saucy sway. Together these verticals and diagonals knit together the surface of the composition. Even the couple's interlocking arms and the braces holding up his trousers participate in the play of suspension and support. ✢ Pasted, torn paper makes choppy waves in a windswept scene conjured up by California artist Lynn Bostick, using an unusually complex technique that combines decoupage, watercolor, pencil, and crayon. Many of her fresh, provocative works deal with the interactions of couples, her handling of intimacy recalling domestic scenes of the painter Édouard Vuillard. East meets West in *Conversation on a Boat Deck*, with a brisk Hokusai sea thrashing below Milton Avery clouds, these seemingly puncturing the paper. Dialogue is reduced to gazes amid the turbulent sea and sky. She in her boldly striped dress seems to look past him in his cautiously checked shirt, contrasts alluding to a complex psychological interaction.

∧ **WALKER EVANS**
Couple at Coney Island, New York, 1928
Gelatin silver print, 8 × 5¹³⁄₁₆ in. (20.4 × 14.8 cm)

> **LYNN BOSTICK**
Conversation on a Boat Deck, 1983
Watercolor, graphite, crayon, and cut and pasted papers on paper;
16 × 14 in. (40.6 × 35.6 cm)

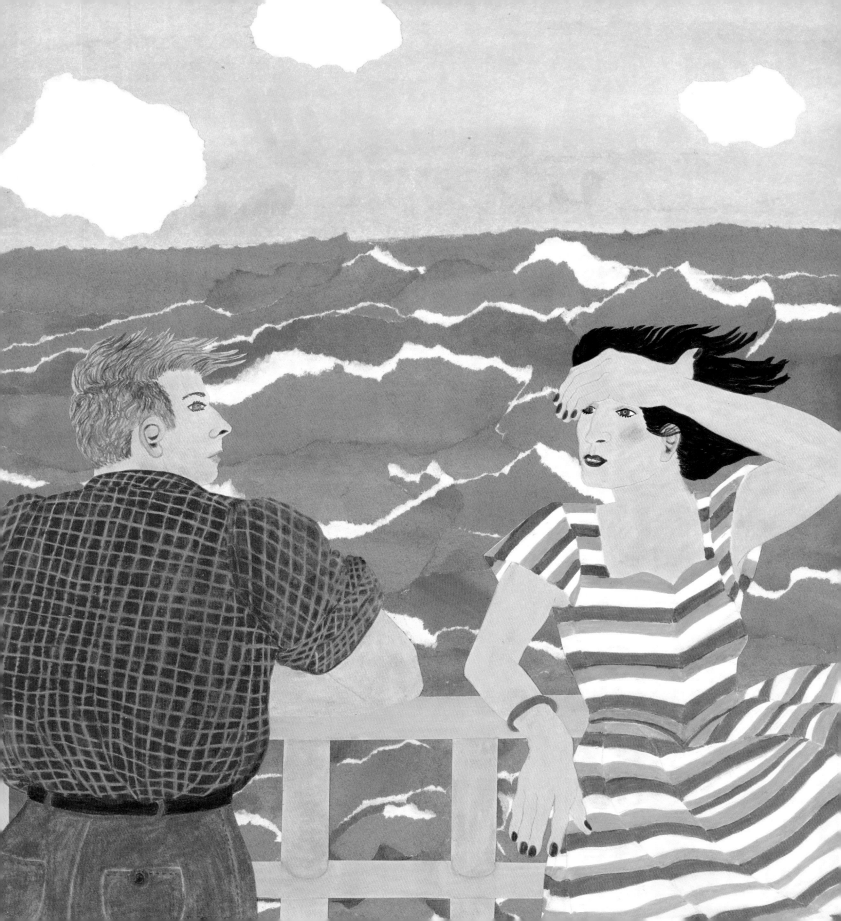

Itinerant artist Joseph H. "Pine Hill Joe" Davis of Maine worked in rural New England in the early 1830s, making more than 160 watercolor portraits. An elaborately penned inscription along the bottom of this scene answers the journalistic "who, what, where, and when?" These worthy citizens of Great Falls, New Hampshire, are Daniel Otis, age forty-six; Betsy Otis, forty; and Polly Otis, seven months old. He reads the Otis-owned *Great Falls Journal*, she has their baby in her lap. A fancy wall clock and richly carpeted or painted floor proclaim the family's prosperity.

David Pixler, born in 1808, is credited with this portrait of his talented Mennonite family, who lived in Fivepointville, in Lancaster County, Pennsylvania. He was a painter and stonecutter who also practiced an elaborate form of illuminated calligraphy called Fraktur, a Pennsylvania Dutch folk art used to make important documents. David, his elder brother, Absalom, and the youngest brother, Levi, are portrayed beneath bust-length profile portraits on a wall of their parents, Abraham and Eve, both born in 1782. The taller Absalom is shown in grownup attire and holding a book, while his brothers, in children's clothing, hold their pets, a bird and a rabbit.

∧ **JOSEPH H. DAVIS**
Mr. and Mrs. Daniel Otis and Child, 1834
Watercolor, gum arabic, and graphite on off-white wove paper;
10¾ × 16⅝ in. (27.3 × 42.2 cm)

> **THE ABRAHAM PIXLER FAMILY**
American, early 19th century
Watercolor, pen and iron gall ink, and gouache on off-white laid paper;
10 × 8 in. (25.4 × 20.3 cm)

Ab.^m Pixler
born Jun 17, 1782

Eve Breadestone
born April 15, 1782

Married Jun
the 14th —1801

Son Absalom
born Mar 24, 1802,

Son David born
January 5 1808.

Son Levi born
May 14, 1810.

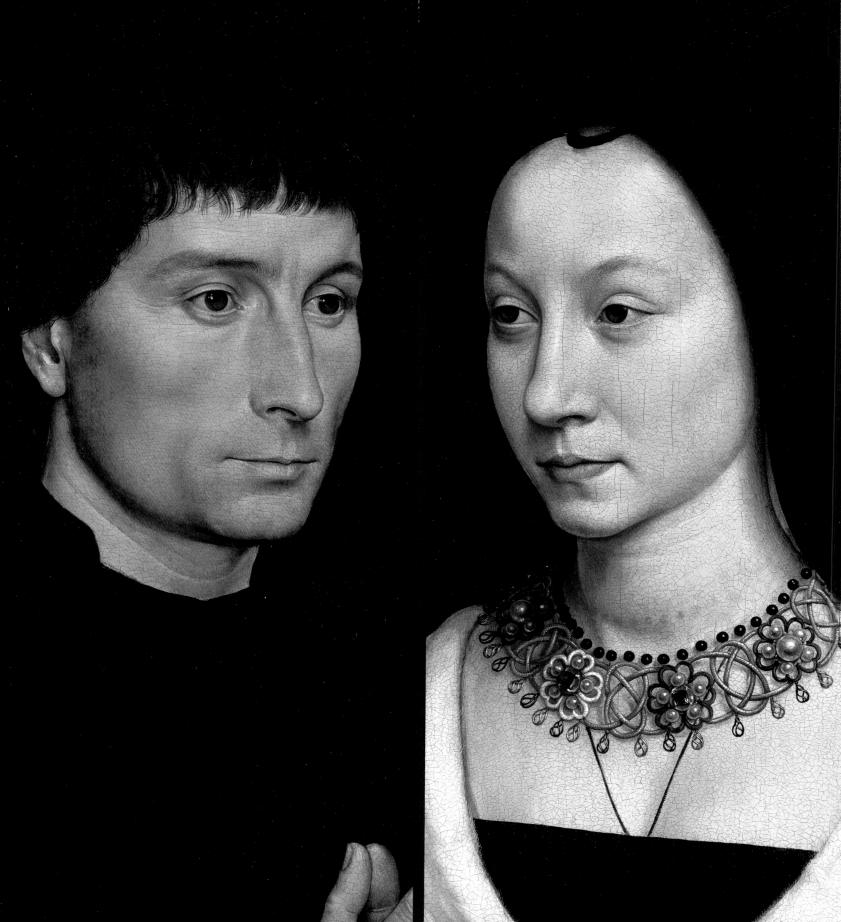

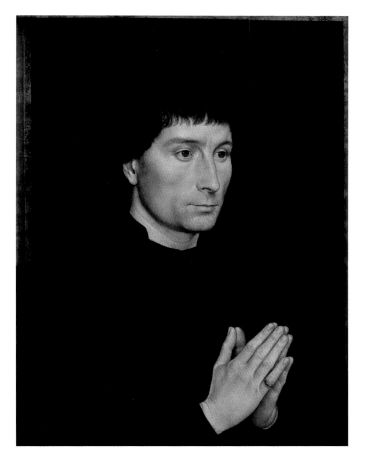
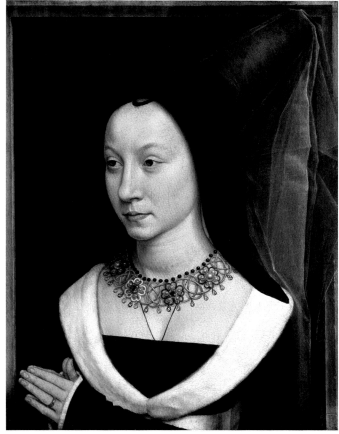

The extraordinary realism of Flemish portraits must have made them seem to have almost magical powers, linking patron and divinity eternally. Members of the Florentine Portinari family were especially impressed by the Flemish painters, whom they repeatedly patronized. Tommaso, who managed the Bruges branch of the Medici bank, was about forty-two when he commemorated his marriage to the fourteen-year-old Maria Baroncelli, also from a prominent banking clan, by commissioning from Hans Memling a portable triptych that featured portraits of himself and his bride flanking an image of the Virgin and Child, now lost.

Tommaso lent heavily to the warlike dukes of Burgundy, but lost all when Charles the Bold, deeply in debt, was slain at the battle of Nancy in January 1477. The Medici had to make good on the loss, and they severed their connection with Tommaso, who spent the rest of his life trying to recover his fortune. Tommaso's faith in Memling was rewarded, however, by the precision, unsurpassed in the artist's oeuvre, with which his likeness is preserved — even an apparent scar on his chin is recorded — together with that of his young bride, her graceful features enhanced by an enameled gold necklace set with glittering stones and lustrous pearls.

HANS MEMLING
*Tommaso di Folco Portinari (1428–1501); and Maria Portinari
(Maria Maddalena Baroncelli, b. 1456),* probably 1470
Oil on wood; each approx. 16⅝ × 12½ in. (42.2 × 31.8 cm)

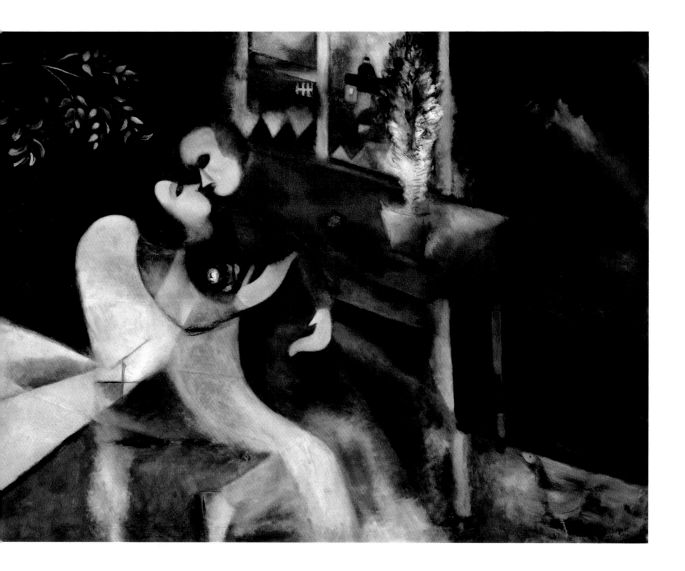

Painted almost at the same moment, these pictures share similar, simplified figural vocabularies but offer a striking contrast in their depictions of romance. Lovers were a favorite theme of Marc Chagall's; being in love for some reason makes his couples seem to levitate. Living in Paris when he painted this fauvist nocturne, the twenty-six-year-old Chagall was still invigorated by memories of the folk art of his native Russia. The fiery sky, seen through the window, and the blushing table beside the lovers reflect the heat of their passion.

While Chagall's hero seems to gently cup the belly of his beloved, the hand of Guy Pène du Bois's "monster" seems ready to cuff his "doll." As a painter, Pène du Bois focused on the beau monde, the social stratum preoccupied by status, money, and fashion, which he knew well both in New York and abroad. More sympathetic to its female than its male denizens, he portrayed fashionable women with great sensitivity — and careful attention to their clothes: the dress of the threatened young woman is the visual focus of the picture, as is the blue dress of Chagall's heroine in his painting.

∧ **MARC CHAGALL**
The Lovers, 1913–14
Oil on canvas; 43 × 53 in. (109.2 × 134.6 cm)

> **GUY PÈNE DU BOIS**
The Doll and the Monster, 1914
Oil on wood; 20 × 15 in. (50.8 × 38.1 cm)

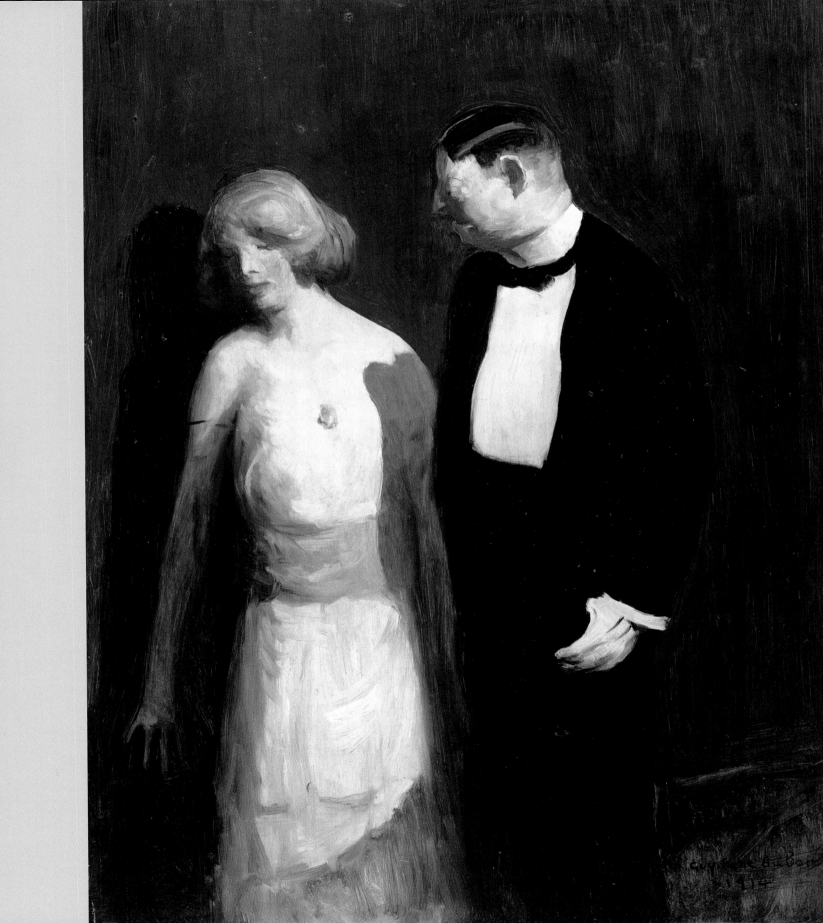

Despite their modest size, these mid-18th-century porcelain figurines capture the movement and passion of real-life actors in the commedia dell'arte, a lively, improvisatory comic theater that originated in Italy in the 16th century and was popular in France until the end of the 17th century. Its beloved characters lived on in the visual arts, especially in paintings and porcelains. Harlequin, always up to naughty tricks, and his beloved Columbine are posed whirling in their dance of pursuit. The work of master modeler Bustelli, these figures and fourteen others in his series of commedia dell'arte characters would have been placed on a banquet table, as if dancing their way up and down the festive board. ❧ In his characteristically flattened, sophisticated style, Nadelman captures the essence of paired motion, not unlike the way Alexander Calder handles figures in the same period. In the formal *Dancing Couple*, the man and woman face the viewer, their figures reminiscent of the American folk art that the artist passionately collected.

∧ **FRANZ ANTON BUSTELLI**
Harlequin and Columbine, Nymphenburg Porcelain Manufactory, ca. 1760
Hard-paste porcelain; ht. (respectively): 7⅞ in. and 8 in. (20 cm and 20.3 cm)

> **ELIE NADELMAN**
Dancing Couple, 1917–18
Ink and wash on paper; 9⅞ × 8 in. (25.1 × 20.3 cm)

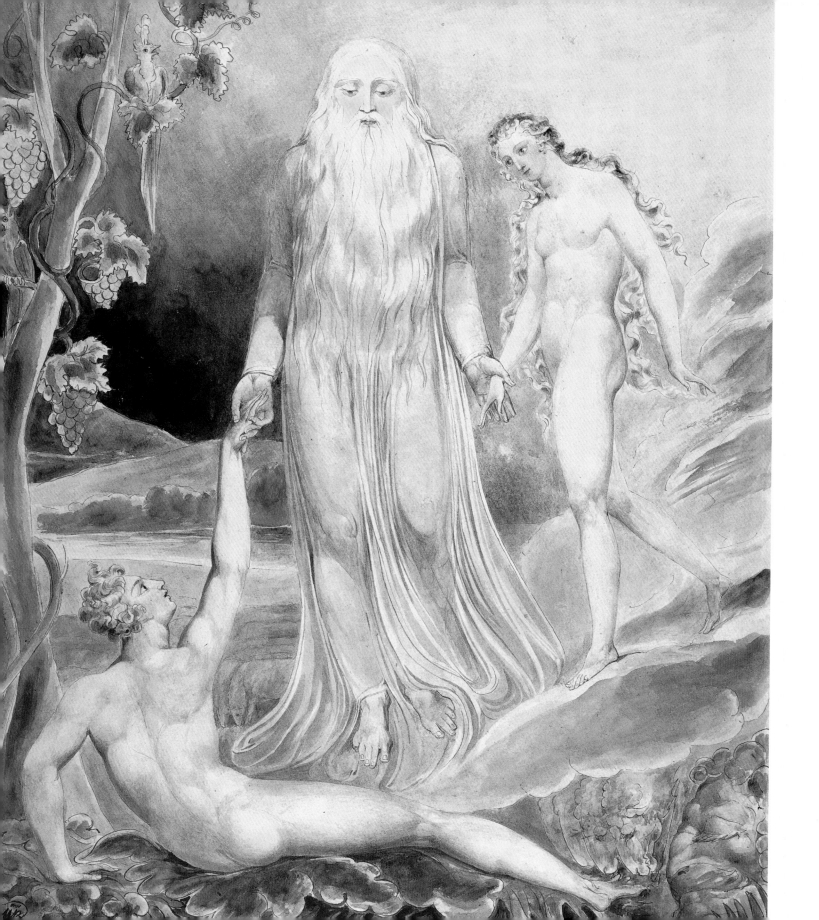

As a visionary poet and graphic artist, William Blake needed to "rewrite" the Bible in pictorial terms. Inspired by the radicalism of the recent French and American revolutions, along with the new science, philosophy, and theology of Isaac Newton, John Locke, and Emanuel Swedenborg, Blake evolved his own eccentric revision of Genesis. Here, God, or the "Angel of the Divine Presence," may have handed Adam the forbidden apple. Rather than rising from Adam's rib, Eve (lacking a navel) has just alighted on the right. Holding her wrist, the Angel appears about to perform a ritual marriage. Worked in watercolor over pen and graphite, the page shows the English mystic's passion for Michelangelo and the Mannerist schools of the early 16th century. ✿ For Blake, a divine presence is needed to bring the first couple together; in Paul Klee's satiric vision, the creative figure is Adam himself — standing in for the artist? — who brings Eve out from within him. His Little Eve, *Evchen*, is perhaps a comment on Eve's secondary status in relation to Adam. Still attached to Adam's rib, she is like a schoolgirl, her flaxen hair tied in a braid, while Adam is a grown man with earrings and a mustache. Their flat, rigid forms and the curtain behind them evoke a puppet-theater stage, as if the grand biblical vision that inspired Blake had become mere entertainment for children.

< **WILLIAM BLAKE**
Angel of the Divine Presence Bringing Eve to Adam, ca. 1803
Watercolor, pen, and black ink over graphite; 16⅜ × 13 1/16 in. (41.6 × 33.2 cm)

∧ **PAUL KLEE**
Adam and Little Eve, 1921
Watercolor and transferred printing ink on paper; 12⅜ × 8⅝ in. (31.4 × 21.9 cm)

T oday's painters are seldom thought of as playwrights, casting directors, or stage managers, but Degas sometimes reveled in all three roles, as in *Sulking*. Here, he seated his friend and advocate Edmond Duranty, the novelist and critic, at an office desk on which a professional model, Emma Dobigny, leans. They are of uncertain relationship. Hanging behind them is Degas's careful copy of a color lithograph after J. F. Herring's *Steeplechase*. Degas, who loved horses, used this lithograph as a source for several of his artworks. The couple's placement against this image — she looking up and out, he down at his papers — could convey the painter's plot line, as a steeplechase is the most arduous and rigorously competitive of all races, with its many jumps and pitfalls. Is Degas implying that relationships are fraught with hazards and uncertainties?

EDGAR DEGAS
Sulking, ca. 1870
Oil on canvas; 12¾ × 18¼ in. (32.4 × 46.4 cm)

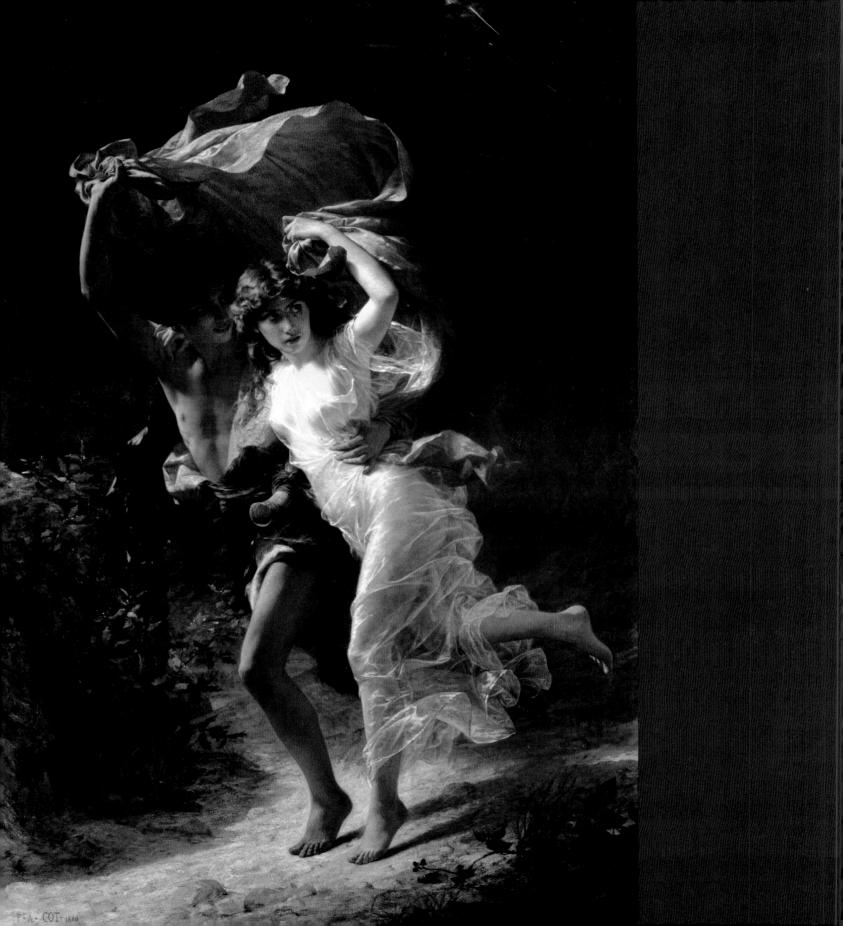

Both reassuringly conventional and mildly titillating, Pierre-Auguste Cot's neo-Rococo melodrama may be loosely based on Bernardin de Saint-Pierre's Romantic classic *Paul et Virginie* (1788), about an innocent young couple, friends from birth, who fall in love on the paradisiacal island of Mauritius and meet a tragic end. A passage in that story has Virginie sheltering herself and Paul beneath her overskirt, which they have pulled up over their heads as an impromptu umbrella; Cot devotes his attention to her lovingly rendered, diaphanous undergarment. The artist produced few anecdotal scenes in a brief career taken up mainly by portraits, but they ensured his lasting popularity.

Inspired by Serge Diaghilev's sensational Ballets Russes of the early 20th century — and, one may suppose, by Cot's well-known painting — Malvina Hoffman depicted two of ballet's most famous dancers, Anna Pavlova and Mikhail Mordkin, stripping the Russians of their clothes to restore the freedom enjoyed by the ancient followers of Bacchus. Dancers were the subjects of the sculptures that brought Hoffman, a pupil of Rodin's, her earliest recognition, and they remained at the center of her work throughout her career.

< **PIERRE-AUGUSTE COT**
The Storm, 1880
Oil on canvas; 92¼ × 61¾ in. (234.3 × 156.8 cm)

∧ **MALVINA CORNELL HOFFMAN**
Bacchanale Russe, 1912
Bronze; 14 × 9 × 9 in. (35.6 × 22.9 × 22.9 cm)

Bisschop's lively depiction of an amorous exchange between a possible prostitute — the red dress is indicative of her calling — and a cavalier may, in fact, portray the artist and his wife. The paintings by Bisschop that are most comparable in style to this undated work, from the late 1650s and the 1660s, include a large self-portrait of 1668 (Dordrechts Museum) whose subject strongly resembles the young man in this canvas; and the young woman, who seems to be the same model Bisschop employed in a few works of the 1660s, may be Geertruyt Botland, whom he married.

Brassaï described the two young men leaning together in a quiet corner at the Bal de la Montagne Sainte-Geneviève, a dance hall in Paris's Latin Quarter that was popular with gay couples in the 1930s, as "dressed in a single suit: one was wearing the jacket, with his legs and buttocks naked; the other wore the pants, his torso and feet bare, since he had given his boyfriend the only pair of shoes." Brassaï explained, "There were no indiscreet onlookers . . . to make them uneasy. No threatening opprobrium from 'normal' men, no humiliating female disdain, no inquisitorial vice squad surveillance looking for outrages to public decency."

∧ **CORNELIS BISSCHOP**
A Young Woman and a Cavalier, probably early 1660s
Oil on canvas; 38½ × 34¾ in. (97.8 × 88.3 cm)

˃ **BRASSAÏ**
Young Couple Wearing a Two-in-One Suit at the
Bal de la Montagne Sainte-Geneviève, ca. 1931
Gelatin silver print; 9⅛ × 6¼ in. (23.2 × 15.9 cm)

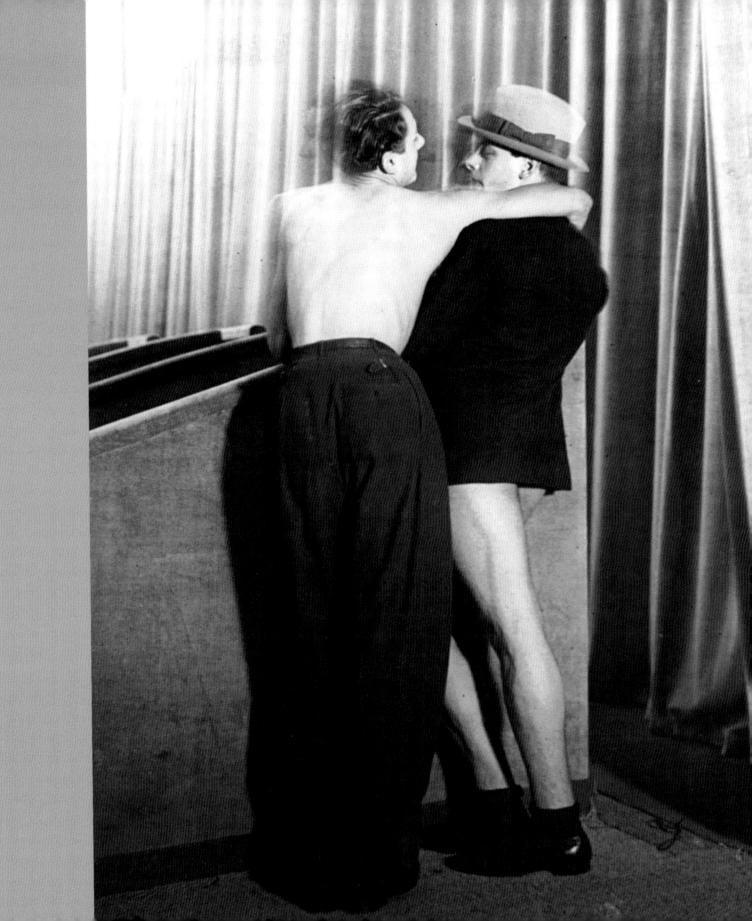

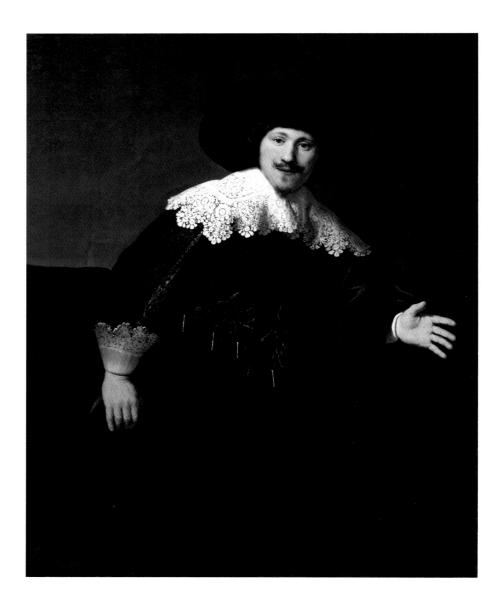

Elegance and spontaneity were seldom hallmarks of Rembrandt's double portraits, which often display an almost Puritan sobriety and a heavy, forbiddingly dark impasto. Among the exceptions to this rule is a brilliant pair of anonymous aristocratic likenesses seen in three-quarter length (and thus known as "knee pieces"), now divided between the Metropolitan Museum of Art, New York, and the Taft Museum of Art in Cincinnati. This is an unusually sad "divorce," since their painter planned the couple to be seen in convincingly animated interaction, with the husband appearing to rise from his chair, perhaps as you enter the room, to introduce his splendidly dressed wife, seated close by. As with so many of Rembrandt's grandest works, this pair's freedom and authority point to his response to Venetian art, to the brushwork of Tintoretto and the audacious freedom of Titian. Rembrandt had arrived in Amsterdam in the winter of 1631–32, and paintings like these quickly made him the city's most original and successful portraitist.

⌃ **REMBRANDT**
Portrait of a Man Rising from His Chair, 1633
Oil on canvas; 48⅞ × 38¾ in. (124.1 × 98.4 cm)
Taft Museum of Art, Cincinnati. Bequest of Charles Phelps
and Anna Sinton Taft (1931.409)

> **REMBRANDT**
Portrait of a Young Woman with a Fan, 1633
Oil on canvas; 49½ × 39¾ in. (125.7 × 101 cm)

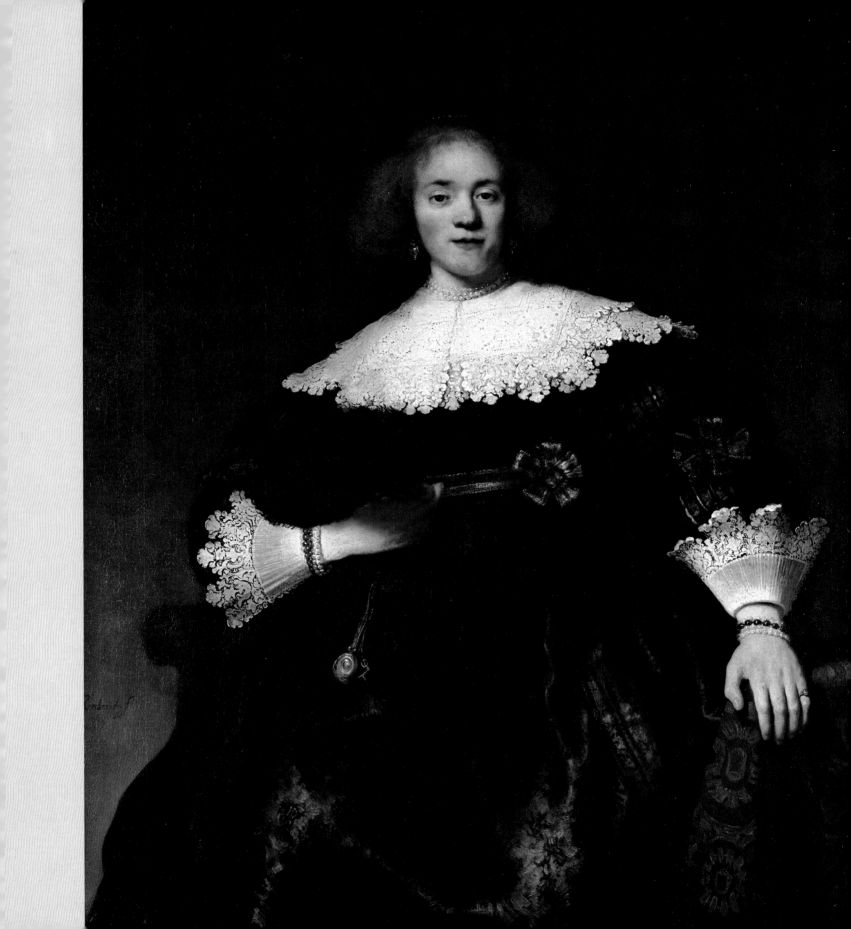

In the late Middle Ages, stained-glass roundels often decorated the windows of affluent burghers' houses in northwestern Europe. This one shows young people playing a game, balance quintain, which had its origin in a tilting exercise for training knights. The man balances on one foot and raises the other to meet the foot of the seated maiden. She will try to make him tumble. By the 15th century, this form of quintain was often played as a courting game. The man points at the sheep in the foreground, over which the couple's legs and footwear create an impromptu roof, and at the maiden as if to say, there will be you and I. A dog, emblem of her fidelity, echoes her rapt attention, and the rooted tree symbolizes the stability that they as a couple will attain.

The official art of the Soviet Union, Socialist Realism was an academic style whose imagery idealized the everyday life of the proletariat and glorified the dictator Joseph Stalin. The artists Vitaly Komar and Aleksandr Melamid parodied the official style and its subjects to comment ironically on the propaganda of Communism. Expelled from the Moscow Union of Artists, they immigrated to Israel in 1977 and a year later moved to New York, where they continued to work together. Painted long after Stalin's death, this canvas belongs to their series *Nostalgic Socialist Realism*. As the dictator looks down from his portrait on the wall and a curtain billows inward with a haunting gust of wind, a couple playing the traditional game blindman's buff seems suddenly aware of a ghostly presence.

140 ∧ **ROUNDEL WITH PLAYING AT QUINTAIN**
French (Paris?), ca. 1500
Colorless glass, vitreous paint, and silver stain; diam. 8 in. (20.3 cm)

＞ **KOMAR & MELAMID**
Blindman's Buff, 1982–83
Oil on canvas; 72 × 47 in. (182.9 × 119.4 cm)

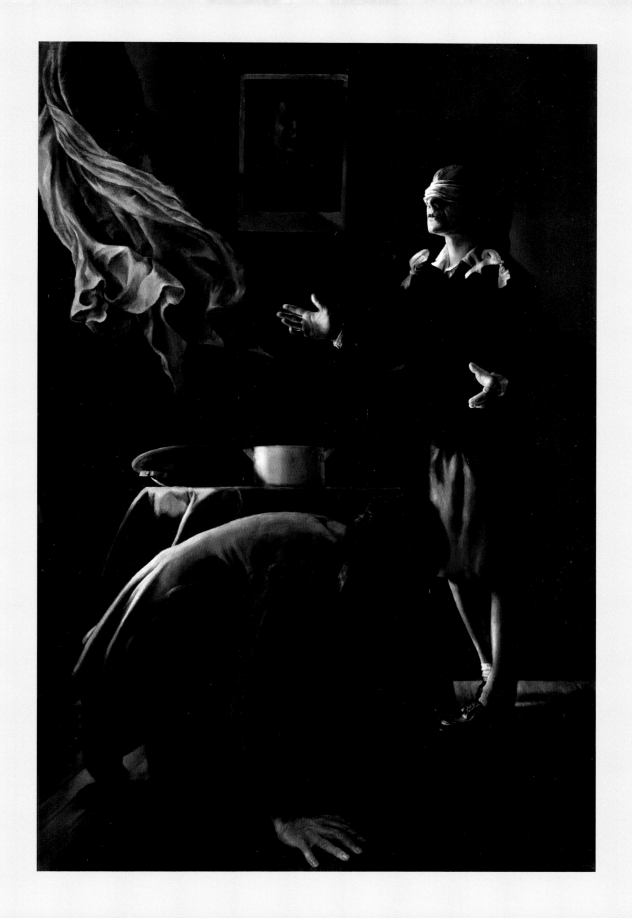

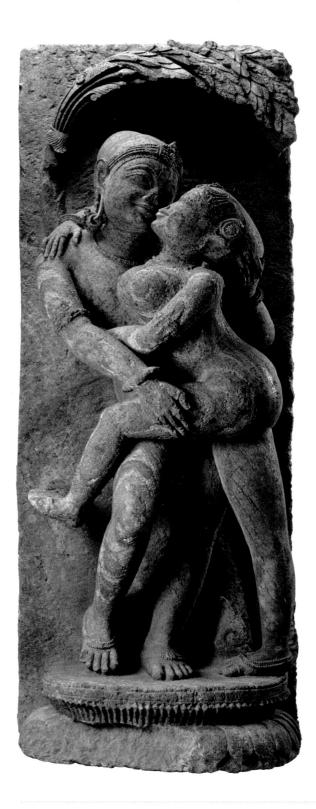

Loving couples (*mithunas*), representing sexual union in a ritual context, often decorated the exteriors of Hindu temples to complement iconic representations of the god or related deities residing within. The full-bodied figures of this bejeweled couple are characteristic of architectural sculptures produced in 13th-century Orissa, a region in northeast India noted for its temples, which often feature figures in astonishingly acrobatic and erotic poses. Couples such as this pair are understood to have multiple meanings, ranging from an obvious celebration of life's pleasures to the more metaphorical symbolism of a human soul's longing for union with the divine. ❧ William Zorach met his wife, the well-off Californian and fellow art student Marguerite Thompson, while living in Paris, where he was much impressed by the bold line and forceful color of the French Fauves. Two years after returning to New York, he envisioned Central Park, one of his favorite places to sketch, as a new Eden for the couple. In the Zorachs' lengthy correspondence they wrote how they would "bloom in loveliness together," and this canvas actually presents the work of both, his *Spring in Central Park* on one side and her *Three Women in the Mountains*, added six year later, on the reverse side.

∧ **LOVING COUPLE (MITHUNA)**
India, Orissa; 13th century
Ferruginous stone; ht. 72 in. (182.9 cm)

〉 **WILLIAM ZORACH**
Spring in Central Park, 1914
Oil on canvas; 46 × 36 in. (116.8 × 91.4 cm)

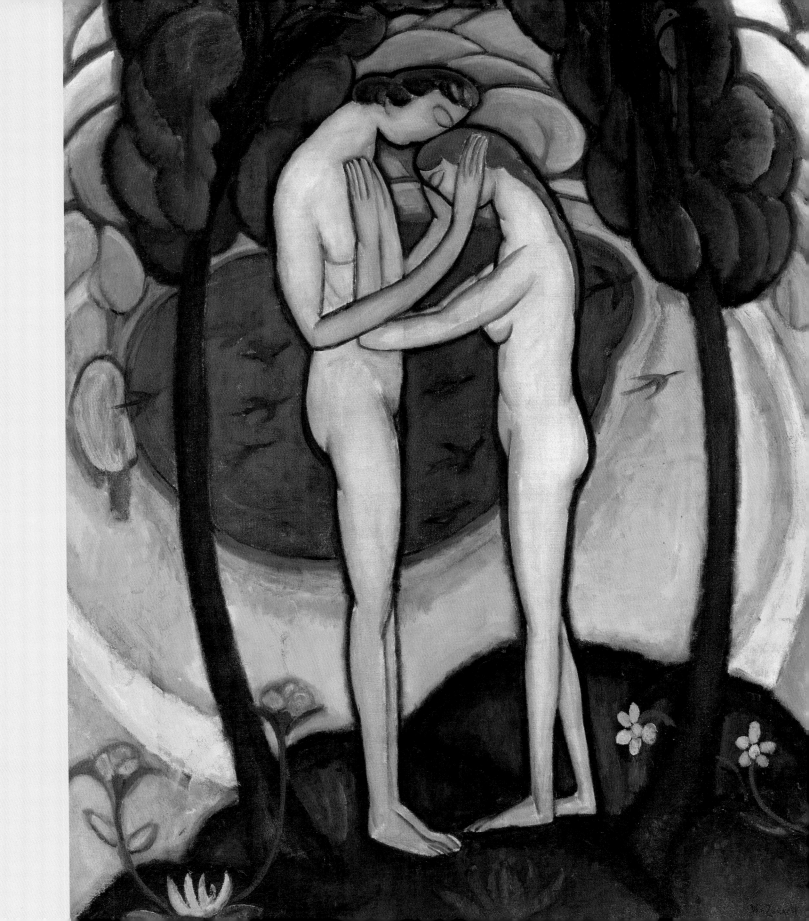

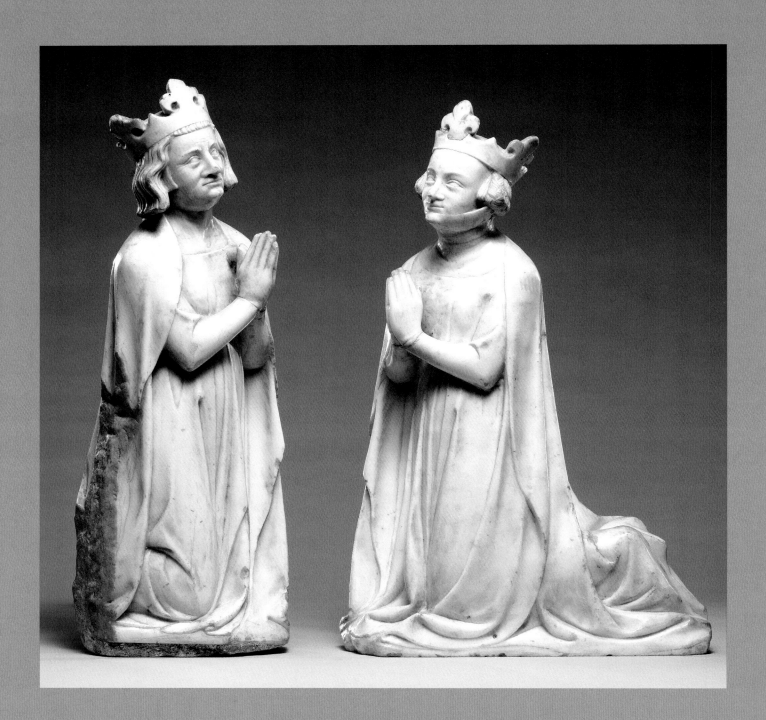

Comparison of these intense, realistic statuettes with contemporary portraits suggests that they may represent Philip VI (reigned 1328–50), the first king of France from the house of Valois, and his first wife, Joan of Burgundy (called Joan the Lame), the powerful queen consort of France. She was regent while her husband led battles, at first successful, then increasingly desperate, against England's Edward III in the early years of the Hundred Years' War. These two are part of a group of donor figures that includes a prince, who may be one of their sons, John the Good or Philip of France. The group originally may have been placed within a sculpted retable.

Joan was called *la male royne boiteuse* ("the lame evil Queen") and considered the brains behind the throne. Her strong-willed rule earned her a bad reputation, which her deformity, thought by some to be a mark of evil, seemed to objectify. A scholarly woman, who supported translations of important works into the French vernacular, she died in the first wave of the black plague, in 1348. Her tomb, built by her grandson Charles V, was destroyed, like so much else redolent of the ancien régime, in the French Revolution, but these portable statuettes, perhaps saved by theft, survived.

KING AND QUEEN FROM A GROUP OF DONOR FIGURES
French, ca. 1350
Marble, traces of paint, and gilding; king: 15¾ × 5¹³/₁₆ × 3¹/₁₆ in.
(40 × 14.7 × 7.8 cm); queen: 15³/₁₆ × 10³/₁₆ × 3¹/₁₆ in. (38.6 × 25.8 × 8 cm)

I n a charming engraving by the German artist known as Master ES, lovers seated on a bench planted with grass and flowers appear to be surprised by the viewer, caught in the midst of an assault on the towers of the young lady's virtue. Each is flanked by attributes: a falcon perched on a glove beside him testifies to his prowess in hunting young birds; a dagger dangling suggestively between his legs reinforces the point. She is ineffectually pawing him away, like the puppy between them. With her slender form and a wreath of flowers braided in her hair, she is mimicked by her attribute, a small tree in a castellated pot, bespeaking her virginal character.
⁂ Dosso Dossi's literary affinity is attested by his friend Ariosto, who celebrates him in verses of *Orlando Furioso* as one of the great artists of the age. Among his finest surviving landscapes is a painting to be read. It appears to show the three ages of man, depicted as three couples: a boy and a girl peeping from behind a bush on the right, two lovers on the left unaware they are being spied upon, and two old men in the right background. The lovers are presented as though they were herders, with their flock of long-eared goats resting in the shadows. But they are dressed as fancy city folk (the rooftops of a town are just visible through the trees at right). The pastoral imagery of Giorgione and Titian is reflected in this work, as is the Venetians' enthusiasm for the ancient theme; Titian's painting on the same subject (National Gallery of Scotland, Edinburgh) is close in date to the Ferrarese painter's canvas.

146 ∧ **MASTER ES**
Pair of Lovers on a Grassy Bench, mid-15th century
Engraving; sheet 5¼ × 6½ in. (13.4 × 16.4 cm)

∨ **DOSSO DOSSI**
The Three Ages of Man, ca. 1515
Oil on canvas; 30½ × 44 in. (77.5 × 111.8 cm)

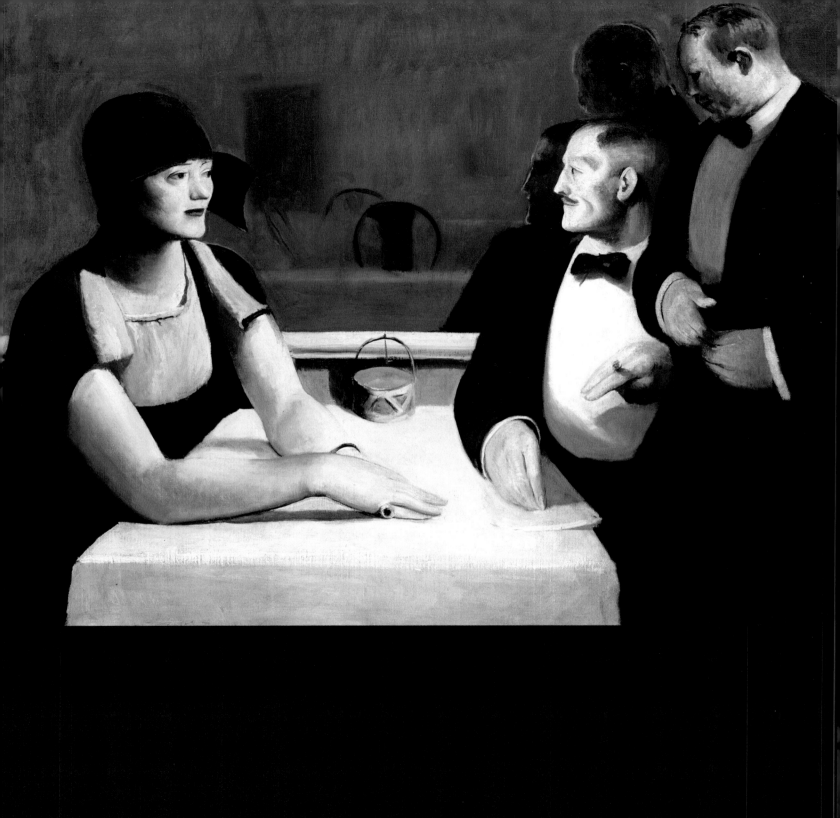

A self-made millionaire who began at fifteen as a Wall Street runner, Chester Dale became a utilities tycoon. Opposite is Maud, the grand-mannered daughter of an art critic, who divorced her first husband, a poor painter, to marry Chester and brought him a lifestyle teeming with the glamour of the avant-garde. He gave up previous hobbies like boxing and chasing fire engines to pursue modern masterpieces. The couple's collection of some seven hundred, mostly French, 18th-to-20th-century paintings went to the National Gallery in Washington, D.C. Living at the Plaza Hotel, the Dales either ordered room service or dined out, thus providing a title for this incisive portrait by Guy Pène du Bois. ⁂ Robert Blackburn grew up in Harlem and attended the well-known DeWitt Clinton High School in the Bronx and the Art Students League in Manhattan. He acquired a lithographic press in the 1940s and set up his own studio, called the Printmaking Workshop, becoming known as a master printmaker. In this early lithograph a grim-faced, middle-aged man in a stovepipe hat, resembling Abraham Lincoln, sits in café with a downcast, young African-American woman, as if the ghost of the president had returned to share her straitened circumstances.

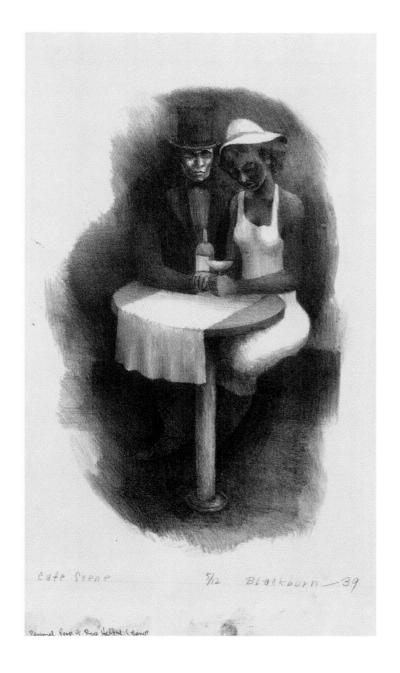

< **GUY PÈNE DU BOIS**
Mr. and Mrs. Chester Dale Dine Out, 1924
Oil on canvas; 30 × 40 in. (76.2 × 100.6 cm)

∧ **ROBERT BLACKBURN**
Café Scene, 1939
Lithograph; 13½ × 8⅜ in. (34.3 × 21.3 cm)

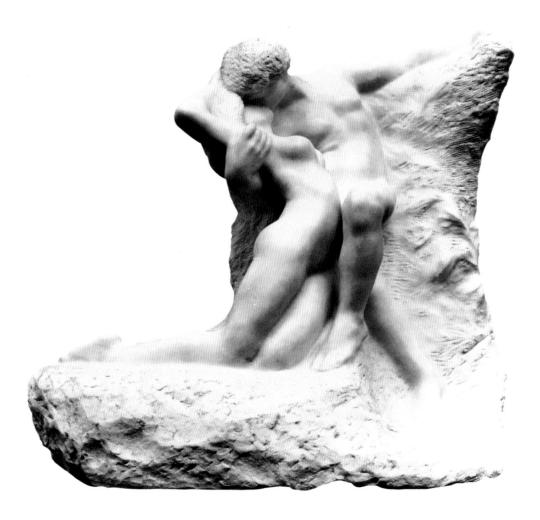

Exuding boundless ego and reveling in a self-styled quasi-divinity, Rodin lorded over his magnificent state-funded Parisian residence and studio. More satyr than saint, he preached a gospel of the sanctity of ecstasy, of the Body Beautiful — a Beat poet in plaster almost a century ahead of his day. Surprisingly, the sculptor's intertwined nudes, often frankly erotic, escaped criticism — let alone censorship — at a time when even piano legs were covered. The torso of a model named Adèle Abruzzezzi, recognizable in this group, was used repeatedly by Rodin in other works, such as *The Gates of Hell*. No guilt or impending punishment is suggested by the popular *Eternal Spring*, however, which Rodin reproduced often in marble and bronze.

Born and trained as a painter in Breslau, John Gutmann saw his photographs published in international magazines before fleeing Germany in 1933. He settled in San Francisco, and by the late 1930s his work appeared in major American magazines, including *Life* and *Time*. Gutmann later said, "I was in Paradise," stalking through the exotic city, capturing images through his waist-high Rolleiflex with the detachment of an anthropologist studying an undiscovered culture. Here he brings us into intimate contact with two young women, with a thrilling contrast of dark hair and white skin, gleaming white blouse and dark dress. Their features merge in a found-Cubist moment, as the face of the woman on the left is pressed into a crescent by her partner's powerful kiss.

150 **∧ AUGUSTE RODIN**
Eternal Spring, 1907
Marble; 28 × 29 × 18 in. (71.1 × 73.7 × 45.7 cm)

> JOHN GUTMANN
Two Women in Love, 1937
Gelatin silver print; 7¹¹⁄₁₆ × 7¹³⁄₁₆ in. (19.6 × 19.8 cm)

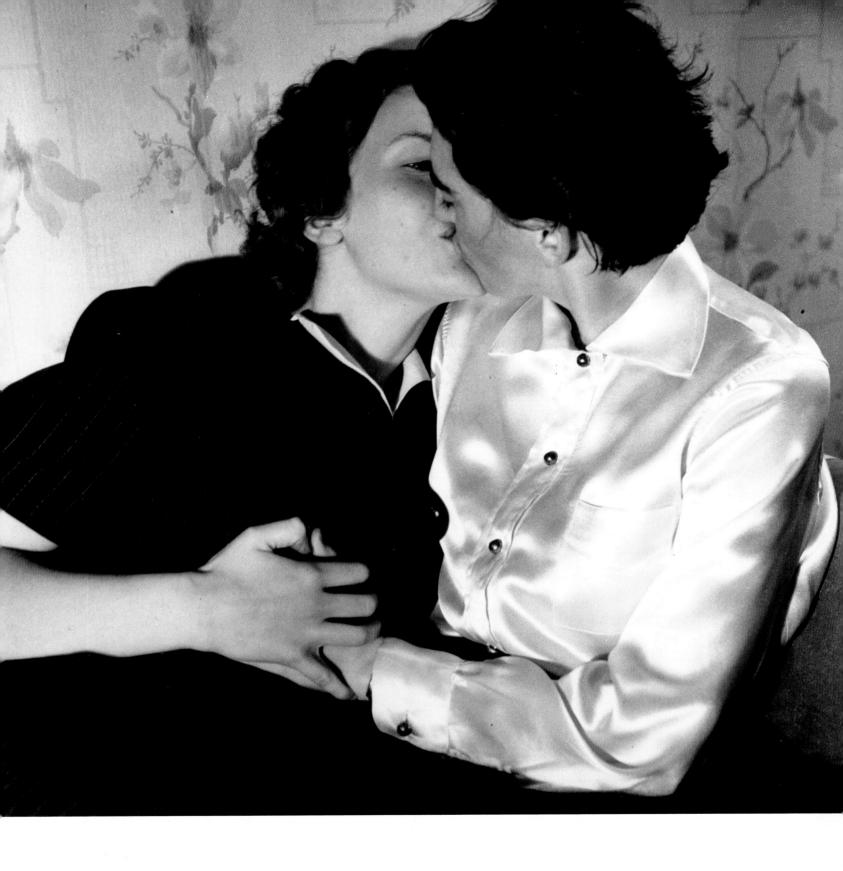

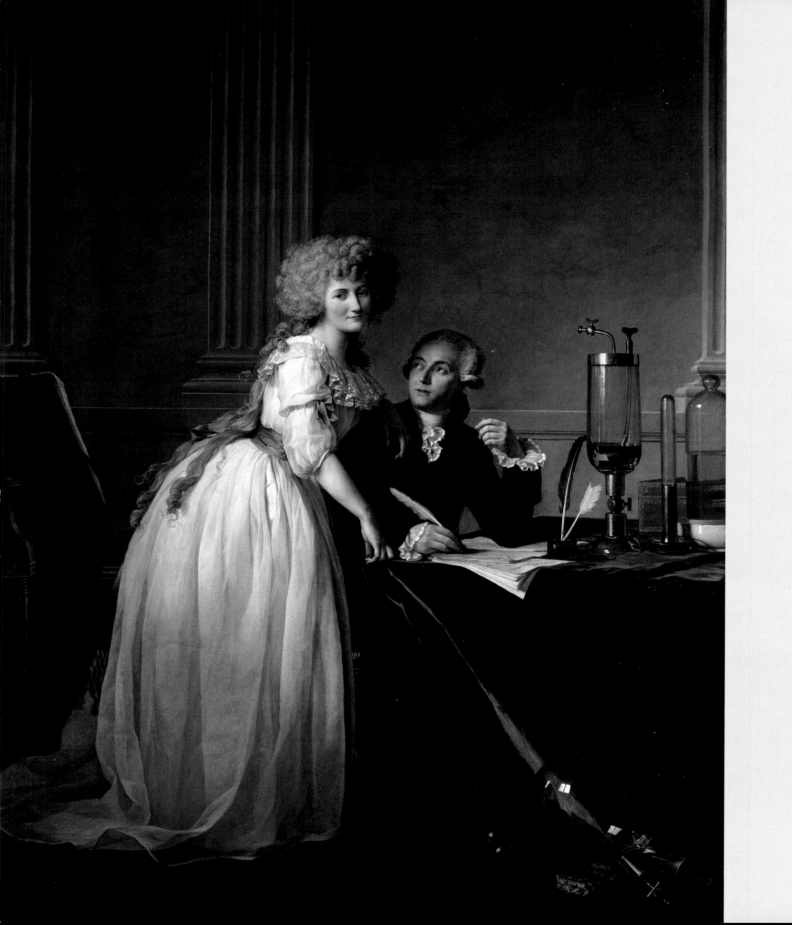

Seldom romantic, and with a twin heritage of antiquity and the Enlightenment, Jacques-Louis David could be a chilly perfectionist, whether working for the aristocracy or the French Revolution. His grandest, most fully realized double portrait — and one of the greatest 18th-century portraits — is of France's leading scientist, Antoine-Laurent Lavoisier, and his wife, Marie-Anne-Pierrette Paulze. The huge canvas testifies to a pioneering modern marriage, partnering love and knowledge, intimacy and joint promotion. Marie-Anne stands behind Lavoisier as if to sustain, protect, and inspire him. Possibly David's student, she recorded Lavoisier's discoveries in skilled drawings, which may be in the portfolio seen at the far left. As pageant master to the revolution, David sketched his patroness Marie Antoinette being trundled to the guillotine in 1793. Lavoisier met the same fate in the following year, when he was branded a traitor during the Reign of Terror. ❧ Nearly thirty years after Richard Hamilton found a discarded photograph of a Japanese couple in Hamburg, he rephotographed and then much enlarged it, making this print using the ink-jet (Iris) process. The artist, who often employs found photos in his work, uses various reproductive techniques in order to distill the iconic or essential from an image. Here a wedding picture, possibly made in the 1920s, shows the standing groom in Western garb and the seated bride in a traditional wedding kimono and headdress. For Hamilton, it captured qualities like those he has said he admires in Jan van Eyck's famous Arnolfini portrait: "It is an epiphany, a crystallization of thought that gives us an instant awareness of life's meaning."

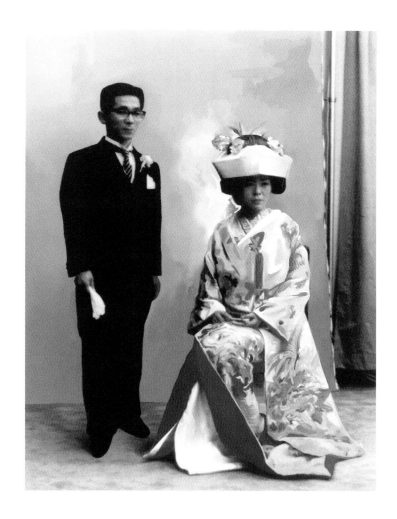

< **JACQUES-LOUIS DAVID**
*Antoine-Laurent Lavoisier (1745–1794) and His Wife
(Marie-Anne-Pierrette Paulze, 1758–1836), 1788*
Oil on canvas; 102½ × 76⅝ in. (259.7 × 194.6 cm)

∧ **RICHARD HAMILTON**
The Marriage, 1998
Ink jet (Iris) print; 35¼ × 26½ in. (89.5 × 67.3 cm)

CHECKLIST

All works are from The Metropolitan Museum of Art (with the exception of Rembrandt, *Portrait of a Man Rising from His Chair*, p. 138)

Giuliano di Piero di Simone Bugiardini (Italian, Florence 1475–1554 Florence). *Adam and Eve.* Oil on canvas; each 26⅜ x 61¾ in. (67 x 156.8 cm). Bequest of Edward Fowles, 1971 (1971.115.3a, b)
pp. 6, 7

Augustus Saint-Gaudens (American, Dublin 1848–1907 Cornish, New Hampshire). *Hannah Rohr Tuffs*, 1872. Shell; 2 x 1½ in. (5.1 x 3.8 cm). Purchase, Sheila W. and Richard J. Schwartz Gift and Morris K. Jesup Fund, 1990 (1990.78.2b)
p. 8

Augustus Saint-Gaudens (American, Dublin 1848–1907 Cornish, New Hampshire). *John Tuffs*, ca. 1861. Shell; 1¾ x 1½ in. (4.5 x 3.8 cm). Purchase, Sheila W. and Richard J. Schwartz Gift and Morris K. Jesup Fund, 1990 (1990.78.1a)
p. 9

Albrecht Dürer (German, Nuremberg 1471–1528 Nuremberg). *Adam and Eve*, 1504. Engraving; fourth state; 10³⁄₁₆ x 8¹⁄₁₆ in. (25.9 x 20.4 cm). Fletcher Fund, 1919 (19.73.1)
p. 10

Frank Eugene (American, New York City 1865–1936 Munich). *Adam and Eve*, 1900s, printed 1909. Photogravure; 7 x 5¹⁄₁₆ in. (17.8 x 12.8 cm). Rogers Fund, 1972 (1972.633.33)
p. 11

Titian (Tiziano Vecellio) (Italian, Pieve di Cadore ca. 1485/90?–1576 Venice). *Venus and Adonis*, ca. 1570. Oil on canvas; 42 x 52½ in. (106.7 x 133.4 cm). The Jules Bache Collection, 1949 (49.7.16)
p. 12

Paolo Veronese (Paolo Caliari) (Italian, Venetian, 1528–1588). *Mars and Venus United by Love*, 1570s. Oil on canvas; 81 x 63⅜ in. (205.7 x 161 cm). John Stewart Kennedy Fund, 1910 (10.189)
p. 13

Frans Hals (Dutch, Antwerp 1582/83–1666 Haarlem). *Petrus Scriverius (1576–1660)*, 1626. Oil on wood; 8¾ x 6½ in. (22.2 x 16.5 cm). H. O. Havemeyer Collection, Bequest of Mrs. H. O. Havemeyer, 1929 (29.100.8)
p. 14

Frans Hals (Dutch, Antwerp 1582/83–1666 Haarlem). *Anna van der Aar (born 1576/77, died after 1626)*, 1626. Oil on wood; 8¾ x 6½ in. (22.2 x 16.5 cm). H. O. Havemeyer Collection, Bequest of Mrs. H. O. Havemeyer, 1929 (29.100.9)
p. 15

Carved amber bow of a fibula (safety pin). Etruscan, Archaic or Classical; ca. 500 BC. Amber; l. 5½ in. (14 cm). Gift of J. Pierpont Morgan, 1917 (17.190.2067)
p. 16

Folio from *Kalila wa Dimna*. Egyptian or Syrian, 18th century. Opaque watercolor, ink, and gold on paper; 12½ x 8⅞ in. (31.8 x 22.6 cm). The Alice and Nasli Heeramaneck Collection, Gift of Alice Heeramaneck, 1981 (1981.373.70)
p. 17

Baron Antoine-Jean Gros (French, Paris 1771–1835 Meudon). *A Man and a Woman Embracing*, n.d. Pen and brown ink with brown wash over black chalk; 7⅞ x 5½ in. (20 x 14 cm). Purchase, Gift of Mrs. Gardner Cassatt, by exchange, 1998 (1998.52)
p. 18

Attributed to the Kiss Painter. Fragment of a kylix (drinking cup). Greek, Attic, Archaic; ca. 510–500 BC. Terracotta; overall 6 x 4¹³⁄₁₆ in. (15.3 x 12.2 cm). Rogers Fund, 1907 (07.286.50)
p. 19

Peter Paul Rubens (Flemish, Siegen 1577–1640 Antwerp). *The Garden of Love* (left portion), 1630s. Pen, brown ink, gray-green wash over traces of black chalk, touched with indigo, green, yellowish, and white paint on paper; 18¼ x 27¾ in. (46.3 x 70.5 cm) (including added strips at left and right). Fletcher Fund, 1958 (58.96.1)
p. 20

Édouard Manet (French, Paris 1832–1883 Paris). *Fishing*, ca. 1862–63. Oil on canvas; 30¼ x 48½ in. (76.8 x 123.2 cm). Purchase, Mr. and Mrs. Richard J. Bernhard Gift, 1957 (57.10)
p. 21

Aquamanile with Aristotle ridden by Phyllis. South Netherlandish, late 14th century. Bronze; ht. 13¼ in. (33.7 cm). Robert Lehman Collection, 1975 (1975.1.1416)
p. 22

Plate with wife beating husband. Netherlandish, ca. 1480. Copper alloy, wrought; 3⅞ x 20¼ in. (9.8 x 51.5 cm). Gift of Irwin Untermyer, 1964 (64.101.1499)
p. 23

Erté (Romain de Tirtoff) (Russian, Petrograd 1892–1990 Paris). "Penelope": cover design for *Harper's Bazar*, March 1921. Gouache on cardboard; sheet 13¾ x 9¹⁵⁄₁₆ in. (34.9 x 25.3 cm). Gift of Jane Martin Ginsburg, President of the Martin Foundation, 1967 (67.762.89)
p. 24

Jean-Michel Folon (Belgian, Uccle 1934–2005 Monaco). *The Shadows*, 1980. Watercolor and graphite on paper; 11¼ x 8⅞ in. (28.5 x 22.5 cm). Gift of the artist, 1990 (1990.95.9)
p. 25

Albrecht Dürer (German, Nuremberg 1471–1528 Nuremberg). *The Promenade*, ca. 1498. Engraving; first state of two; sheet 7¹¹⁄₁₆ x 4¾ in. (19.5 x 12.1 cm) trimmed to plate line. Fletcher Fund, 1919 (19.73.106)
p. 26

William Powell Frith (British, 1819–1909). Study for the two central figures of *Derby Day*, 1860. Oil on canvas; 18 x 12½ in. (45.7 x 31.8 cm). Gift of Mrs. Charles Wrightsman, 2008 (2008.547.3)
p. 27

Attributed to Francesco Melzi (Italian, Milan 1491/93–ca. 1570 Vaprio d'Adda). *Two Grotesque Heads: Old Woman with an Elaborate Headdress and a Man with Large Ears*, 1491/93–1570. Pen and brown ink; 2⅛ x 3⅞ in. (5.4 x 9.9 cm). Gift of Mrs. Edward Fowles, in memory of Edward Fowles, 1975 (1975.96)
p. 28

Netsuke with Omori Hikoshichi. Japanese, 18th century. Ivory; ht. 6 in. (15.2 cm). Gift of Mrs. Russell Sage, 1910 (10.211.1502)
p. 29

Edward Penfield (American, 1866–1925). *HARPER'S AUGUST: TOM SAWYER DETECTIVE a new story by MARK TWAIN begins in this number*, 1896. Commercial lithography; gray, yellow, red, and black; 18⅝ x 13⅝ in. (47.3 x 34.6 cm). Leonard A. Lauder Collection of American Posters, Gift of Leonard A. Lauder, 1984 (1984.1202.91)
p. 30

D. J. Hall (American, born 1951). *Piece of Cake*, 1987. Colored pencil on paper; 30 x 39½ in. (76.2 x 100.3 cm). Gift of Karen and Les Weinstein, 1989 (1989.182)
p. 31

Miguel Rio Branco (Brazilian, born Spain, Las Palmas de Gran Canaria 1946). *Blue Tango*, 1984. Silver-dye bleach prints, suite of 9; 17⁵⁄₁₆ x 23⅝ in. (43.9 x 60 cm) each. Purchase, The Howard Gilman Foundation Gift, 1998 (1998.206a–i). Illustrated a, d, e, and h
pp. 32, 33

The Royal Acquaintances Memi and Sabu. Egyptian, probably Giza; ca. 2575–2465 BC. Limestone, paint; 24⁷⁄₁₆ x 9⅝ x 6 in. (62 x 24.5 x 15.2 cm). Rogers Fund, 1948 (48.111)
p. 34 (left)

Seated Couple. Dogon peoples, Mali; 18th–early 19th century. Wood, metal; 28¾ x 9⁵/₁₆ in. (73 x 23.7 cm). Gift of Lester Wunderman, 1977 (1977.394.15) p. 34 (right), detail p. 35

The Bridal Chamber of Herse, from a set of eight tapestries depicting the story of Mercury and Herse. Flemish, Brussels, ca. 1550. Design attributed to Giovanni Battista Lodi da Cremona (Italian, active 1540–52; After a print by Giovanni Jacopo Caraglio (Italian, Parma or Verona ca. 1500/1505–1565 Krakow[?]): *Marriage of Alexander & Roxana*, after Raphael; Border design attributed to Giovanni Francesco Penni (Italian, Florence ca. 1496–after 1528 Naples), from the set of the "Acts of the Apostles." Weaving workshop directed by Willem de Pannemaker, Brussels, active 1535–78. Wool, silk, silver, silver-gilt thread (20–22 warps per in., 8–9 per cm); overall 172 x 213 in. (436.9 x 541 cm). Bequest of George Blumenthal, 1941 (41.190.135) p. 36, detail p. 37

Jean-Auguste-Dominique Ingres (French, Montauban 1780–1867 Paris). *Madame Jacques-Louis Leblanc (née Françoise Poncelle, 1788–1839)*, 1823. Oil on canvas; 47 x 36½ in. (119.4 x 92.7 cm). Catharine Lorillard Wolfe Collection, Wolfe Fund, 1918 (19.77.2) p. 38

Jean-Auguste-Dominique Ingres (French, Montauban 1780–1867 Paris). *Jacques-Louis Leblanc (1774–1846)*, 1823. Oil on canvas; 47⅝ x 37⅝ in. (121 x 95.6 cm). Catharine Lorillard Wolfe Collection, Wolfe Fund, 1918 (19.77.1) p. 39

Master b x g (German?; active ca. 1470–1490). *The Lovers*, late 15th century. Engraving; 7⅛ x 6¼ in. (18 x 15.8 cm). Harris Brisbane Dick Fund, 1934 (34.38.6) p. 40

Young lovers embracing. Iranian, Qazvin; 16th century. Watercolor, opaque watercolor, ink, silver, and gold on paper; 14⁵/₁₆ x 9½ in. (36.4 x 24.1 cm); decorated leaf 8⁹/₁₆ x 5⅝ in. (21.8 x 14.3 cm); drawing 3¾ x 2³/₁₆ in. (9.5 x 5.5 cm). Purchase, Elizabeth S. Ettinghausen Gift, in memory of Richard Ettinghausen, 1990 (1990.51) p. 41

Jean-Léon Gérôme (French, Vésoul 1824–1904 Paris). *Pygmalion and Galatea*, ca. 1890. Oil on canvas; 35 x 27 in. (88.9 x 68.6 cm). Gift of Louis C. Raegner, 1927 (27.200) p. 42

Honoré Daumier (French, Marseilles 1808–1879 Valmondois). *Pygmalion*, 1842. Lithograph; overall 11¾ x 8⅝ in. (29.8 x 21.9 cm); image 9⅛ x 7½ in. (23.1 x 19.1 cm). Gift of Weston J. Naef in honor of Kathleen W. Naef, 1978 (1978.656.5) p. 43

Fra Filippo Lippi (Italian, Florence ca. 1406–1469 Spoleto). *Portrait of a Woman with a Man at a Casement*, ca. 1440. Tempera on wood; 25¼ x 16½ in. (64.1 x 41.9 cm). Marquand Collection, Gift of Henry G. Marquand, 1889 (89.15.19) p. 45, detail p. 2

Panel of Wilhelm von Weitingen. German, 1518. Pot-metal glass, white glass, vitreous paint, silver stain, and colored enamel; overall: 24 x 16½ in. (61 x 41.9 cm). Gift of John D. Rockefeller Jr., 1930 (30.113.5) p. 46 (left)

Panel of Barbara von Zimmern. German, 1518. Pot-metal glass, white glass, vitreous paint, silver stain, and colored enamel; overall: 24 x 16½ in. (61 x 41.9 cm). Gift of John D. Rockefeller Jr., 1930 (30.113.6) p. 46 (right), detail p. 47

Gilbert & George (Gilbert, British, born Italy, 1943; George, British, born 1942). *Here*, 1987. Mixed mediums; overall 119 x 139 in. (302.5 x 353.1 cm). Anonymous gift, 1991 (1991.210a–ii) pp. 48–49

Will Barnet (American, born 1911). *Kiesler and Wife*, 1963–65. Oil on canvas; 48 x 71½ in. (121.9 x 181.6 cm). Purchase, Roy R. and Marie S. Neuberger Foundation Inc. Gift and George A. Hearn Fund, 1966 (66.66) p. 51 (above)

Marble sarcophagus lid with reclining couple. Roman, Imperial, Severan; ca. 220 AD. Marble; l. 91 in. (231.1 cm). Purchase, Lila Acheson Wallace Gift, 1993 (1993.11.1) p. 51 (below), detail p. 50

Two young men. American (unknown artist), ca. 1850. Daguerreotype; image 4¼ x 3¼ in. (10.8 x 8.3 cm). Gift of Herbert Mitchell, 2001 (2001.714) p. 52

Riza ʿAbbasi (ca. 1565–1635). *Two Lovers*, AH 1039/AD 1630. Iranian, Isfahan. Opaque watercolor, ink, and gold on paper; painting 6⅞ x 4⅜ in. (17.5 x 11.1 cm); page 7½ x 4¹⁵/₁₆ in. (19.1 x 12.5 cm); mat 19¼ x 14¼ in. (48.9 x 36.2 cm). Purchase, Francis M. Weld Gift, 1950 (50.164) p. 53

Jacometto (Jacometto Veneziano) (Italian, active Venice by ca. 1472–died before 1498). *Alvise Contarini*(?) (recto); *A Tethered Heart* (verso), ca. 1485–95. Oil on wood; overall 4⅝ x 3⅜ in. (11.9 x 8.6 cm); recto, painted surface 4⅛ x 3⅛ in. (10.6 x 7.9 cm); verso, painted surface 4⅜ x 3⅛ in. (11 x 7.9 cm). Robert Lehman Collection, 1975 (1975.1.86) p. 54 (left)

Jacometto (Jacometto Veneziano) (Italian, active Venice by ca. 1472–died before 1498). *A Woman, Possibly a Nun of San Secondo* (recto); scene in grisaille (verso), last quarter of the 15th century. Oil on wood; overall 4 x 2⅞ in. (10.2 x 7.3 cm); recto and verso, painted surface 3¾ x 2½ in. (9.5 x 6.4 cm). Robert Lehman Collection, 1975 (1975.1.85) p. 54 (right), detail p. 55

Thomas Eakins (American, Philadelphia 1844–1916 Philadelphia). Thomas Eakins and John Laurie Wallace on a beach, ca. 1883. Platinum print; 10¹/₁₆ x 8¹/₁₆ in. (25.5 x 20.4 cm), irregular. David Hunter McAlpin Fund, 1943 (43.87.23) p. 56

John Singer Sargent (American, Florence 1856–1925 London). *Tommies Bathing*, 1918. Watercolor and graphite on white wove paper; 15⁵/₁₆ x 20¾ in. (38.9 x 52.7 cm). Gift of Mrs. Francis Ormond, 1950 (50.130.48) p. 57

Julia Margaret Cameron (English, born India, Calcutta 1815–1879 Kalutara, Ceylon). *The Parting of Lancelot and Guinevere*, 1874. Albumen silver print from glass negative; image 13¹/₁₆ x 11⁵/₁₆ in. (33.2 x 28.8 cm); mount 17⁵/₁₆ x 13⅛ in. (44 x 33.3 cm). David Hunter McAlpin Fund, 1952 (52.524.3.10) p. 59

Cecilia Beaux (American, 1855–1942). *Mr. and Mrs. Anson Phelps Stokes*, 1898(?). Oil on canvas; 72¹/₁₆ x 39⅞ in. (183 x 101.3 cm). Gift of the family of the Rev. and Mrs. Anson Phelps Stokes, 1965 (65.252) p. 60

John Singer Sargent (American, Florence 1856–1925 London). *Mr. and Mrs. I. N. Phelps Stokes*, 1897. Oil on canvas; 84¼ x 39¾ in. (214 x 101 cm). Bequest of Edith Minturn Phelps Stokes (Mrs. I. N.), 1938 (38.104) p. 61

Plate with a hunting scene from the tale of Bahram Gur and Azadeh. Iranian, ca. 5th century AD. Silver, mercury gilding; ht. 1⅝ in. (4.1 cm); diam. 7⅞ in. (20.1 cm). Purchase, Lila Acheson Wallace Gift, 1994 (1994.402) p. 62

Bowl with two scenes of Bahram Gur and Azadeh. Iranian, 12th–13th century AD. Stonepaste; polychrome in-glaze and overglaze painted and gilded on an opaque monochrome glaze (*mina'i*); ht. 3⁷/₁₆ in. (8.7 cm); diam. 8¹¹/₁₆ in. (22.1 cm). Purchase, Rogers Fund, and Gift of The Schiff Foundation, 1957 (57.36.2) p. 63

Goya (Francisco de Goya y Lucientes) (Spanish, Fuendetodos 1746–1828 Bordeaux). *The Swing*, page 21 from the *Madrid Album*, 1796–97. Brush, India ink, and gray wash on laid Netherlandish paper; 9⁵/₁₆ x 5¾ in. (23.7 x 14.61 cm). Harris Brisbane Dick Fund, 1935 (35.103.2) p. 64

Goya (Francisco de Goya y Lucientes) (Spanish, Fuendetodos 1746–1828 Bordeaux). *Lovers Sitting on a Rock*, 1796–97. Brush and gray wash on laid Netherlandish paper; 9¼ x 5¾ in. (23.5 x 14.6 cm). Harris Brisbane Dick Fund, 1935 (35.103.6)
p. 65

Thomas Forster (English, active ca. 1690–1713). *Portrait of a Man*, 1700. Plumbago on vellum; oval, 4⅜ x 3⅝ in. (112 x 92 mm). Rogers Fund, 1944 (44.36.2)
p. 66

Thomas Forster (English, active ca. 1690–1713). *Portrait of a Woman*, 1700. Plumbago on vellum; oval, 4⅜ x 3⅝ in. (112 x 90 mm). Rogers Fund, 1944 (44.36.5)
p. 67

Saddle. Central European, ca. 1400–20. Bone, linden, rawhide, birch bark, and paint; 13⁵/₁₆ x 20½ x 13⅝ in. (33.8 x 52.1 x 34.6 cm). Harris Brisbane Dick Fund, 1940 (40.66)
p. 69, detail p. 68

Honoré Daumier (French, Marseilles 1808–1879 Valmondois). *Philosophes d'eau douce* (*Freshwater philosophers*), from *Croquis Aquatiques*, 1855. Lithograph; 9⅝ x 14¹/₁₆ in. (24.5 x 35.7 cm). Gift of Edwin de Turck Bechtel, 1952 (52.633.1(10))
p. 70

Édouard Manet (French, Paris 1832–1883 Paris). *Boating*, 1874. Oil on canvas; 38¼ x 51¼ in. (97.2 x 130.2 cm). H. O. Havemeyer Collection, Bequest of Mrs. H. O. Havemeyer, 1929 (29.100.115)
p. 71

William Gropper (American, 1897–1977). *Fox Trot*, ca. 1922. Pen and graphite on paper; 12¼ x 9½ in. (31.1 x 24.1 cm). Bequest of Scofield Thayer, 1982 (1984.433.173)
p. 72

William Henry Johnson (American, 1901–1970). *Jitterbugs II*, ca. 1941. Screenprint; 17 x 13¾ in. (43.2 x 34.9 cm). Gift of Reba and Dave Williams, 1999 (1999.529.79)
p. 73

Petrus Christus (Netherlandish, Baerle-Duc [Baarle-Hertog], active by 1444–died 1475/76 Bruges). *A Goldsmith in His Shop, Possibly Saint Eligius*, 1449. Oil on oak panel; overall 39⅜ x 33¾ in.; painted surface 38⅝ x 33½ in. (98 x 85.2 cm). Robert Lehman Collection, 1975 (1975.1.110)
p. 74

Jewish betrothal ring. East European or Italian, 17th–19th century(?). Gold, enamel; ⅞ x 1¾ in. (2.2 x 4.4 cm). Gift of J. Pierpont Morgan, 1917 (17.190.996)
p. 75

Titian and Workshop (Italian, Pieve di Cadore ca. 1485/90?–1576 Venice). *Venus and the Lute Player*, ca. 1565–70. Oil on canvas; 65 x 82½ in. (165.1 x 209.6 cm). Munsey Fund, 1936 (36.29)
pp. 76–77

Israhel van Meckenem (German, Meckenem ca. 1440/45–1503 Bocholt). *Lute Player and Harpist*, from *Scenes of Daily Life*, n.d. Engraving; 6⁵/₁₆ x 4⁵/₁₆ in. (16 x 11 cm). Harris Brisbane Dick Fund, 1927 (27.5.2)
p. 78

Sir Edward Burne-Jones (British, Birmingham 1833–1898 Fulham). *The Love Song*, 1868–77. Oil on canvas; 45 x 61⅜ in. (114.3 x 155.9 cm). The Alfred N. Punnett Endowment Fund, 1947 (47.26)
p. 79

Frans Hals (Dutch, Antwerp 1582/83–1666 Haarlem). *Young Man and Woman in an Inn* (*Yonker Ramp and His Sweetheart*), 1623. Oil on canvas; 41½ x 31¼ in. (105.4 x 79.4 cm). Bequest of Benjamin Altman, 1913 (14.40.602)
p. 80

Frans Hals (Dutch, Antwerp 1582/83–1666 Haarlem). *The Smoker*, ca. 1625. Oil on wood; octagonal, 18⅜ x 19½ in. (46.7 x 49.5 cm). Marquand Collection, Gift of Henry G. Marquand, 1889 (89.15.34)
p. 81

Brassaï (French, born Romania, Brasov 1899–1984 Côte d'Azur). *Couple d'amoureux dans un petit café, quartier Italie*, ca. 1932, printed mid-1960s. Gelatin silver print; 11⅛ x 8¹⁵/₁₆ in. (28.3 x 22.7 cm). Warner Communications Inc. Purchase Fund, 1980 (1980.1023.5)
p. 82

Garry Winogrand (American, 1928–1984). *El Morocco*, 1955. Gelatin silver print; 9¼ x 13¼ in. (23.5 x 33.7 cm). The Horace W. Goldsmith Foundation Gift, through Joyce and Robert Menschel, 1992 (1992.5107)
p. 83

Auguste Edouart (French, 1789–1861). *Frank Johnson, Leader of the Brass Band of the 128th Regiment in Saratoga, with his wife, Helen*, 1842–44. Cut paper silhouettes mounted on board; 11¼ x 9¼ in. (28.6 x 23.5 cm). Gift of Philip S. P. and Elisabeth W. Fell, 1976 (1976.652.3-4)
p. 84

Princely couple. Iranian, possibly Tabriz; AD 1400–5. Opaque watercolor and gold on paper; 19¼ x 12⁹/₁₆ in. (48.9 x 31.9 cm). Cora Timken Burnett Collection of Persian Miniatures and Other Persian Art Objects, Bequest of Cora Timken Burnett, 1956 (57.51.20)
p. 86

Bahram Gur in the White Palace on Friday from the Khamsa (Quintet) of Nizami (fol. 235). Present-day Afghanistan, Herat; AH 931/AD 1524–25. Calligraphers: Sultan Muhammad Nur, Mahmud Muzahib; artists: Sultan Muhammad, Shaykh Zada; author: Nizami (Ilyas Abu Muhammad Nizam al-Din of Ganja), probably 1141-1217. Opaque watercolor, ink, and gold on paper; painting 8¹³/₁₆ x 4½ in. (22.4 x 11.4 cm); page 12⅝ x 8¾ in. (32.1 x 22.2 cm); mat 19¼ x 14¼ in. (48.9 x 36.2 cm). Gift of Alexander Smith Cochran, 1913 (13.228.7.14)
p. 87

Hans Holbein the Younger (German, Augsburg 1497/98–1543 London). *William Roper (1493/94–1578)*, 1535-36. Vellum laid on card; diam. 1¾ in. (4.5 cm). Rogers Fund, 1950 (50.69.1)
p. 88

Hans Holbein the Younger (German, Augsburg 1497/98–1543 London). *Margaret More (1505–1544), Wife of William Roper*, 1535-36. Vellum laid on playing card; diam. 1¾ in. (4.5 cm). Rogers Fund, 1950 (50.69.2)
p. 89

Mirror case. French, 1350-75. Elephant ivory; overall 4⅜ x 4⅛ x ⁷/₁₆ in. (11.1 x 10.4 x 1.1 cm); diam. 4 in. (10.1 cm). Gift of George Blumenthal, 1941 (41.100.160)
p. 90

William James Glackens (American, 1870–1938). *LIPPINCOTT'S AUGUST: CONTAINS A COMPLETE NOVEL SWEETHEART MANETTE BY MAURICE THOMPSON*, 1894. Commercial lithography; yellow, vermilion, and black; image 16 x 11¹³/₁₆ in. (40.6 x 30 cm); sheet 17⁷/₁₆ x 12⁹/₁₆ in. (44.3 x 31.9 cm). Leonard A. Lauder Collection of American Posters, Gift of Leonard A. Lauder, 1984 (1984.1202.38)
p. 91

Elie Nadelman (American, 1882–1946). *Tango*, ca. 1917-18. Ink and wash on paper; 9½ x 6⅜ in. (24.1 x 16.2 cm). Gift of Lincoln Kirstein, 1965 (65.12.10)
p. 92

Fernando Botero (Colombian, born 1932). *Dancing in Colombia*, 1980. Oil on canvas; 74 x 91 in. (188 x 231.1 cm). Anonymous Gift, 1983 (1983.251)
p. 93

John George Brown (American, 1831–1913). *The Music Lesson*, 1870. Oil on canvas; 24 x 20 in. (61 x 50.8 cm). Gift of Colonel Charles A. Fowler, 1921 (21.115.3)
p. 94

Shepherd and Shepherdess Making Music. South Netherlandish, ca. 1500-30. Wool and silk; 92½ x 115 in. (234.9 x 292.1 cm). Bequest of Susan Vanderpoel Clark, 1967 (67.155.8)
p. 95

Michelino da Besozzo (Michelino de Mulinari) (Italian, Lombard, active 1388–1450). *The Marriage of the Virgin*, ca. 1430. Tempera and gold on wood; 25⅝ x 18¾ in. (65.1 x 47.6 cm). Maitland F. Griggs Collection, Bequest of Maitland F. Griggs, 1943 (43.98.7)
p. 96

Bowl base with a marriage scene. Roman or Byzantine, 4th-5th century. Glass, gold leaf; 3⁵/₁₆ x ³/₁₆ in. (8.4 x 0.5 cm). Rogers Fund, 1915 (15.168)
p. 97

Rembrandt (Rembrandt van Rijn) (Dutch, Leiden 1606–1669 Amsterdam). *Man with a Magnifying Glass*, ca. 1660-64. Oil on canvas; 36 x 29¼ in. (91.4 x 74.3 cm). Bequest of Benjamin Altman, 1913 (14.40.621)
p. 98 (left)

Rembrandt (Rembrandt van Rijn) (Dutch, Leiden 1606–1669 Amsterdam). *Woman with a Pink*, ca. 1660–64. Oil on canvas; 36¼ x 29⅜ in. (92.1 x 74.6 cm). Bequest of Benjamin Altman, 1913 (14.40.622)
p. 98 (right), detail p. 99

Théodore Chassériau (El Limón [Santo Domingo, now Dominican Republic] 1819–Paris 1856). *Portrait of Félix Ravaisson*, 1846. Pencil on white wove paper darkened to buff; 13⅛ x 10 in. (33.3 x 25.4 cm). Robert Lehman Collection, 1975 (1975.1.583)
p. 100

Théodore Chassériau (El Limón [Santo Domingo, now Dominican Republic] 1819–Paris 1856). *Portrait of Madame Ravaisson*, 1846. Pencil on white wove paper darkened to buff; 13⅛ x 10 in. (33.3 x 25.4 cm). Robert Lehman Collection, 1975 (1975.1.582)
p. 101

Attributed to the Maestro delle Storie del Pane (Italian [Emilian], active late 15th century). *Portrait of a Man, possibly Matteo di Sebastiano di Bernardino Gozzadini*, ca. 1485–95. Tempera on wood; overall 20¾ x 14⅝ in. (52.7 x 37.1 cm); painted surface 19⅜ x 14 in. (49.2 x 35.6 cm). Robert Lehman Collection, 1975 (1975.1.95)
p. 102

Attributed to the Maestro delle Storie del Pane (Italian [Emilian], active late 15th century). *Portrait of a Woman, possibly Ginevra d'Antonio Lupari Gozzadini*, ca. 1485–95. Tempera on wood; overall 19¾ x 14⅝ in. (50.2 x 37.1 cm); painted surface 19⅛ x 14⅛ in. (48.6 x 35.9 cm). Robert Lehman Collection, 1975 (1975.1.96)
p. 103

Peter Paul Rubens (Flemish, Siegen 1577–1640 Antwerp). *Rubens, His Wife Helena Fourment (1614–1673), and One of Their Children*, mid- to late 1630s. Oil on wood; 80¼ x 62¼ in. (203.8 x 158.1 cm). Gift of Mr. and Mrs. Charles Wrightsman, in honor of Sir John Pope-Hennessy, 1981 (1981.238)
p. 104

Édouard Manet (French, Paris 1832–1883 Paris). *The Monet Family in Their Garden at Argenteuil*, 1874. Oil on canvas; 24 x 39¼ in. (61 x 99.7 cm). Bequest of Joan Whitney Payson, 1975 (1976.201.14)
p. 105

Caspar David Friedrich (German, Greifswald 1774–1840 Dresden). *Two Men Contemplating the Moon*, ca. 1825–30. Oil on canvas; 13¾ x 17¼ in. (34.9 x 43.8 cm). Wrightsman Fund, 2000 (2000.51)
p. 106

Marius de Zayas (Mexican, 1880–1961). *George H. Seeley and J. Nilsen Laurvik*, 1910. Ink and metallic paint on paper; 17⅜ x 11¼ in. (44.1 x 28.6 cm). Alfred Stieglitz Collection, 1949 (49.70.202)
p. 107

Andrea Schiavone (Andrea Medulich or Meldolla) (Italian, Venetian, 1522?–1563). *The Marriage of Cupid and Psyche*, ca. 1550. Oil on wood; overall, with corners made up, 51½ x 61⅞ in. (130.8 x 157.2 cm); painted surface 50½ x 61½ in. (128.3 x 156.2 cm). Purchase, Gift of Mary V. T. Eberstadt, by exchange, 1972 (1973.116)
p. 108

Antonio Canova (Italian, born Possagno, active in Venice and especially Rome, 1757–1822). *Cupid and Psyche*, 1794. Plaster; 53 x 59½ x 32 in. (134.6 x 151.1 x 81.3 cm). Gift of Isidor Straus, 1905 (05.46)
p. 109

George Platt Lynes (American, 1907–1955). Lew Christiensen, William Dollar, and Daphne Vane performing in the opera *Orpheus and Eurydice*, 1936. Gelatin silver print; 13⁹⁄₁₆ x 10⅝ in. (34.4 x 27 cm). Gift of Mr. and Mrs. Russell Lynes, 1983 (1983.1160.16)
p. 110

Auguste Rodin (French, 1840–1917). *Orpheus and Eurydice*, probably modeled before 1887, this marble executed in 1893. Marble; 50 x 30 x 28 in. (127 x 76.2 x 71.1 cm). Gift of Thomas F. Ryan, 1910 (10.63.2)
p. 111

North Netherlandish Painter. *First Count of Egmond (Jan, 1438–1516)*, ca. 1510. Oil on canvas, transferred from wood; overall, with arched top, 16¾ x 10¼ in. (42.5 x 26 cm); original painted surface 16¼ x 9⅝ in. (41.3 x 24.4 cm). The Friedsam Collection, Bequest of Michael Friedsam, 1931 (32.100.122)
p. 113 (left), detail p. 112

North Netherlandish Painter. *Countess of Egmond (Magdalena van Werdenburg, 1464–1538)*, ca. 1510. Oil on wood; overall, with arched top and engaged frame, 19¼ x 12½ in. (48.9 x 31.8 cm); painted surface 16½ x 9¾ in. (41.9 x 24.8 cm). The Friedsam Collection, Bequest of Michael Friedsam, 1931 (32.100.118)
p. 113 (right), detail p. 112

Marcel Duchamp (American, born France, Blanville 1887–1968 Neuilly-sur-Seine). *At the Palais de Glace*, 1909. Ink with splatter on paper; 17 x 12 in. (43.2 x 30.5 cm). Gift of Mrs. William Sisler, 1975 (1975.428.2)
p. 114

Pablo Picasso (Spanish, Malaga 1881–1973 Mougins, France). *At the Lapin Agile*, 1905. Oil on canvas; 39 x 39½ in. (99.1 x 100.3 cm). The Walter H. and Leonore Annenberg Collection, Gift of Walter H. and Leonore Annenberg, 1992, Bequest of Walter H. Annenberg (2002. 1992.391)
p. 115

François Boucher (French, Paris 1703–1770 Paris). *Jupiter, in the Guise of Diana, and Callisto*, ca. 1763. Oil on canvas; oval, 25½ x 21⅝ in. (64.8 x 54.9 cm). The Jack and Belle Linsky Collection, 1982 (1982.60.45)
p. 117 (above, left)

François Boucher (French, Paris 1703–1770 Paris). *Angelica and Medoro*, 1763. Oil on canvas; oval, 26¼ x 22⅛ in. (66.7 x 56.2 cm). The Jack and Belle Linsky Collection, 1982 (1982.60.46)
p. 117 (below, right), detail p. 116

Cover of a writing tablet. French, ca. 1325–50. Ivory; 3¹¹⁄₁₆ x 2⁵⁄₁₆ x ⁵⁄₁₆ in. (9.3 x 5.9 x 0.8 cm). The Cloisters Collection, 2003 (2003.131.3a, b)
pp. 118, 119

Walker Evans (American, St. Louis 1903–1975 New Haven). *Couple at Coney Island, New York*, 1928. Gelatin silver print, 8 x 5¹³⁄₁₆ in. (20.4 x 14.8 cm). Ford Motor Company Collection, Gift of Ford Motor Company and John C. Waddell, 1987 (1987.1100.110)
p. 120

Lynn Bostick (American, born 1940). *Conversation on a Boat Deck*, 1983. Watercolor, graphite, crayon, and cut and pasted papers on paper; 16 x 14 in. (40.6 x 35.6 cm). Purchase, Lillian L. Poses Gift, 1983 (1983.465.1)
p. 121

Joseph H. Davis (American, 1811–1865). *Mr. and Mrs. Daniel Otis and Child*, 1834. Watercolor, gum arabic, and graphite on off-white wove paper; 10¾ x 16⅝ in. (27.3 x 42.2 cm). Gift of Edgar William and Bernice Chrysler Garbisch, 1972 (1972.263.6)
p. 122

The Abraham Pixler Family. American, early nineteenth century. Watercolor, pen and iron gall ink, and gouache on off-white laid paper; 10 x 8 in. (25.4 x 20.3 cm). Gift of Edgar William and Bernice Chrysler Garbisch, 1966 (66.242.3)
p. 123

Hans Memling (Netherlandish, Seligenstadt, active by 1465–died 1494 Bruges). *Tommaso di Folco Portinari (1428–1501)*, probably 1470. Oil on wood; overall 17⅜ x 13¼ in. (44.1 x 33.7 cm); painted surface 16⅝ x 12½ in. (42.2 x 31.8 cm). Bequest of Benjamin Altman, 1913 (14.40.626)
p. 125 (left), detail p. 124

Hans Memling (Netherlandish, Seligenstadt, active by 1465–died 1494 Bruges). *Maria Portinari (Maria Maddalena Baroncelli, born 1456)*, probably 1470. Oil on wood; overall 17⅜ x 13⅜ in. (44.1 x 34 cm); painted surface 16⅝ x 12⅝ in. (42.2 x 32.1 cm). Bequest of Benjamin Altman, 1913 (14.40.627)
p. 125 (right), detail p. 124

Marc Chagall (French, born Belarus, Vitebsk 1887–1985 Saint-Paul de Vence). *The Lovers*, 1913–14. Oil on canvas; 43 x 53 in. (109.2 x 134.6 cm). Jacques and Natasha Gelman Collection, 1998 (1999.363.14)
p. 126

Guy Pène du Bois (American, 1884–1958). *The Doll and the Monster*, 1914. Oil on wood; 20 x 15 in. (50.8 x 38.1 cm). Gift of Mr. Harry Payne Whitney, 1921 (21.147)
p. 127

Franz Anton Bustelli (modeler) (ca. 1720–1763, active 1754–63). Harlequin, Nymphenburg Porcelain Manufactory (Neudeck-Nymphenburg), ca. 1760. Hard-paste porcelain; ht. 7⅞ in. (20 cm). The Lesley and Emma Sheafer Collection, Bequest of Emma A. Sheafer, 1973 (1974.356.525)
p. 128 (left)

Franz Anton Bustelli (modeler) (ca. 1720–1763, active 1754–63). Columbine, Nymphenburg Porcelain Manufactory (Neudeck-Nymphenburg), ca. 1760. Hard-paste porcelain; ht.: 8 in. (20.3 cm). The Lesley and Emma Sheafer Collection, Bequest of Emma A. Sheafer, 1973 (1974.356.524)
p. 128 (right)

Elie Nadelman (American, 1882–1946). *Dancing Couple*, 1917–18. Ink and wash on paper; 9⅞ x 8 in. (25.1 x 20.3 cm). Gift of Lincoln Kirstein, 1965 (65.12.11)
p. 129

William Blake (British, London 1757–1827 London). *Angel of the Divine Presence Bringing Eve to Adam; "And She Shall be Called Woman" (Genesis)*, ca. 1803. Watercolor, pen, and black ink over graphite; 16⅜ x 13¹/₁₆ in. (41.6 x 33.2 cm). Rogers Fund, 1906 (06.1322.2)
p. 130

Paul Klee (German, born Switzerland, Münchenbuchsee 1879–1940 Muralto-Locarno). *Adam and Little Eve*, 1921. Watercolor and transferred printing ink on paper; 12⅜ x 8⅝ in. (31.4 x 21.9 cm). The Berggruen Klee Collection, 1987 (1987.455.7)
p. 131

Edgar Degas (French, Paris 1834–1917 Paris). *Sulking*, ca. 1870. Oil on canvas; 12¾ x 18¼ in. (32.4 x 46.4 cm). H. O. Havemeyer Collection, Bequest of Mrs. H. O. Havemeyer, 1929 (29.100.43)
p. 133

Pierre-Auguste Cot (French, Bédarieux 1837–1883 Paris). *The Storm*, 1880. Oil on canvas; 92¼ x 61¾ in. (234.3 x 156.8 cm). Catharine Lorillard Wolfe Collection, Bequest of Catharine Lorillard Wolfe, 1887 (87.15.134)
p. 134

Malvina Cornell Hoffman (American, 1885–1966). *Bacchanale Russe*, 1912. Bronze; 14 x 9 x 9 in. (35.6 x 22.9 x 22.9 cm). Bequest of Mary Stillman Harkness, 1950 (50.145.40)
p. 135

Cornelis Bisschop (Dutch, Dordrecht 1630–1674 Dordrecht). *A Young Woman and a Cavalier*, probably early 1660s. Oil on canvas; 38½ x 34¾ in. (97.8 x 88.3 cm). The Jack and Belle Linsky Collection, 1982 (1982.60.33)
p. 136

Brassaï (French, born Romania, Brasov 1899–1984 Côte d'Azur). *Young Couple Wearing a Two-in-One Suit at the Bal de la Montagne Sainte-Geneviève*, ca. 1931. Gelatin silver print; 9⅛ x 6¼ in. (23.2 x 15.9 cm). Ford Motor Company Collection, Gift of Ford Motor Company and John C. Waddell, 1987 (1987.1100.393)
p. 137

Rembrandt (Rembrandt van Rijn) (Dutch, Leiden 1606–1669 Amsterdam). *Portrait of a Man Rising from His Chair*, 1633. Oil on canvas; 48⅞ x 38¾ in. (124.1 x 98.4 cm). Taft Museum of Art, Cincinnati, Ohio. Bequest of Charles Phelps and Anna Sinton Taft (1931.409)
p. 138

Rembrandt (Rembrandt van Rijn) (Dutch, Leiden 1606–1669 Amsterdam). *Portrait of a Young Woman with a Fan*, 1633. Oil on canvas; 49½ x 39¾ in. (125.7 x 101 cm). Gift of Helen Swift Neilson, 1943 (43.125)
p. 139

Roundel with playing at quintain. French (Paris?), ca. 1500. Colorless glass, vitreous paint, and silver stain; diam. 8 in. (20.3 cm). The Cloisters Collection, 1980 (1980.223.6)
p. 140

Komar & Melamid (Vitaly Komar, Russian, born 1943; Alexander Melamid, Russian, born 1945). *Blindman's Buff*, 1982–83. Oil on canvas; 72 x 47 in. (182.9 x 119.4 cm). Anonymous Gift, 1991 (1991.466)
p. 141

Loving couple (mithuna). India, Orissa; 13th century. Ferruginous stone; ht. 72 in. (182.9 cm). Purchase, Florance Waterbury Bequest, 1970 (1970.44)
p. 142

William Zorach (American, 1889–1966). *Spring in Central Park*, 1914. Oil on canvas; 46 x 36 in. (116.8 x 91.4 cm). Gift of Peter Zorach, 1979 (1979.223a, b)
p. 143, detail p. 4

King (from a group of donor figures including a king, queen, and prince). French, ca. 1350. Marble, traces of paint, and gilding; 15¾ x 5¹³/₁₆ x 3¹/₁₆ in. (40 x 14.7 x 7.8 cm). Gift of J. Pierpont Morgan, 1917 (17.190.387)
p. 144 (left)

Queen (from a group of donor figures including a king, queen, and prince). French, ca. 1350. Marble, traces of paint, and gilding; 15³/₁₆ x 10³/₁₆ x 3¹/₁₆ in. (38.6 x 25.8 x 8 cm). Gift of J. Pierpont Morgan, 1917 (17.190.388)
p. 144 (right)

Master ES (German, active ca. 1450–67). *Pair of Lovers on a Grassy Bench*, mid-15th century. Engraving; sheet 5¼ x 6½ in. (13.4 x 16.4 cm). Harris Brisbane Dick Fund, 1922 (22.83.14)
p. 146

Dosso Dossi (Giovanni de Lutero) (Italian, Tramuschio ca. 1486–1541/42 Ferrara). *The Three Ages of Man*, ca. 1515. Oil on canvas; 30½ x 44 in. (77.5 x 111.8 cm). Maria DeWitt Jesup Fund, 1926 (26.83)
pp. 146–47

Guy Pène du Bois (American, 1884–1958). *Mr. and Mrs. Chester Dale Dine Out*, 1924. Oil on canvas; 30 x 40 in. (76.2 x 100.6 cm). Gift of Chester Dale, 1963 (63.138.1)
p. 148

Robert Blackburn (American, 1920–2003). *Café Scene*, 1939. Lithograph; 13½ x 8⅜ in. (34.3 x 21.3 cm). Gift of Reba and Dave Williams, 1999 (1999.529.7)
p. 149

Auguste Rodin (French, 1840–1917). *Eternal Spring*, probably modeled ca. 1881, executed 1907. Marble; 28 x 29 x 18 in. (71.1 x 73.7 x 45.7 cm). Bequest of Isaac D. Fletcher, 1917 (17.120.184)
p. 150

John Gutmann (American, born Germany, Breslau 1905–1998 San Francisco). *Two Women in Love*, 1937. Gelatin silver print; 7¹¹/₁₆ x 7¹³/₁₆ in. (19.6 x 19.8 cm). Gift of the artist, 2000 (2000.651.5)
p. 151

Jacques-Louis David (French, Paris 1748–1825 Brussels). *Antoine-Laurent Lavoisier (1745–1794) and His Wife (Marie-Anne-Pierrette Paulze, 1758–1836)*, 1788. Oil on canvas; 102½ x 76⅝ in. (259.7 x 194.6 cm). Purchase, Mr. and Mrs. Charles Wrightsman Gift, in honor of Everett Fahy, 1977 (1977.10)
p. 152

Richard Hamilton (British, born 1922). *The Marriage*, 1998. Ink jet (Iris) print; 35¼ x 26½ in. (89.5 x 67.3 cm). Purchase, Reba and Dave Williams Gift, 2000 (2000.149)
p. 153

Mirror. English, third quarter of the 17th century. Satin worked with silk, chenille, purl, shells, wood, beads, mica, bird feathers, coral; detached buttonhole variations, long-and-short, satin, couching stitches, and knots; 23¾ x 19½ in. (60.3 x 50.5 cm). Gift of Irwin Untermyer, 1964 (64.101.1332)
p. 160

For their advice and assistance in helping to realize this book,
the publisher wishes to thank the following individuals:

Carrie Rebora Barratt
Barbara Bridgers
Thomas P. Campbell
Nadja Hansen
Anna-Claire Harkness
Marilyn Jensen
Philippe de Montebello
Gwen Roginsky
Dina Selfridge
Robin Straus
Valerie Troyansky
Samantha Waller
Julie Zeftel

DelMonico Books, an imprint of
Prestel, a member of Verlagsgruppe Random House GmbH

Prestel Verlag
Neumarkter Strasse 28
81673 Munich
Germany
Tel.: +49 (0)89 41 36 0
Fax: +49 (0)89 41 36 23 35

Prestel Publishing Ltd.
4 Bloomsbury Place
London WC1A 2QA
United Kingdom
Tel.: +44 (0)20 7323 5004
Fax: +44 (0)20 7636 8004

Prestel Publishing
900 Broadway, Suite 603
New York, NY 10003
Tel.: +1 212 995 2720
Fax: +1 212 995 2733
E-mail: sales@prestel-usa.com

www.prestel.com

© 2011 Prestel Verlag, Munich • London • New York
All images are © 2011 The Metropolitan Museum of Art, with the exception of page 138

Library of Congress Cataloging-in-Publication Data

Lyon, Christopher, 1949-
 Couples in art / Chistopher Lyon ; artworks selected by Colin Eisler
in collaboration with Caroline Kelly.
 p. cm.
 ISBN 978-3-7913-5006-6 (hardback)
1. Love in art. 2. Couples in art. 3. Metropolitan Museum of Art
(New York, N.Y.) I. Title.
 N8220.L96 2011
 704.9'4930681—dc23
 2011028747

ISBN: 978-3-7913-5006-6

IMAGE CREDITS

*Unless otherwise noted: All images © The Metropolitan
Museum of Art*

© The Estate of Robert Blackburn, used with permission: 149
Courtesy of the Estate of Yvonne Pène du Bois Mckenny and
 James Grayham & Sons, New York: 127, 148
© Lynn Bostick: 121
© Fernando Botero: 93
© Miguel Rio Branco, courtesy of the artist and Christopher
 Grimes Gallery, Santa Monica: 32–33
© ESTATE BRASSAÏ–RMN: 82, 137
Center for Creative Photography, University of Arizona,
 ©1998 Arizona Board of Regents: 151
Photograph by Geoffrey Clements: 122
© Walker Evans Archive, The Metropolitan Museum of Art: 120
© Gilbert & George, photograph courtesy of the artists: 48–49
© William Gropper Estate: 72
© D. J. Hall: 31
© Komar & Melamid, courtesy Ronald Feldman Fine Art,
 New York: 141
© The Estate of George Platt Lynes: 110
© Succession Picasso / VG Bild-Kunst, Bonn 2011: p. 115
Photograph by Tony Walsh, Cincinnati, Ohio; courtesy
 Taft Museum of Art, Cincinnati, Ohio: 138
Photograph by Malcolm Varon: 126
© VG Bild-Kunst, Bonn 2011: 24, 25, 114, 126, 153
Photograph by Bruce White: 34 (left), 142
© The Estate of Garry Winogrand, courtesy Fraenkel Gallery,
 San Francisco: 83
© Marius de Zayas: 107
© Zorach Collection, LLC: 4, 142

EDITOR
Elisa Urbanelli

DESIGN
Rita Jules and Claire Bidwell, Miko McGinty Inc.

TYPEFACES
Vendetta by John Downer, Galliard by
Matthew Carter, and Whitney by Tobias Frere-Jones

ORIGINATION
GHP, West Haven, Connecticut

PRINTING AND BINDING
C&C Offset Printing, Hong Kong

MIRROR
English, third quarter of the 17th century
Satin worked with silk, chenille, purl, shells, wood, beads, mica, bird feathers, coral;
detached buttonhole variations, long-and-short, satin, couching stitches, and knots;
23¾ x 19½ in. (60.3 x 50.5 cm)

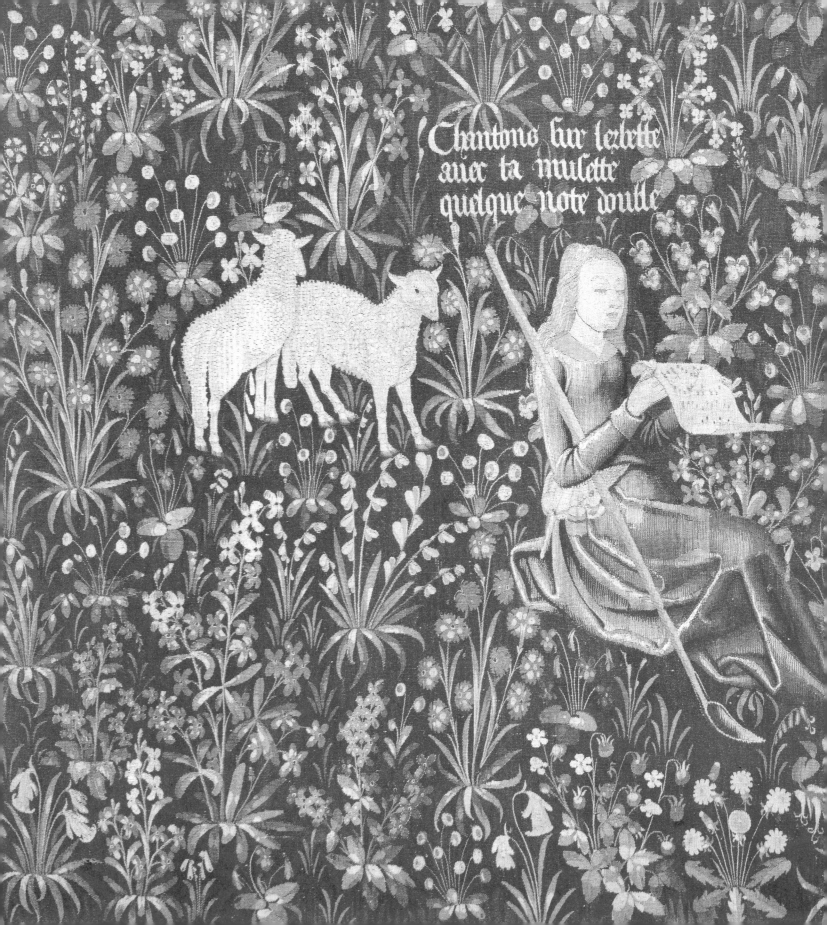